U0164962

傅新民

现代雕塑艺术作品集（二）

FU XIN MIN MODER SCULPTURE ART SERIES（2）

人民美术出版社

目 录

Contents

自 序

　　上自茫茫苍穹，下至荒草甘露，浑然中以各自的规律运行着。有始以来，人类与自然的互动、依存，正如在老子所谓的"人法地，地法天，天法道，道法自然"。然而当事物呈现在我们面前时却总是呈现着错综复杂、千变万化、形态各异的状态，无论是从古代贤哲或是到当代80后生都是背负着时代的属性，循环反复的不断探索着事物的本真和自然的法则。

　　作为现代人，创作主题自然也就离不开对自然规律的探索和生命哲学的研究，我在思索着：

　　宇宙万物循环往复，运动变化的状态；

　　生命轮回运动以及生命与自然的互动关系；

　　精神定义与物质体现的辩证换位；

　　自然而然我的思想跨越了时空，创作也超越了形式，形成了一个时空的太极。只要能表现主题，表达思想，任何材料都是可能的。没有了钢铁与朽木的界限，没有了油彩与水墨的界限，甚至没有了平面与立体的界限，一切思想和主题相互融合构成了完整的太极行为，形成了如下太极现象：

　　早年坚实的传统实践和业余创作，对材料深入认识和娴熟的掌握，以及图形色彩的灵活转换与运作，夯实了我的创作平台，构成了太极的充实原点。后来多年的多方位、多角度地生活历练，社会管理实践，对规律的再认识以及对自然的反复提问，形成了一个虚拟的思想语境，构成太极的虚发原点，无所谓作品元素与表现形式，时间与空间，虚实相间，浑然一体，此太极之一。

　　我运用了大量相互排斥的异质材料进行创作，没有材料的局限，无论是树根朽木、废铁还是铮亮的不锈钢，都能得到有机结合，他们交织、糅和、挤压、相契，在灵感、智慧的涌动中形成了对立统一的作品实体，构成了太极的坚实原点。然而作品以多变的抽象形体和异质的材料现象，为观者提出了无数的命题和想象的延伸，营造了思维与探索的无限空间，构成了虚发语境的始点，作品与观者虚实相间，浑然一体，此太极之二。

　　总之，我们这一代人经历了大量的社会变革现象，体会了更多的探索规律的思维碰撞。使命感让我们努力真诚地去创作更多的实践作品，同样是使命感让我们不断对变幻的规律提出更深邃的思想平台。现代与传统，破坏与建立，构成了一个当代的太极语境。

Forward

From the boundlessness of heaven to the wild grasslands, their movements run with the laws of nature. Since the beginning, the interaction and interdependence of humans and nature, as Laozi the father of Taoism said, "Humans rule on earth, earth rules in the universe and the universe rules in the multi power which comes from nature. However, when we see things in the beginning that may seem apparent, but then when we look inward, this always present a complex and ever-changing forms. Regardless of the philosophers from ancient times or young contemporaries today, those who were born in the later 80s, the repeated cycle of continuous exploration of the things, the truth and the laws of nature.

I was thinking further about several points on the condition of universal circulation and varieties of movements; life circulation and the relation between life and natural interaction; the position of dialectical conversion between the spiritual definition and the material appearance. As with modern people creating themes, they certainly can not separate the exploration of natural law and philosophy of life.

Naturally, my thoughts across time and space go beyond the creative forms, forming primal chaos. As long as the performance of the theme is in tune with my thinking, any material is possible. No boundaries lie between the iron, steel and deadwood. No limits on oil and ink, not even a three-dimensional plane or line. All the ideas and topics of mutual integration constitute a complete primal chaos and were formed as following:

In my early years, the solid traditional practice and odd industry creation brought in-depth understanding of materials, color graphic conversion and flexible knowledge that strengthened my creative platform and established a substantial origin of primal chaos.

It was through my multi-directional, multi-angle life experiences and social management practices years later that I further began to understand the laws of nature and the repeated question of what forms a virtual ideological context. It did not matter that the work elements and the manifestations of time and space actually interacted as the unified whole and primal chaos one.

I utilized an abundance of exclusive and heterogeneous materials to create my works. No matter if it was the roots of the deadwood tree, scrap iron or shiny stainless steel, they can be organically integrated. They are intertwined, squeezed and engraved to become the surging inspiration and wisdom to form the unification of the opposite works to ensure the primal chaos of a solid zero point.

However, my works offer more themes and imagination for my audience. The extensive abstract changeability of content and appearance of different materials has structured the thoughts and exploration of unlimited space and the beginning of a hypothesized linguistically environment. My works, the illusory, and the audience, the real, make up the whole. This is chaos two.

In brief, our generation has experienced the massive reforms in our socialistic system and has realized the impact during more explorative thought. This sense of mission will press us create the more practical works genuinely and diligently. Similarly, the sense of mission lets us propose the profound thinking platform for the rule which fluctuates unceasingly. The modern age and the tradition, the destruction and the establishment, constitute a contemporary primal chaos' environment.

名家评论

邵大箴 / 中央美术学院教授，博士生导师，《美术研究》主编

　　傅新民有一种出其不意的发现，出其不意的创造，这是很不容易的，这些本来都是很简单的材料，他可以把它们组合起来，当把它们形成一个新的东西的时候，使我们产生一种陌生感，感觉到震撼。

范迪安 / 中国美术馆馆长，教授，曾任中央美术学院副院长

　　傅先生的作品无论是从造型还是体量，从结构还是主题，都体现了一种现代艺术的观念。他把自己对现实的感受，对很多文化主题的思考，特别是把自己一种发自内心的思想情感运用到一种创作中来。

盛　杨 / 中央美术学院教授，中国美术家协会雕塑委员会会长

　　这些年来，傅新民以其独特的抽象雕塑作品活跃在我国当代雕塑艺坛，为人瞩目，我多次观看过他的作品，他对雕塑的真挚感情和投入雕塑创作的勤奋劳动，令我十分钦佩，而他的作品所呈现出来的感染力更使我久久激动。

邹　文 / 清华大学美术学院教授，博士，中国美术家协会雕塑委员会秘书长

　　我初见傅新民的作品，第一印象是解渴、痛快。因为美术之为职业，其实难得痛快。要天天看，看别人制造的视觉产品，不想看也得看，否则不职业不敬业。偏偏想看的很少。要么太平、太淡、太缺乏冲击力；要么太修饰太优雅让人腻味。傅新民让我去看他的东西，有几间仓库那么多，完全与习见的不一样。是木质的，带着跟土地撕心裂肺拆离后的根须；是金属的，响当当地透着大与光的气节，一下就让你觉得硬朗、干脆、坦荡。作者把对人性人生的觉悟，直率地交由这些材料，或自然或机械的部件去传告，绝无啰嗦，更不闪烁，让观众没法俯看只能仰视。他的作品，不在借审美的折损——因为优美的比例、尺度、形式的舒服不是他的追求，他要的是浩大、旷远、辽阔、厚重、磊落。傅新民嘹亮地做到了。你看他的作品，有阵势、有规模、有气场，扑面而来，轰轰隆隆，让情绪直抒人间大悲大喜；让哲理直追宇宙深奥，让美挣脱红楼梦般的小情小调，重返三国的时代，美得有豪气、血性，这种冲击力极强的造型效果，形成对观众苛刻的选择性。身体不好、心智不成熟的观众几乎不具备欣赏的条件，这才是造型艺术都需要的雕塑感；这才符合当代艺术的气质。

　　我认为，傅新民的作品，正是那种为美术界补短的作品。正是那种能让眼睛过瘾的"大片"级的作品。

Artists' Reviews

Shao Dazhen / Professor of the Central Academy of Fine Arts,Doctoral Tutor, Editor-in-Chief of Art Research

It is unusual that Fu Xinmin has the ability of his surprise discovery and surprise creations .He combines original simple materials into new elements and made us feel strange and shocked.

Fan Di' an / China Art Gallery Curator, Professor, and former vice president of the Central Academy of Fine Arts.

Either from sculpting or body shape, from structure or theme, Mr. Fu's works embodies a concept of modern art. in his creations. He includes his feelings on reality, his thoughts on many cultural themes and in particular his heartfelt emotion.

Sheng Yang / Professor of the Central Academy of Fine Arts, Director of Chinese Art Committee of the sculpture

During these years, Fu Xinmin plays an active role in contemporary sculpture with his unique abstract sculptures making people focus their attention on him. I have followed his works over time and I admire his sincere feelings and the hard work he put into his creations. What is more, the influence represented by his works kept me excited for a long time.

Zou Wen / Academy of Fine Arts professor in Tsinghua University, Ph.D.,Secretary-General of Sculpture Committee of Chinese Art Association.

The first impression Fu Xinmin's works gave me, is that it could satisfying my thirst and make me excited. Art, as a career, is hard for me to get excited about. If you look at different artworks every day and see the visual products created by others and have to look even if you are not willing to, you sometimes feel that you are not dedicated and professional. What you would like to see is the unusual works and not the dull and unexciting works, those lacking wallop or are too elegant making people bored. Fu Xinmin allows me look at his works and they were completely different from the usual works I saw. They were made of wood, with root beard detached. They were metal, showing characteristics of bigness and light, to let you feel tough, simply, magnanimous. The artist gripped the consciousness of human life straight forward through these materials. He applied natural or mechanical components to pass information, not being flashy. His works do not care about aesthetic impairment - because of there beautiful proportions, measurements and comfortable form are not his pursuit; what he want is hugeness, vastness, expansion, messiness, and on the up-and-up.

Fu Xinmin clearly achieved these effects. His works are spectacular, large-scale and magnificent. They tend to rush toward us expressing the human sorrow and sadness; thus making philosophy catch up to the esoteric universe. This beauty breaks loose from a kind of 'Dream of the Red Chamber' affection and returns to Three Kingdoms era. The beauty has heroic spirit and noble sentiment. This is the sculpture sense needed in plastic arts. The audiences who experience bad health and immature can hardly appreciate his works. This is in accordance with the temperament of contemporary art.

I think that Fu Xinmin's works are those that provide a complement to the art world. It is his "magnificent works" that can satisfy our eyes.

艺术就是他的生活——傅新民现代雕塑随想

孙振华 / 深圳雕塑院院长，博士

在厦门雕塑家傅新民先生的作品陈列室和工作室里，他的现代雕塑作品，他的工作状态给了我很大的震撼；他饱满而炙热的创作激情，他丰富的材料积累和创作构思，使他的雕塑创作时时处在"在路上"的状态。他对艺术的真挚和虔诚，他作品的多样和高产都足以使他的创作成为中国现代雕塑中一个有意义的个案。

特别是当我了解到傅新民先生的从艺的经历和创作背景以后，更加坚定了我对探究这样一些问题的兴趣：在转型期的中国社会，艺术对我们个人生活究竟有着怎样的意义？在一个信息的时代，一个影像的时代，在一个克隆和机械复制的时代，艺术家的手工劳作，还有没有发展空间？在"艺术死了"，市场就是一切的各种嘈杂的喧嚣声中，什么是艺术家安身立命，坚守自己价值标准的理由？

有些艺术家的创作也许是面向艺术史，解决艺术史的问题；而像傅新民这一类的艺术家，我以为他们的创作更多的是解决当代人生存意义问题，他们对艺术的热情和坚守表示了一种人生的态度，艺术作为一种生活方式，他们在艺术中，寄寓的是一个人的理想和信念，他们在这样一个精神匮乏的时代里，用艺术这种方式和世界进行永无休止的对话，在这种旷日持久的对话过程中，他们的艺术丰富了他们的思想，提升了他们的想象力和创造力。对于社会，他们艺术创作的意义在于，它们充分昭示出了人的各种可能的生活，而正是他们的工作，使我们这个日益物质化的社会多了一些精神的话题，多了一种思想的激活，多了一种可供选择的生存的智慧。

他对材料异常敏感，他具有化腐朽为神奇的能力，他特别具有这样的素质，在人们习以为常的，熟视无睹的日常事物中，发现美，并将他们转化为艺术。

他对材料的把握来自几十年对艺术执著的追求，他最早从事根雕艺术的创作，这个漫长的过程，给了他一种良好地把握材料的自然属性的能力，他的材料的运用总是得心应手，从不显得勉强和生涩，这就得益于他长期与自然材料打交道，形成了对材料的肌理、质感、表现力的充分了解，而他长期收集、储存的艺术材料，成为他现在也是将来的一笔巨大的财富。

木质材料与中国文化有着不解之缘，特别在空间艺术中，中华民族的几千年的历史，形成了对木质材料的独特审美感受。中国人对木质材料的人工与自然的关系，形与神的关系，巧与拙的关系，文与质的关系，都有着深厚的文化积淀，所以，尽管傅新民在现代雕塑的创作中也吸收了西方现代雕塑的创作理念和方式，但是，他在作品中的中国文化的根性仍然是那样强烈，那样鲜明。

更为重要的是，他不仅是一个擅长材料处理的艺术家，他的创作还蕴含了丰富的哲理，这种哲理来自大自然，来自对生活的观察，来自古老的东方智慧。他的作品呈现出来的冲突、对比、穿插、并列、互补、顺应、和谐等各种境界，就充分体现了它所蕴含的思想。著名旅法雕塑家、哲学家、诗人熊秉明先生曾经说过："有一种精神遗产是不能从书本上得到的，是通过一个活活泼泼的人，一个广博的人格，一个生命的真实经验传下去的，也就是禅宗所谓'以心传心'的道理。"傅新民正是这样，向生活学习，向造化学习，向传统学习，向西方学习，在博采众长的基础上，形成了他独具面目的现代雕塑艺术。

在生活中创造，以创造作为生活，这就是傅新民的艺术人生。

Art is His Life——Random Thoughts on Fu Xinmin's Contemporary Sculptures

Sun Zhenhua / Dean of Shenzhen Sculpture Academy , Ph.D.,

In the artworks exhibition room and studio of Xiamen sculptor Fu Xinmin, his contemporary sculptures and his state of working filled me with awe. His zest for art creation and the rich accumulation of art materials and creation ideas keep him always in a state of "on the way" in sculpture creation. His sincerity and piety for art and the diversity and prolificacy of his works all make him a unique artist in China's contemporary sculptor circle.

Especially after I got to know Fu Xinmin's art experience and background of his creation, I am more interested in exploring the answers to these questions: What is the significance of art to our personal life in such a transitional period of China's society? Is there still any room for the development of artists' manual handwork in such an age of an excess of information, images, clone and mechanical duplication? In the noisy uproar that "art is dead", market is everything, what is the reason for artist to hold his ground and stick to his artistic pursuit and personal value?

Some artists' creation may be directed to the history of art and solving the problems in art history, while for artists like Fu Xinmin, I feel that their art creation is more about exploring the significance of people's life in the modern society. Their enthusiasm and perseverance for art express a sort of life attitude. Art has become a lifestyle for them. They place their ideals and beliefs in art. in such an age that is deficient in spiritual support, they use art as a way to keep a ceaseless dialogue with the world, and in such a process, their art enrich their thoughts and enhance their capabilities of imagination and creation. For the society, the significance of their art creation is they fully show the diversity and possibilities of people's lives. And their work provides some spiritual topics, an activation of thoughts and optional life wisdom in such increasingly materialistic society.

Fu Xinmin is very sensitive to materials. He has the ability to turn waste material into something miraculous. He can discover the beauty in the daily ordinary things which people usually get accustomed to or turn a blind eye to, and transform them into art.

His years of root carving experience trained him to possess a great command of the natures of different materials. He always applies the materials with high proficiency, which is attributable to his long-term contact with natural materials. He has fully understood the texture, nature and expressive force of different materials. The materials he has collected all the way from the past have become a big fortune for him at present and in the future.

Wooden material has an indissoluble bond with Chinese culture. Especially in the spatial art. History of several thousand years of Chinese nation has formed the unique aesthetic experience to the wooden material. There is a profound cultural accumulation in Chinese people's understanding of the relationship of craftsmanship and nature, form and spirit, skillfulness and clumsiness in wooden material. Therefore, although Fu Xinmin's contemporary sculptures have taken in the concept and method of western contem-porary sculptures creation, the Chinese culture rooting in his works is still so strong and distinct.

What is more important is he is not only an artist who is good at dealing with materials but also an artist whose works have rich philosophy, which comes from the nature, the observation of life, and the ancient Oriental wisdom. The states such as conflict, comparison, inserting, parataxis, mutual comple menting, conformance and harmony in his art works are the embodiments of artist's thoughts implied. The sculptor residing in France, philosopher and poet Xiong Bingming once remarked, "There is a kind of spiritual legacy which is not available from the books. It can only be passed down by a fresh person, a living personality, a real life experience, which is the socalled 'passing heart by heart' in Zen Buddhism." This is just what Fu Xinmin is doing. He learns from life, from the tradition, from the West, taking in the strengths of all and forms his own contemporary sculpture art style.

To create in life, to live in creation, this is the art life of Fu Xinmin.

对历史使命的承担

刘骁纯 / 美术评论家、策展人

　　傅新民已奔花甲，但想象活力和创作精力还像年轻人一样充满朝气，大量尝试着巨型艺术创作。在他各种各样的探索中，给我印象最深的是那些根木和金属相互嵌接或并置的雕塑和装置艺术作品。在传统根艺向当代艺术转化的历史过程中，这类作品具有特殊的意义，承担着特殊的使命。

　　为什么这样说？这需要从中国的赏根传统与赏石传统说起。

　　在中国传统文化中，赏石与赏根，就其内在指向而言，走了两条不同的路。赏石，文人主导话语权；赏根，民间主导话语权。赏石，就是赏石本身。米癫拜石拜的就是眼前的那尊石头，是此石的此形此色此质地此纹理此阅历……综合而成的审美感应，使米芾神魂颠倒，是此石的此灵此气此势此骨此个性此风神此造化，使米芾五体投地。赏根则不同，它既要顾此又不能失彼，既要赏此根还要赏此根像个什么别的东西，"不似而似"是赏根的基本信条，在赏根的情境中，甚至特别欣赏模拟物象的雕凿技巧——如果稍事雕凿根形便活现出鹰犬龙马之类，那个雕刻家便会备受推重。因此，根艺又称根雕。

　　赏石与赏根的差异，首先是境界的不同。赏石，体现的是"大璞不雕"、"大美无言"的审美理想，是"道法自然"的哲学理念在审美上的体现，它比传统的赏根理念高出一个层次。按照赏石的审美理想，根艺应该像观赏石一样突出原生的自然美，而不必模拟其他物象。因此，多数根艺雕刻家的劳作并不值得称赞，太多的根神根王被能工巧匠毁掉了，太多的自然造化被人为雕琢破坏了。米癫拜石便含有对强暴自然行为的批判。

　　其次，赏石与赏根的差异还体现着不同的艺术观念。所谓艺术观念，就是对艺术的根本看法，不同的看法会外显为不同的艺术形态，写实、写意、抽象、现成品就是因为观念的不同而形成的四种基本艺术形态。写实、写意属古典形态，抽象、现成品属现代形态。

　　赏石，内藏着抽象观念（非模仿）和现成品观念（非加工）的古代基因，它比传统的赏根观念更具前卫色彩，因此当现当代艺术兴起时，赏石观念必然会向赏根观念渗透，并最终导致传统赏根观念的崩溃。也就是说，中国的文人赏石传统的影响和西方现当代艺术的冲击，共同推动着根艺的现代转化。

　　十余年来，已经出现了一些推动根艺现代转型的艺术家，其作品的主要着力点在于去模仿和去雕饰，抛开"不似而似"的信条，以慧眼取代巧手，让根还原为根本身。而真正承担起历史转折重任的，是厦门的南昌人傅新民。他将已经出现裂缝的古典规范的围墙整个炸开了，他不仅让根还原为根本身，而且让根成为他当代雕塑和装置艺术的基本构成要素。也就是说，还原为根只是他的第一步，第二步则是对还原的根进行全新意义的再加工和再利用。他不是让根回到千年前米元章拜石的理念，而是让根发出当代声音。第一步对应于早期现代意识，强调艺术自身的纯粹性，强调根自身的自然意蕴。第二步则对应于当代意识，当代意识反纯粹性，强调艺术对意义的表达，强调艺术对当代人类社会问题和生存问题的关注。

　　根材是傅新民艺术的命根子，但他的艺术观念却是反根雕的，他对传统根雕的艺术观念和审美系统提出了挑战。如果说让根还原为根本身意味着对传统的模仿物象信条的解构和破坏，那么，他自己的创作则意味着对新规范的建构和创立。应该说，艺术史上的一切解构都是建构，无建构的解构只是空洞的口号和惊世骇俗的废话，它不可能形成解构的力量。同样，没有解构意义的所谓建构则是虚夸的，其实质依然是

对旧制的重复。在解构旧规范中为新规范的萌芽开辟道路，在新规范越来越强有力的创建中形成对旧制的实质性的瓦解——这就是所谓的建构即解构，破坏即创造。

傅新民艺术的最大特征是金木交响，原始根木和金属原材料，都以比较朴素的原材面貌（现成品）出现，进行他特有的嵌接和并置，让自然造物和人工造物近距离对撞。当这种近距离地对撞以巨大的体量和结构的张力出现在人们面前时，震撼人们视觉和心灵的，既不是根木也不是金属，而是两者的关系，是两者在对撞中爆炸出的新的意义，这意义的感染力又因金木双方的各自的强悍和真实而被极度放大。这意义是复杂的、多解的、丰富的，但都指向人与自然、人与环境的紧张关系。这批作品的总基调，是抒发作者对人类泛滥的物欲和人对自然肆虐的掠夺所造成的天人关系的不断恶化的严酷现实的忧虑。傅新民将他的作品分为八大系列，分别名为"感悟"、"穿行"、"织造"、"对话"、"流淌"、"蜕变"、"裂变"、"凝固的风景"，仅从这些词语中，我们不难感受到，傅新民的心灵已经深深地陷入了他悲天悯人的金木交响。

《流淌№1-3》在长方形的不锈钢板上镶嵌着树根。钢板的长方形十分规范，与树根不规则形构成了人工与天成的鲜明对照。闪亮的钢板表面经过特殊技巧的打磨，形成了密集的升腾波纹，在不同的光照下，显示出不同的纵深幻觉，在理性中增加了科幻意味和浪漫色彩。树根经过精选，奇美而又质朴，它被置于钢板上半部，顶部冲出钢板的上边框，显出不齐之齐的错落韵致。这组作品笼罩在理性与和谐的欢快情境中，可以视为傅新民天人和谐共处理想的寄托。

《对话№6》将巨大的枯木用锈钢片和锈螺钉铆接在了一起，形成一堵宽4米，高3.2米，厚1米的高墙。枯木的纹理呈密集的扭动的上下走向，纹理的凹凸深而有力，高墙四角带着放射的力感。这是一首震撼人心的悲怆和力量的交响乐，可以视为傅新民对天人之间危机关系的忧患情怀的表达。

我并不是说傅新民的艺术已经十全十美，他自号"新萌"也清楚地说明，他将自己当前的艺术视为一个大过程的开端。重要的是，在战略上，他立意高远，战役上，他已经创作了数量惊人的作品，许多作品体量巨大，而且，已经出现了《感悟№4》、《穿行№13》、《对话№6-10》、《流淌№1-3》、《裂变№2》、《凝固的风景№1、2》等较为成功的作品。

这一切说明，他已经站在了历史的转折点上，承担起了推进艺术发展的历史使命。

2007年11月21日　厦门

Shouldering the Historic Mission

Liu Xiaochun / Fine Arts ReviewerScheme Exhibition People

Fu Xinmin is nearly sixty years old, but he is still as energetic and imaginative as a young man, keeping on the creation of large scale art works. In his various art explorations, what impresses me most is those tree-root and metal intersecting or co-existing carving art works. These art works have taken on a special significance in the transition of root art from a traditional art to modern art and shoulder the special mission.

To explain this, we should start from a comparison of Chinese root appreciation and stone appreciation tradition.

In Chinese traditional culture, stone appreciation and root appreciation are quite different in their inward directions. As for stone appreciation, it is presided by scholars and literati, while folks play a dominant role in root appreciation. Stone appreciation is to appreciate the stone itself. In the story that the celebrated scholar Mi Fu of Song Dynasty worshipped a marvelous natural stone, what he marveled at was the shape, the color, the texture, the veins and the experience of this stone. He was infatuated by the overall beauty of the stone. Its soul, its style, its manner, its character, its charm attracted Mi Fu so much that he prostrated himself before the stone to express his sincere admiration for it. However, root appreciation is different, only appreciating the root itself is not enough, you should also tell what the root looks like. Making the root look like something is essence of root art. If the creator is good at carving techniques and can easily make the root look like something such as eagle, dog, dragon or horse, he will be highly praised. Therefore, root art is also called root carving.

First of all, the difference between stone appreciation and root appreciation is their distinct aesthetic ideals.Stone appreciation is a pursuit and admiration of natural beauty. It presents a philosophical opinion that we should just keep anything as it originally is. The natural uncut jade is good enough and there is no need to carve it artificially. Therefore, it is up a notch in the traditional root appreciation conception. According to the aesthetic ideal of stone appreciation, the highlight of root art is the natural beauty of the root, and it is not necessary to copy anything else. The hard work of many root art creators is not praiseworthy, because many marvelous natural roots were ruined by these skillful root artists; those masterpieces of nature were destroyed by the artificial carving work. The story that Mi Fu worshipped a natural stone actually implies a criticism of the brutal behavior towards nature.

Secondly, the difference between stone appreciation and root appreciation is a reflection of the different artistic conceptions.

The so-called artistic conception is one's fundamental view towards art. Different views will take different art forms. Realism, impressionism, abstraction, and readily-availability are the four basic art forms engendered based on different artistic conceptions. Realism and impressionism are classical forms, while abstraction, and readily-availability belong to modern forms.

There are the ancient genes of abstract concept (non-imitating) and ready-available concept (non-processed) hidden in the traditional stone appreciation concept. It is more avant-garde than the traditional root appreciation concept. Given the fact that modern art is booming, the concept of stone appreciation will definitely influence the concept of root appreciation and eventually result in the collapse of the traditional root appreciation concept. That's to say, the influence of the Chinese stone appreciation tradition and the impact of Western modern art are pushing forward together the modernization of root art.

During the past more than ten years, some artists have started to work on the modernizing transition of root art. They don't imitate or carve. They abandon the credo of modifying the root to look like something and return root artworks to the original conditions of the root. For them the most important thing for a root art creator is not his skillful hands but his acute eyes to discover the original beauty of roots. The one who actually has shouldered this historic mission is Fu Xinmin, a Nanchang artist now living in Xiamen. He completely bombed the bounding wall of traditional norms which already had openings. He not only return root to its original conditions but also make it the fundamental element in his contemporary sculpture and ornamental art. Returning root to its original conditions is only a first step, then his second step is to re-process and re-use the root in a completely new way. He is not a follower of Mi Fu to just worship the natural beauty of root as Mi Fu did a thousand years ago; he wants the root to voice our age. The first step is an early awareness of modern times, the emphasis of which is the purity of art, the natural significance of root itself, while the second step is a full awareness of contemporary age. It is against purism, and stresses the artistic expression of significance and the artistic attention paid to contemporary social and living

problems of human beings.

The root is the very life of Fu Xinmin's art, but he is against root carving, and has posed a challenge against the traditional root carving artistic concept and aesthetic system. If returning the root to its original condition is a deconstruction and destruction of the traditional root art credo, then his root art works creation is a construction and set-up of new standards in root art. Actually all the deconstruction happened in the art history is new construction; the deconstruction without new construction is merely an empty slogan or nonsense, which is too weak to destroy anything. Similarly, a so-called new construction without real deconstruction significance is only a boasting, and it is in essence still a repetition of the old system. The deconstruction of old standards opens the road for the setup of new systems, and the construction of new standards materially disintegrates the old systems, which is the so-called "deconstruction is construction, destruction is creation".

The most distinct characteristic of Fu Xinmin's art is a symphony of wood and metal. The simple original wood and metal (readily-available) are inter-placed in a unique way with an implication of the very close collision of natural things and artificial things. When people are confronted with such giant art work and its strong structural force in collision, what impresses their visions and souls is neither the wood root nor the medal, but their relationship, the new significance from the collision, the affecting power of which was even extremely magnified due to the brutal nature and realness of the both. The significance is very complicated, rich in meaning and with many possible interpretations, but they all point to the intense relationship between people and the nature, people and the environment. The keynote of these artworks is to express the artist's worry about people's over flooding material desire and the severely worsening relationship between people and the nature. Fu Xinmin classified his art works into eight series, namely "sentiment", "walking through", "fabricating", "dialogue", "flowing", "metamorphosis", "fission" and "stiffened landscape". Just reading these names, we can feel that the artist has completely immersed himself in this symphony of wood and metal to bemoan the worsening environment and pity the fate of mankind.

In "Flowing No.1-3", wood root is inlaid into a rectangular stainless steel plate. The irregularity of wood root provides a striking contrast to the very regularity of oblong steel plate which is a comparison of natural things and artificially made products. The shining surface of the steel plate is specially polished to form intense rising ripples which have distinct appearances in different lights and add a science fictional touch and romantic feelings to the rational work. The odd and beautiful wood root was carefully chosen, which was set in the upper part of the steel plate, and the top of root obtrudes the upper frame of the steel plate. The overall composition is in picturesque disorder. The artwork is enveloped in a rational, harmonious and cheerful atmosphere, which expresses the artist's ideal of a harmonious co-existence of people and the nature.

In "Dialogue No.6, a giant dried-up wood was riveted together with rusted steel sheet and rusted bolts, which formed a high wall that is four meters wide, three point two meters high, and one meter thick. The veins on the dried-up wood are deep and full of power, and the four corners of the high wall are carrying a radiating strength. This is a great symphony of sorrow and strength, and which can be regarded as his expression of the suffering feelings of the crisis between people and the nature.

I am not saying that Fu Xinmin's art is perfect now. His calling himself "a new sprout" also clearly shows that he takes his current art creation as a beginning in a long course. The important thing is he has taken a right strategy and in practice, he has produced plenty of art works, among which there already have some successful works like "Sentiment No.4", "Walking through No.13", "Dialogue No.6-10", "Flowing No.1-3", "Fission No.2", "Stiffened Landscape No.1,2".

This shows that he is now standing at the turning point of art history and has shouldered the historic mission to advance the development of root art.

Xiamen 2007-11-21

当人在思考生命的时候——傅新民的现代艺术创作

徐恩存／《中国美术》主编　美术评论家

　　作为当代艺术家，傅新民作品不同于前人的是——他以自己的艺术思考生命、叩问意义，书写"生命与艺术同在"的文本，他自觉地改写着传统的艺术观念，探索着艺术本质性表现的新领域，在材料运用与语言表现中，他把自己的追问，直接指向意义的深处。

　　傅新民的雕塑作品，在当代文化语境下，漾溢着鲜明的批判性和创造精神，他力求在时代的高度上，俯瞰生命本质和艺术本质，并反思精神之旅的坎坷曲折，这使他的艺术具有浓郁的厚重感、精神性和现代意义。

　　当代文化语境中丰富而多样的文化信息，以其综合性启迪并滋养了作为当代艺术家的傅新民，使他在独创性和个性化方面走得很远。我们看到，在他极富抽象意味的雕塑作品中，他充分运用了如枯木、贝类等承载岁月风云的"现成品"，同时，还选择了现代工业技术提供的金属材料，以强烈的"人为性"或"人工特点"置入现代性结构之中；而现代意义的冷金属以不同形态与略加修饰的枯木（或原生态呈现）相结合时，其意义便赫然显现了。首先，体现了从远古到现代的文明跨度，以及时间、空间的重叠性"整合"，重要的是，这些作品及其材料表现，表明了一种对生命意义、艺术意义的前瞻性思考，它是现代社会科技文明高度发达的必然产物。

　　在一种类似几何学的归纳、叠加、错位与概括中，不稳定的动态感中包含不变的、确定性的精神守望与思考，愈至晚近，傅新民的作品越来越出格，也越来越大，且极其多产，所采用的技法也使他能自如和自由地表现自己的思想。

　　应该说，傅新民的现代雕塑艺术是以生命本质为母题的，它具有与人分享的特点，表达着仁者见仁、智者见智、难以言表的内在意味。而且，其外在材料与形式结构的选择，又是与其内在涵义相一致或契合的。他选择的数百年朽木，斑痕错杂，本身便具有雕塑的凝重性，也具有强烈的张力，很能给人以长久的记忆，既传达出唤起"童年记忆"的历史感，也焕发着现代形式意味的抽象性。而经过加工、切割、处理过的冷金属材料，作为形式语言元素的介入，使人在被自然力量震撼的同时，又看到人类创造性劳动的美感和魅力，这种多样性的综合和处理手段，使作品在不和谐中，达到和谐。在不统一中，达到统一。在不完整中，达到完整。而在事实上，傅新民创作的意义，在于赋予生命本质以全新的形式美感和意义形态，让人在耳目一新中，感受到不露声色的心灵震撼。

　　这是一种在心智上，体现东方哲学把握世界的宏观方式的阐释。在感觉上，以形式、材料的整合，追问生命意义的现代性艺术表现。在空间中的时间因素，推助了作品的深度。显而易见，傅新民更关注的是艺术的内部问题，把艺术的本体性和生命本质意义进行有机的整合，是他创作的目的，也是他艺术的终极追求。因为，对于傅新民而言，艺术的内部问题都是指向艺术与生命的意义的。所以，他在创作过程中日益关注艺术与生命意义的发生方式，并且，更强调作品的玄妙素质，以及来自内在的潜意识的反衬效果——由枯木粗大的形态或冷金属加工后的规则形态的结合性处理，都不仅是空间中的物理性存在，其意义显然要大得多。因为，其中一种本质的非逻辑性和规律之外的个性化系统，为想象所充实。于是，才展示出生命思考的特点——有时是一种深沉，一声叹息，一种赞美，一种见证……其间蕴含的恰是那难以言表或

不可言说的生命意义，这正是傅新民雕塑的现代性所在，美感所在。

　　傅新民的现代雕塑，标志着与传统雕塑观念的彻底决裂，在于他在创作中强调了材料的意义和内在的意义，这使他的作品中"事物"不是表现的目的，形态及其意义才是表现的日的。"事物"与形态在雕塑中没有一对一的契合关系，在这里，形式、语言产生了意义，它们本身就是意义，且在创作与解读中创造和配置出意义的无限可能性，而且，艺术作为形式、语言的实验便是无所不能的。

　　这样，"当人在思考生命的时候"，才能直入本质，拒绝固定化的心态，得以在三维之外思考相关问题，在逻辑之外发挥创造活力。傅新民正是这样以普世襟怀给自己的作品更大容量，在冷峻自强中，开劈自己的艺术之路，且义无返顾，在全新的艺术道路上越走越远。因为，傅新民有他切切不肯放弃的守望精神在，他便能不知疲倦地前行，在自己选择的道路上。

When people are thinking of life ——Fu Xinmin's Modern Artistic Creations

XU Encun / Editor-in-Chief of China Art Fine Arts Reviewer

As a contemporary artist, Fu Xinmin works is different from his predecessors. He thought to himself that art is life and wrote "life and art with" the text. He is rewriting the traditional artistic ideas consciously. What's more, he is exploring a new field of behavioral artistic essence. He points to the depths of the meaning of one's own questions, directly within language of the materials.

Under the linguistic context of a contemporary culture, Fu's sculptures are overflowing and permeate the distinct criticism and spirit of his creations. He makes every effort to look back on life's essence in these times and reviews the frustrating twists and turns of the spirit, which makes his art have a deep and serious meaning.

With an abundance of cultural information, Fu Xinmin, as a contemporary artist, has been nourished by the comprehensive inspiration of the linguistic context of our contemporary culture. He is a step ahead of his peers utilizing his unique powers of originality. His extremely rich abstract sculptures are expressed in the use of ancient woods, shells, etc., which bear the weight of the years of constant change. Fu's choice of metal materials offered by the modern technological industry and then using "artificial characteristics" into a modernistic way among to structure his sculptures. When the cold steel of different shapes is combined with the ancient wood its significance is manifested. At first, it not only reflects the span of civilization from time immemorial to modern times, but also in combining and overlapping of time and space, it is important that the materials used in these works behave as Fu intended them to perform. It is the inevitable result that the modern social scientific and technological civilization is highly developed.

As in the geometry-like induction, overlapping, misplacement, summarization, meditation and spiritual watch over stability and certainty as shown in the instable dynamics, Fu Xinmin's recent works become freer and freer, expanding in size, as well as in productivity. The skills and techniques adopted by Fu Xinmin enable him to display his own thought easily and freely.

It should be said that Fu Xinmin's modern sculpture are taking life essence as with Mother Nature. It has characteristics that people share. Benevolent people do good deeds. Wise people do intelligent things. Moreover, the external materials and structure are in line with its inherent meaning. The ancient wood, some several hundred years old of which he chose were already sculpted by time with deep and strong tension. The aged wood from being around for so many years is evidence by the modification of its structure as compared to matured people who can recall their past history. This can be expressed in a sense of arousing one's 'childhood memories' radiating the abstractness that these modern forms depict. The cold metal materials that have been worked as to form a language of the elements through the intervention, enables people to experience a pleasing feeling of the creative work while they maybe shocked by its natural strength. Such diversified synthesis and treatment works in harmony. To achieve harmony that is not uniform or to achieve unity in the incomplete is to achieve complete. In fact, what Fu aims is to create, lies within, entrusting it to life's essence with a brand-new form. The aesthetic feeling and meaningful shape, allows the viewer to experience fresh new finding in the soul of the sculpture without any change of expression.

This is one time to reflect on the wisdom that holds the answers to the macroscopic way of the world in eastern philosophy. Sensuously, he questions the modern artistic expression in the meaning of life by the integration of form and material. The time factor in space has pushed away and helped the depth of the works. It is obvious that Fu Xinmin is more concerned about the internal issue of art. Carrying on organic integration is the essence of art and the essential meaning of life, which is the purpose of his creations and his ultimate pursuit in his art. In his opinion, the internal issues of art point to art and the meaning of life. He pays close attention to his works and the meaning of life.Involved in the day by day scheme of his creations and by emphasizing the mysterious quality of the works as well as from The inherent subconscious contrasting results - associatively treatment of the regular shape and the bold shape of the ancient wood and

the cold metal. It does not merely exist physically in space, its meaning is obviously more important. Because it is essentially non-logical with an individualized system not including the law of nature, imagination and substance born with the characteristics that is in life's deep thinking process... During that time, it just holds the meaning of life that is beyond expression or conviction. This is exactly the modernity and aesthetic feeling of Fu Xinmin 's sculptures.

Fu Xinmin's modern sculptures, marks a complete break-away from the traditional Chinese sculpture idea. His meaning is emphasized through his choice of materials in creating an inherent feeling in his sculptures. His purpose is to display his works, but the intent is for the viewer to draw forth the meaning of the sculpture from the form and language. The pieces themselves have their own meanings and create the limitless possibility through there significance. Moreover, art is omnipotent as the experiment of the form and language.

In this way, 'when people are thinking of life', they can ponder over relevant problems except threedimensional and give way to the vigor of creating without logic and refusing the fixed psychology. Fu Xinmin's mental attitude governs his work and he has the capacity to improve himself inexorably as he makes his own inroads in his unique sculptural style.. Because he is unwilling to give his spirit to his art, the road he travels will not be a tireless journey. He makes his own choices of where he needs to go in the contemporary art world.

对 话 系 列

人与人之间是两个不同物质世界的认识，
似乎荒谬，
彼此的藩篱可谓是语义繁生。
人与自然之间……
人文向自然的渗透、扩张……。
物质自然趋于崩溃，
但也将重新创造它自身。

Dialogue Series

The direct cognition between two people, as between two physical entities is
something absurd.
The barriers of understanding between humans can be described as complicated
as between human beings and the Nature···
with the infiltration and expansion of human culture into Nature.
Substances tend to break down as a natural rule,
yet they re-build themselves as well.

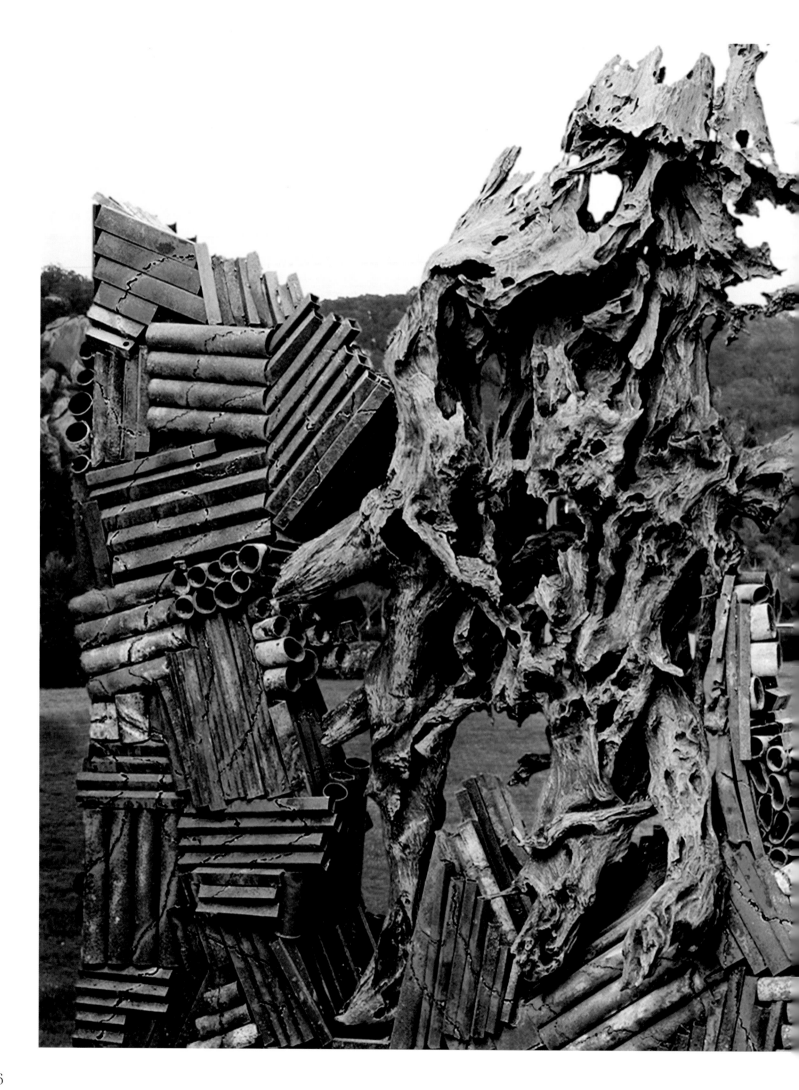

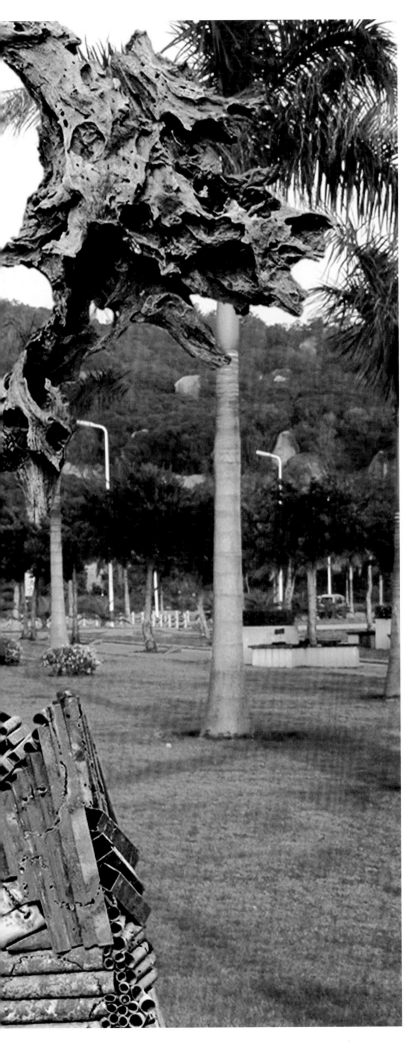

对话 NO2　　Dialogue　No.2

280cm × 220cm × 60cm　木、钢材　　Wood, steel
2002

对　话 NO2

　　我将废弃的钢管、角铁，按所需裁截组合排列成为浓缩的万卷"书架"，以"书架"为依托的朽木，虽说只是残留风骨，但仍然隐约可见秀色。它们的组合是人文向自然的挤压渗透，还是自然向人文的衍化，在永恒的对话中去反思……

Dialogue No.2

　　I took advantage of the scrap steel tubes and corner irons to form a concentrated "bookshelf" form.with the necessary cutting,aligning and combining the rotten wood it started to take form. The "bookshelf", though still in ruins, had a faint elegance. .Does the combination of this signify the squeezing permeation of humanity with nature, or a human bound derivation of nature? Reflections lie in eternal dialogue…

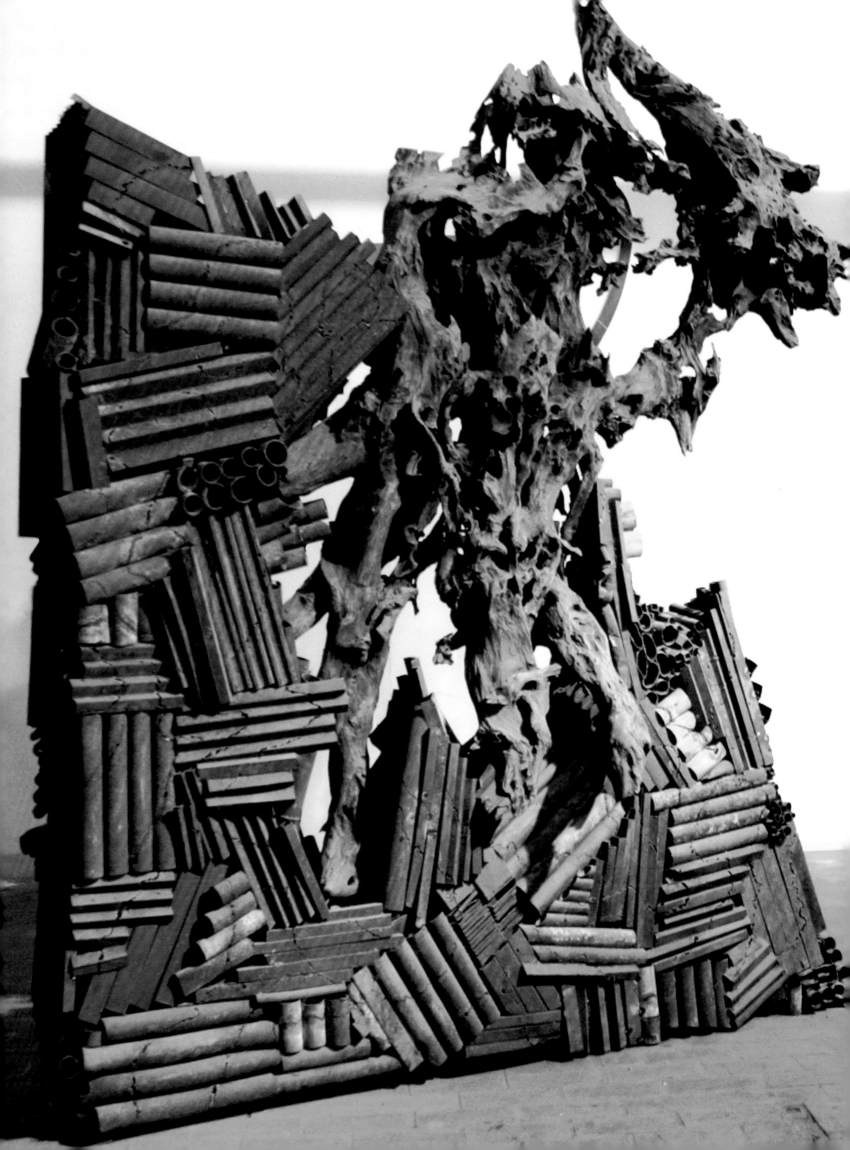

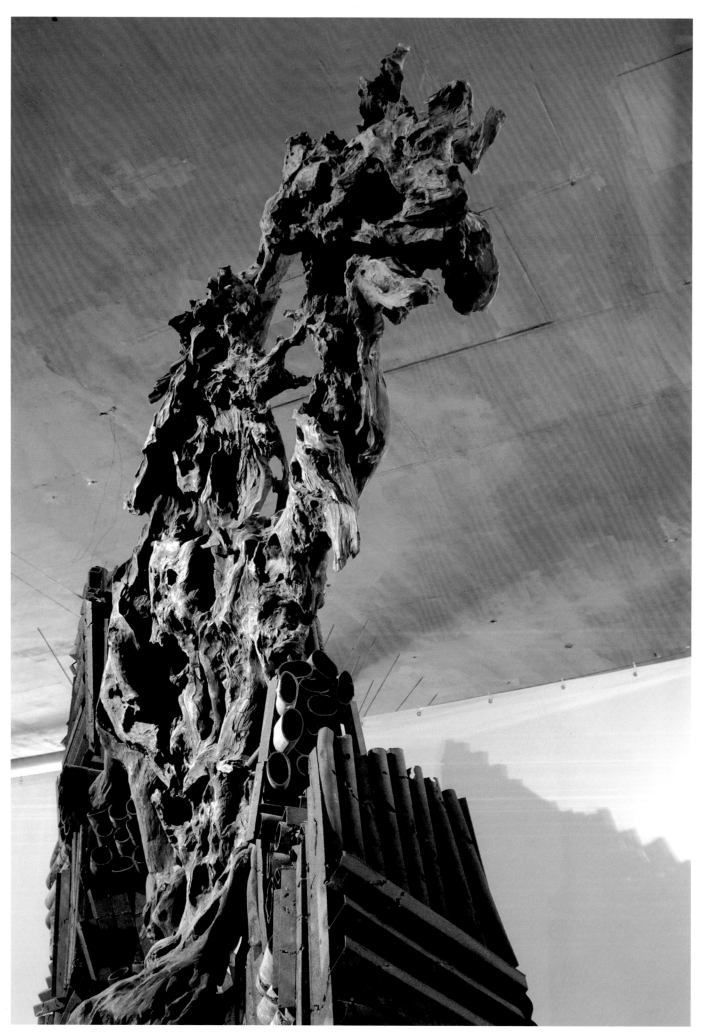

对话 No.2（局部）

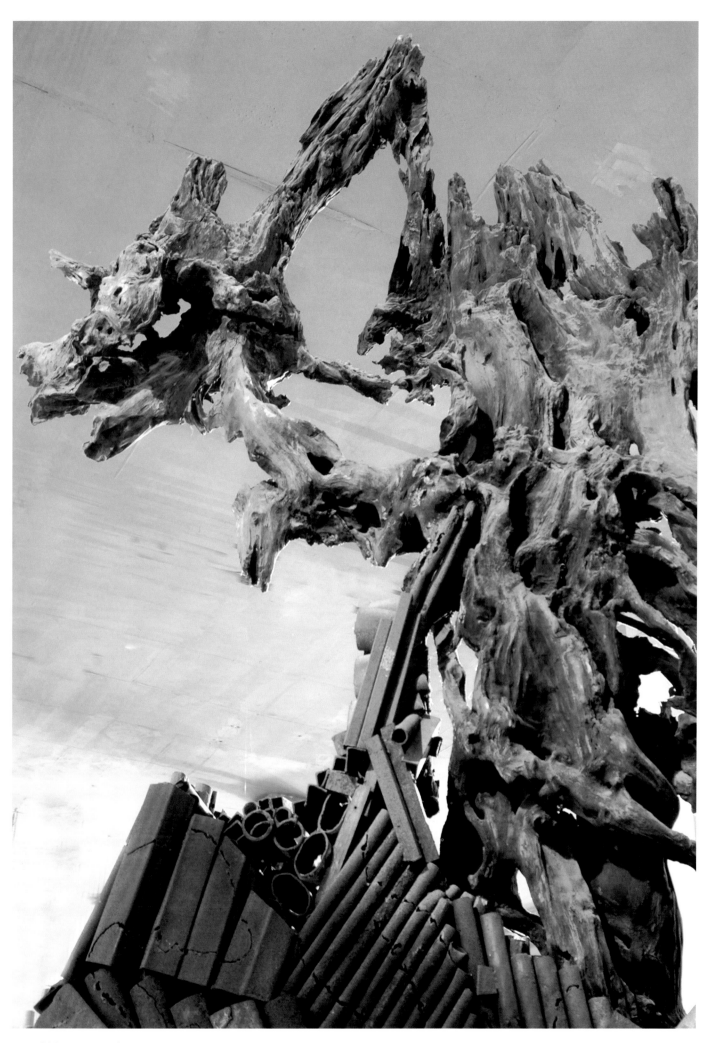

对话 No. 2（局部）

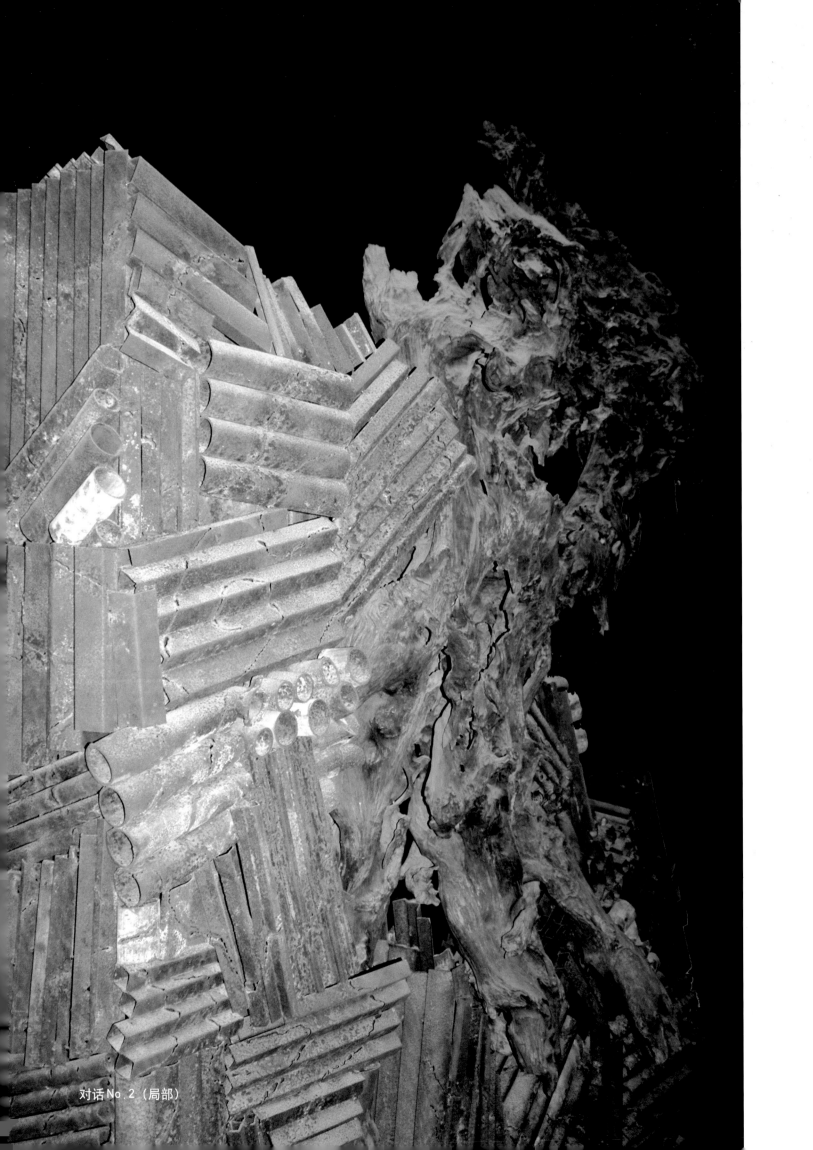

对话 No. 2（局部）

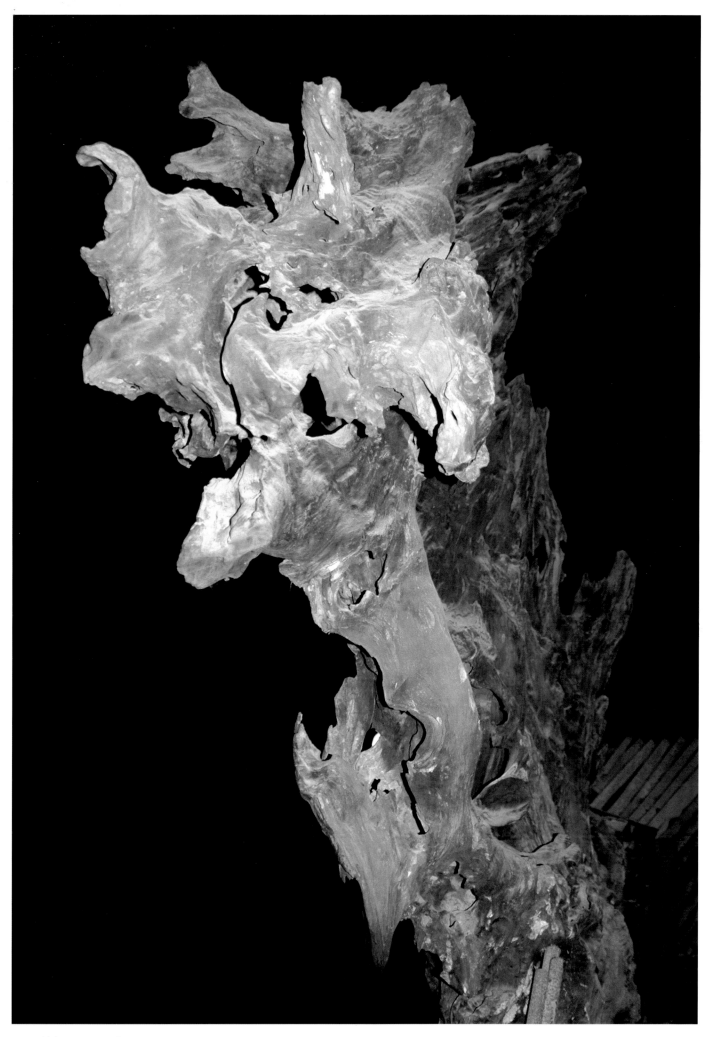

对话 No.2（局部）

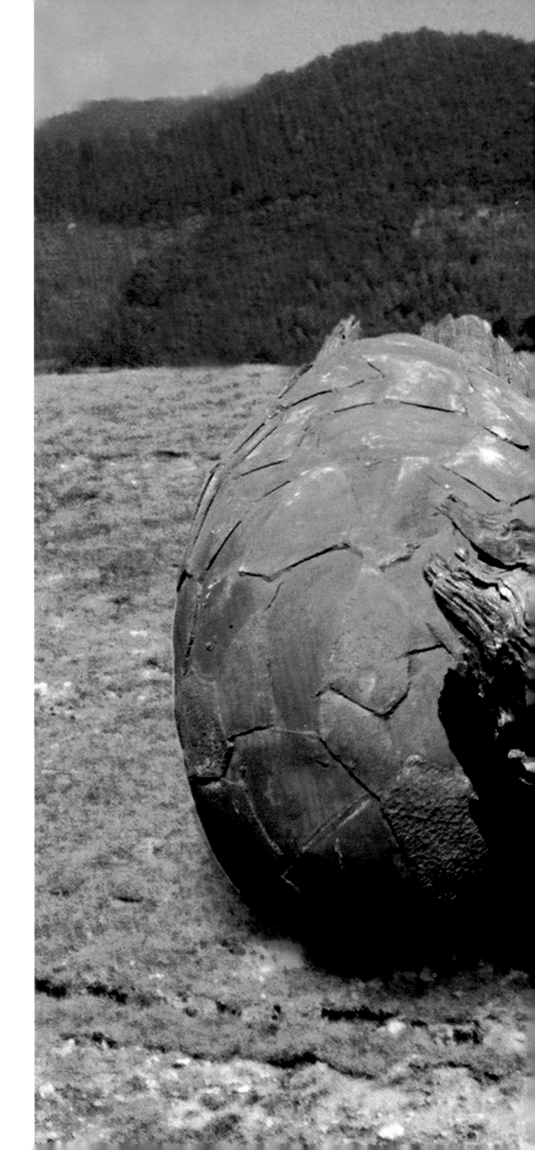

对话NO3、NO4、NO5 （滴血）
Dialogues NO.3, NO.4, NO.5 (Bleeding)

NO3：直径 Diameter 150cm × 200cm
NO4：直径 Diameter 160cm × 220cm
NO5：直径 Diameter 170cm × 250cm
木、铁板　　Wood, iron sheets
2003

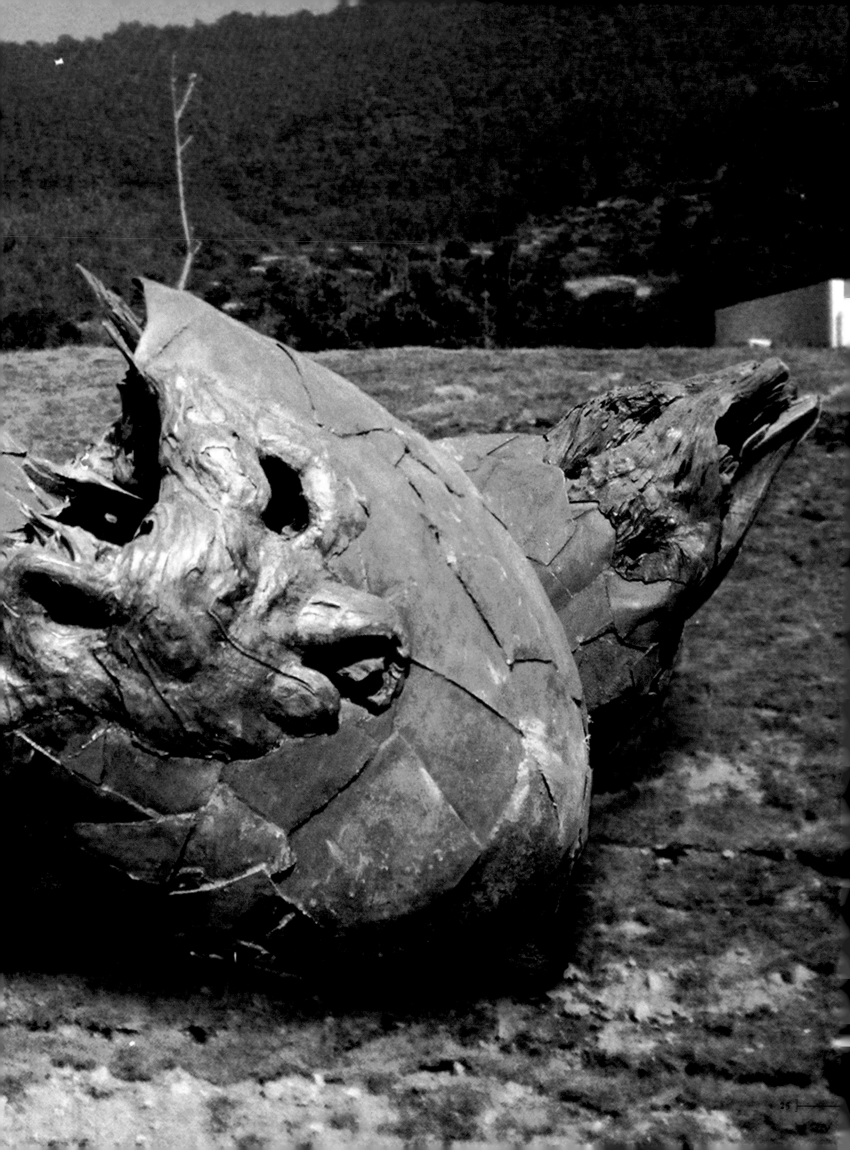

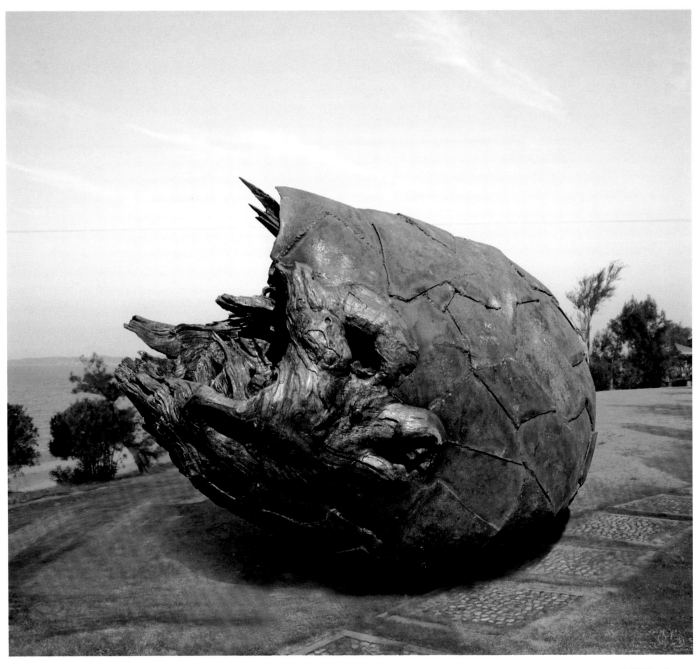

对话NO3、NO4、NO5 （滴血）

　　把现代工业产物铁板镶嵌在自然的有几百年的树桩中，旨在让它们作永久的对话。

　　创作中我左手食指撞在飞转的切割机齿轮上，鲜血直流，望着地下一滴滴的鲜血，联想到工业文明发展的速度和地球资源的有限以及子孙后代将来的生存问题，把当时内心的感受为这一组作品取名为"滴血"。

Dialogues NO.3、NO.4、NO.5 （Bleeding）

　　Iron sheets from modern industry have been inserted into the natural age-old stumps, suggesting a permanent dialogue between them.

　　In the process of shaping the piece, my index finger of the left hand got accidentally cut by the wheel of the slitter and bled. The sight of the blood reminded me of the speedy development of industrial civilization against the background of limited global resources and the survival of the future generations. Hence inspired, I dubbed the piece "Bleeding".

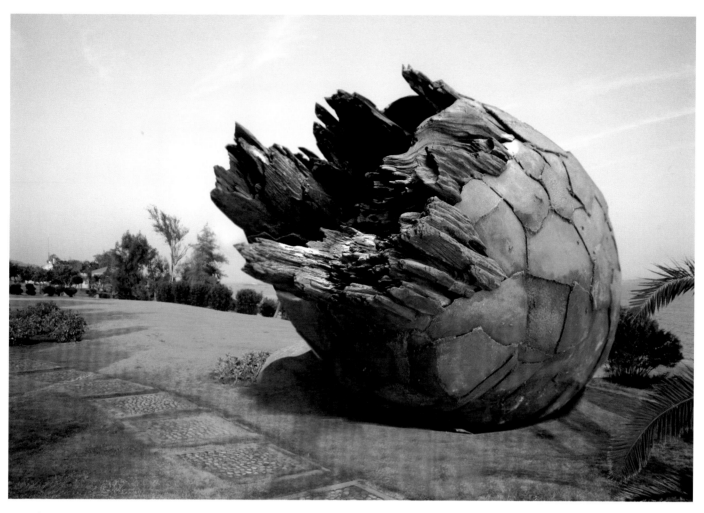

对话No.4

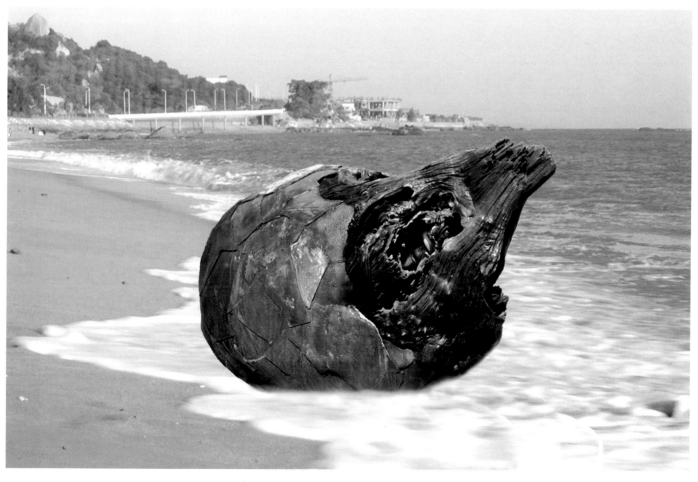

对话No.5

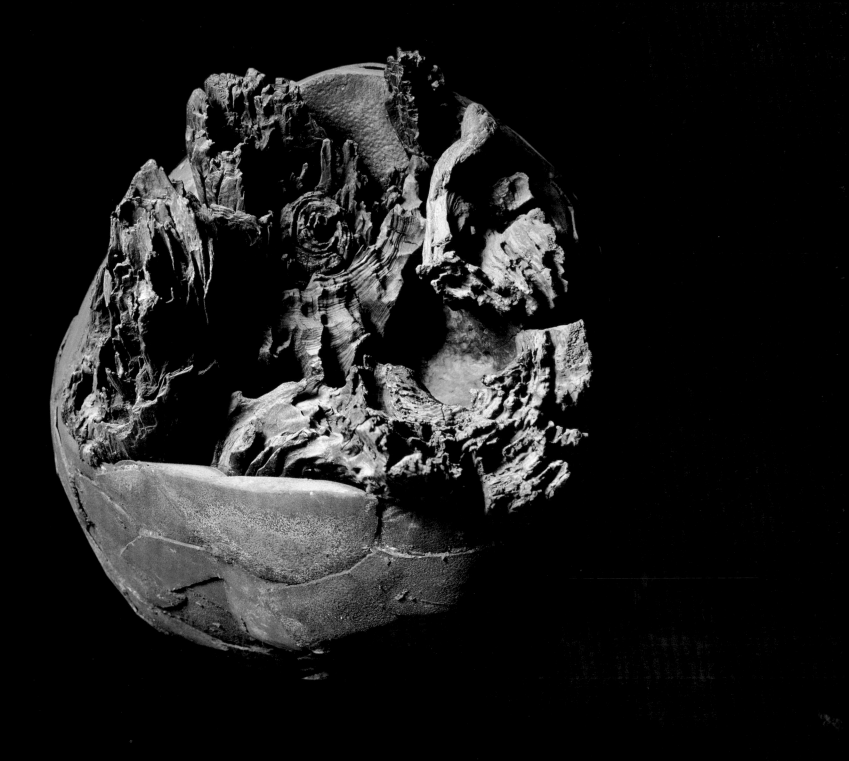

对话 No.4（局部）

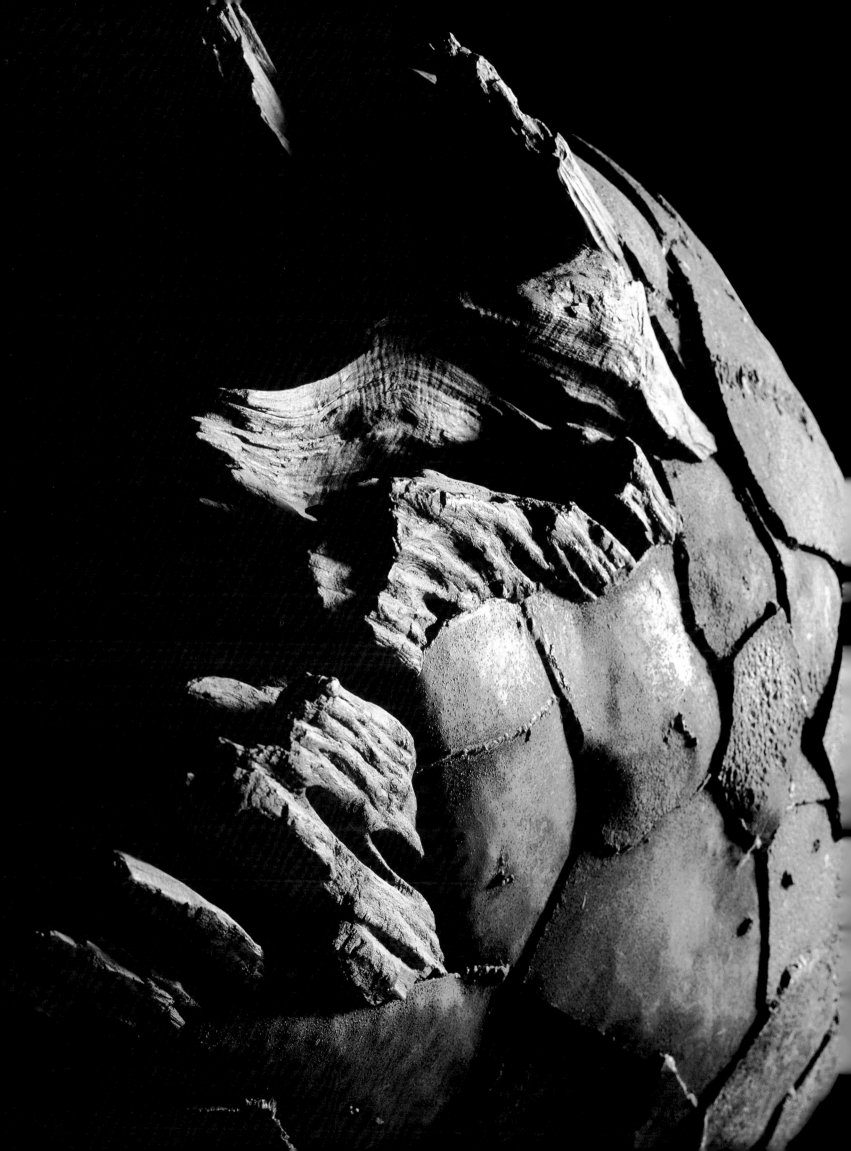

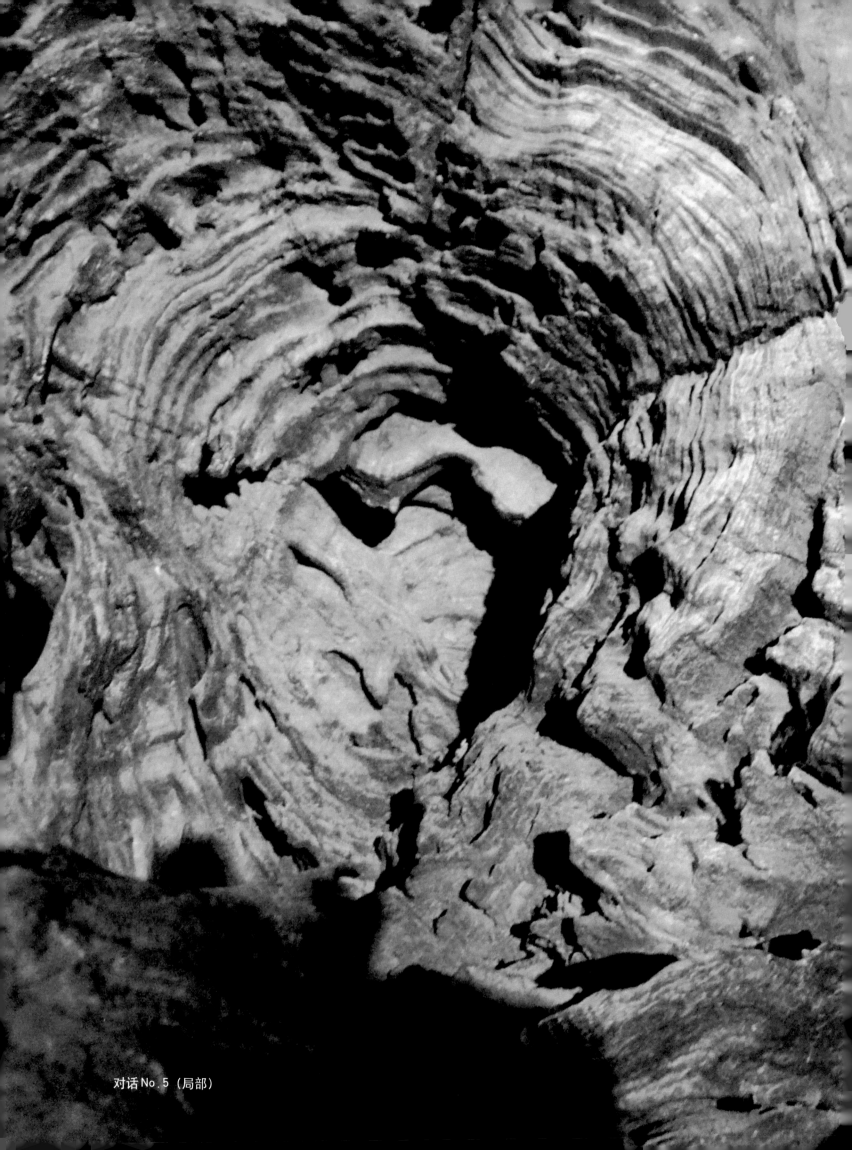

对话 No.5（局部）

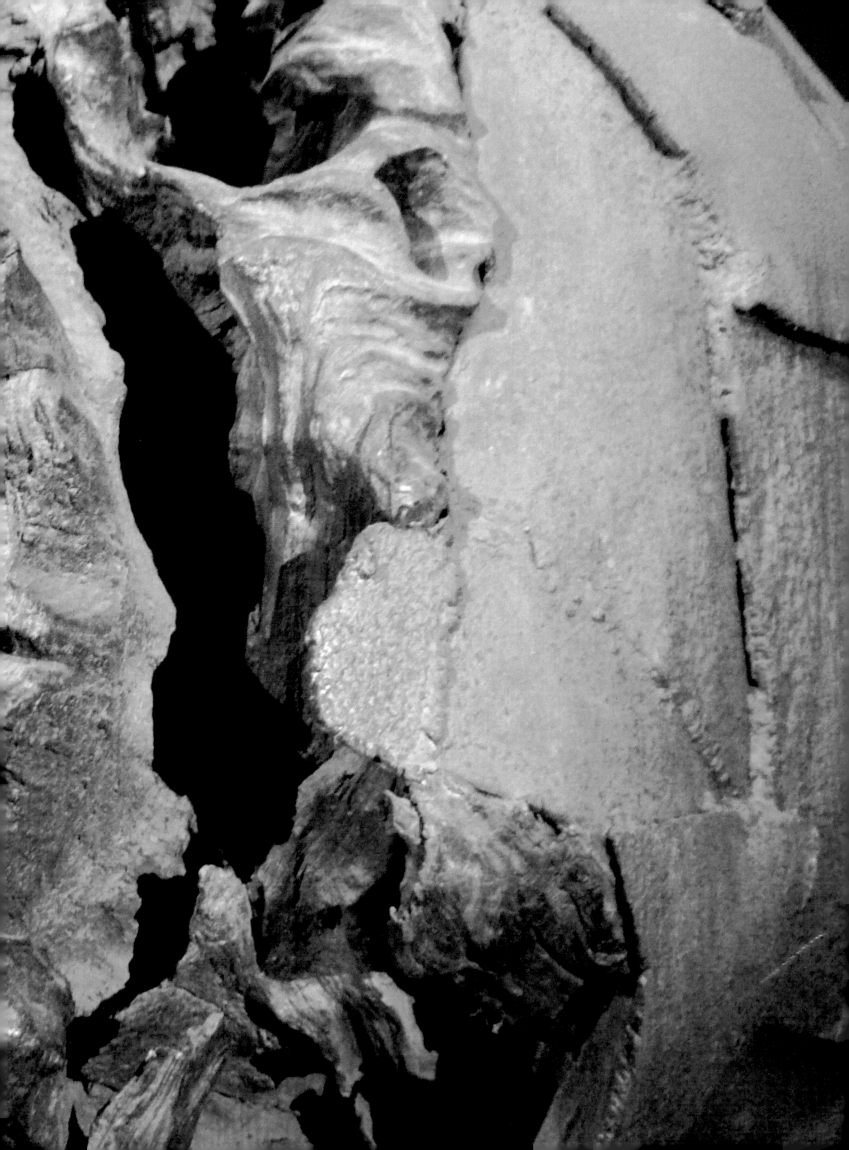

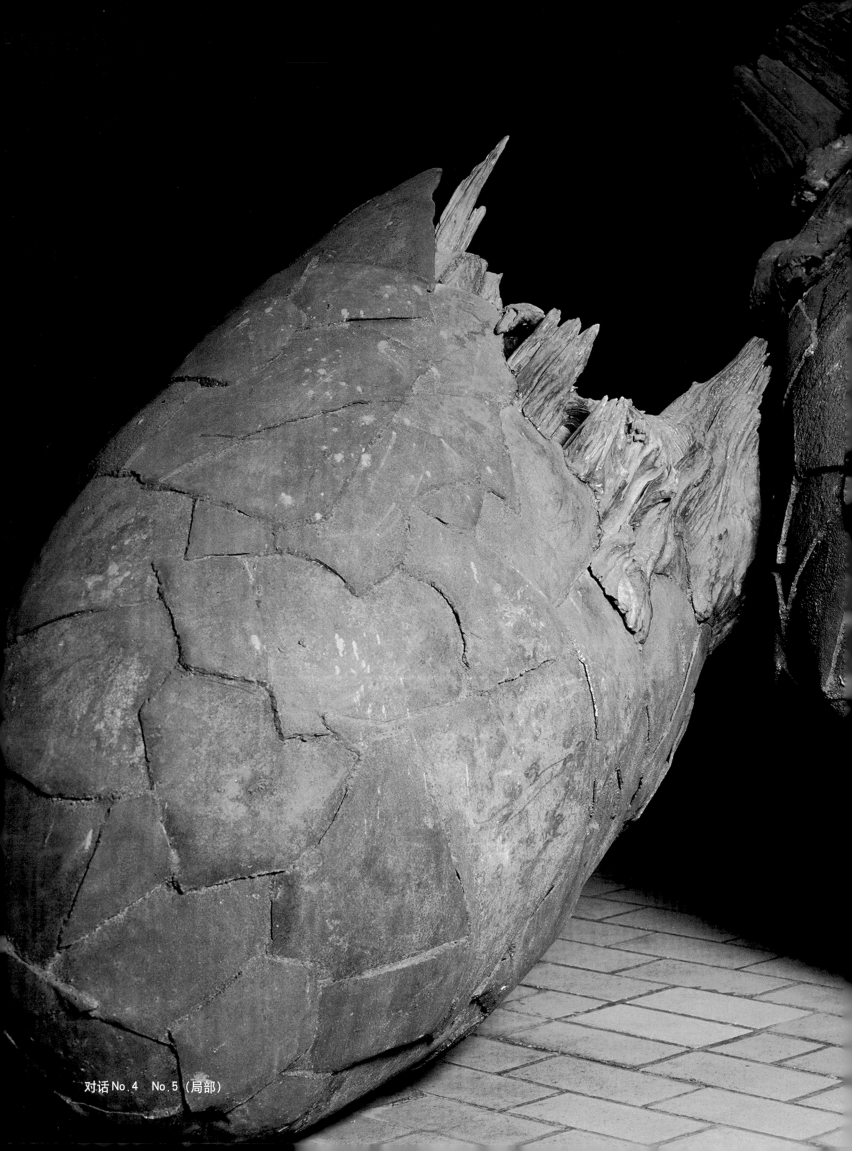

对话No.4　No.5（局部）

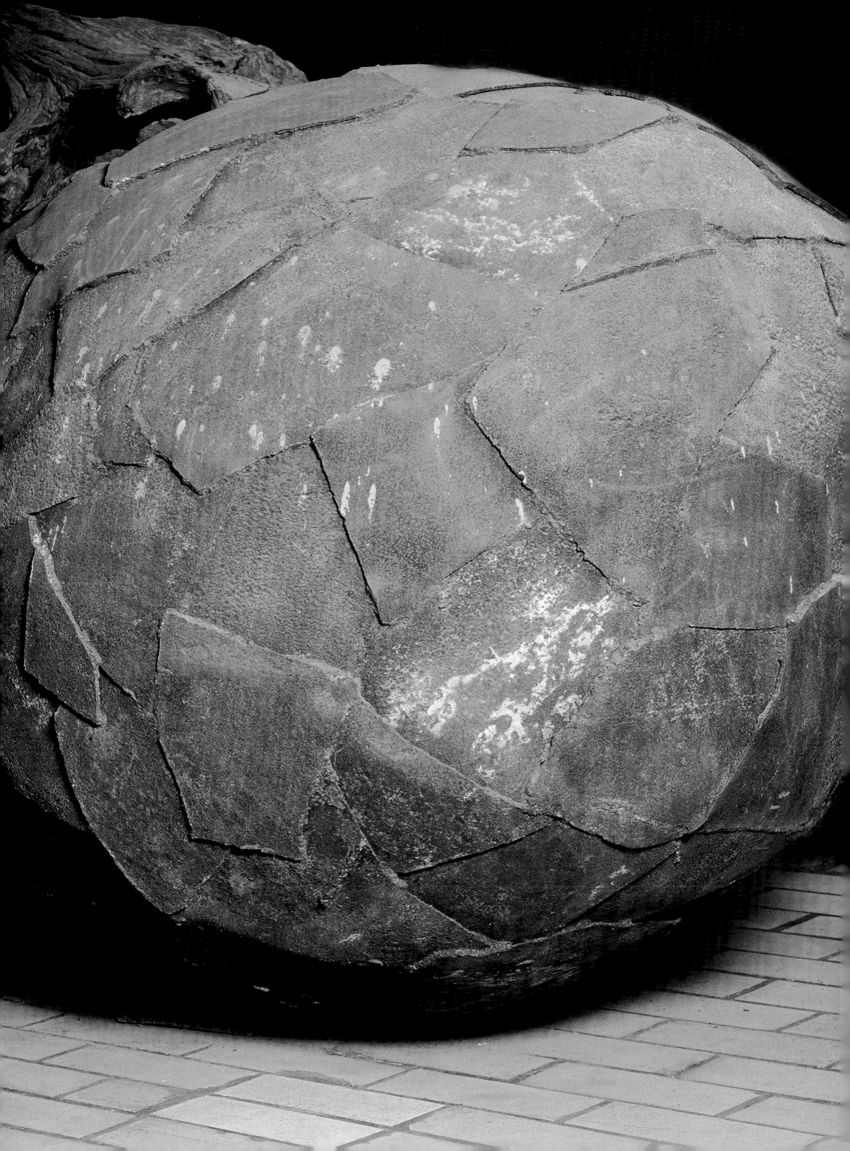

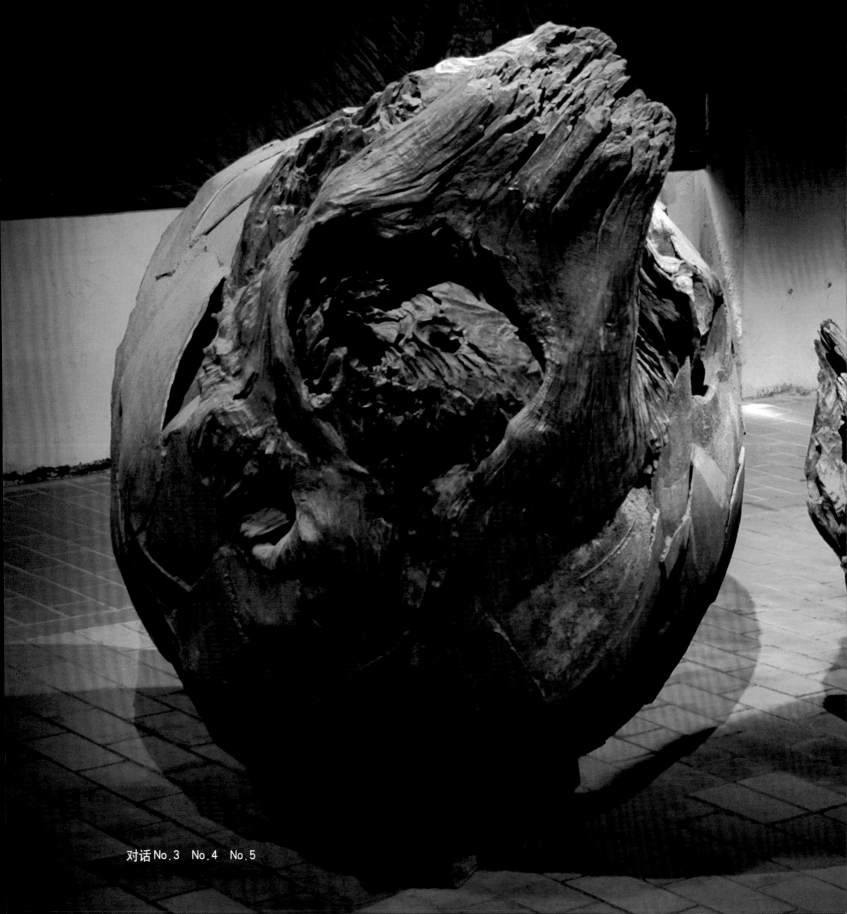

对话No.3　No.4　No.5

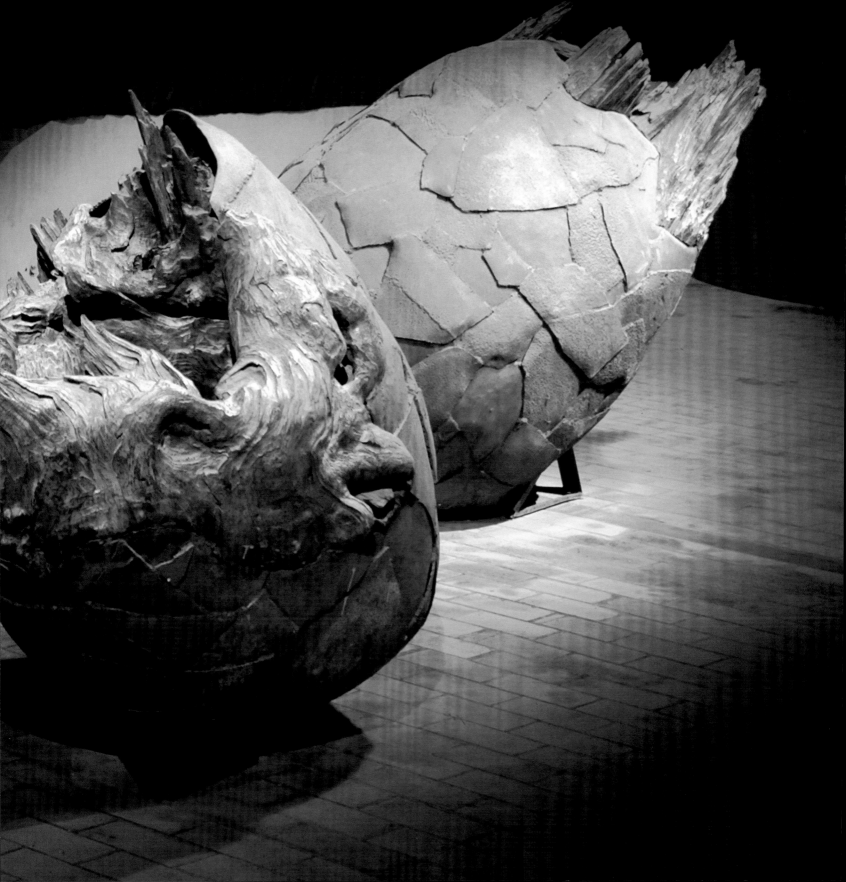

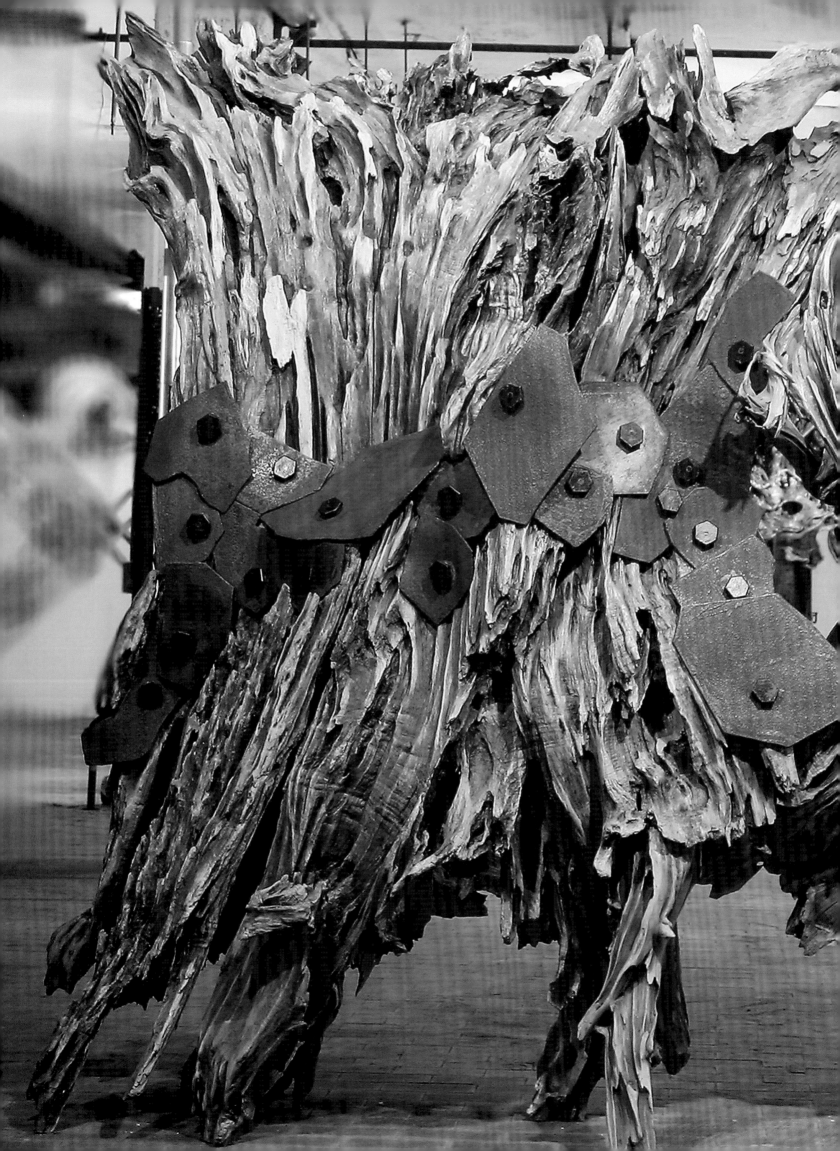

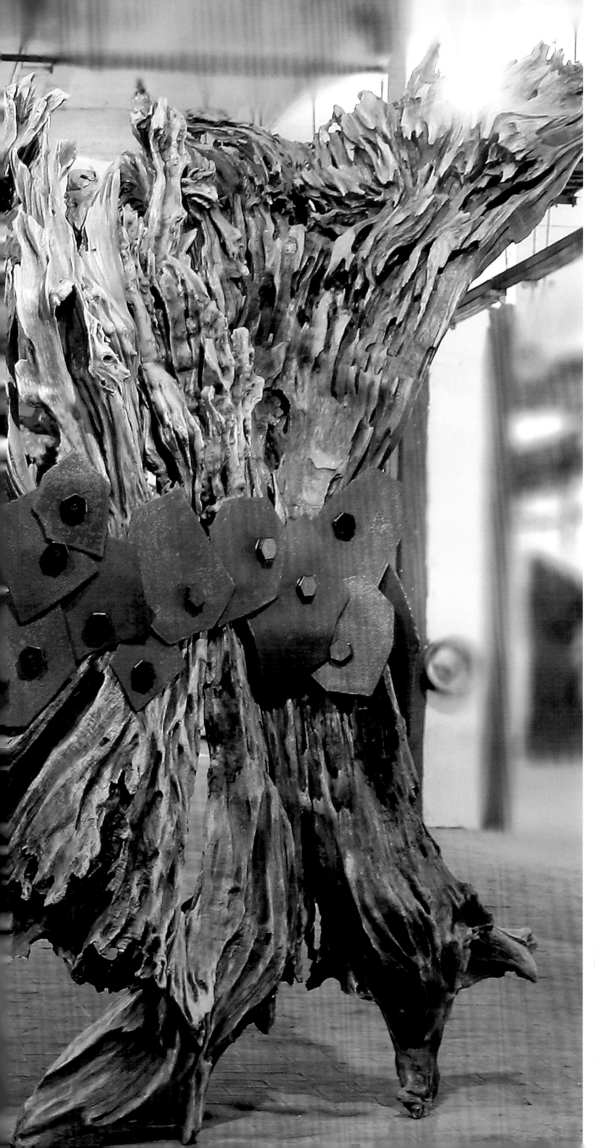

对话NO6　　（文明的碎片）
Dialogue No.6
(Fragments of Civilization)

300cm × 350cm × 100cm
木、钢板　Wood, steel plate
2004

对话NO6（文明的碎片）

　　用几十块钢板将数百年以上风化的树桩朽木连结组合在一起，形成一个大块面，好似一面刀枪不入的大盾牌；更像一座坚不可摧的城墙，气势雄浑。为了丰富作品的形式语言，对原生朽木和钢板作了技术上的处理，使自然的人文化，人文的自然化，达到人与自然的和谐与统一。这样做是想表现人文向自然渗透时，让人们去思考人与自然相互的作用力，在人类认识自然、改造自然的不断丰富文明成果的今天，是否更应该去思考"以天下之柔，驰骋天下之坚"的现实的科学内涵。

Dialogues NO6 (Fragments of Civilization)

　　A vast surface is formed out of the combination of dozens of steel plates and rotten stumps of century-year old. It resembles a giant, weapon-proof shield, or even an indestructible wall being grand and magnificent. To enrich the formal language of the work, I technically processed the raw rotten stumps and the steel plates, making nature humanized, and human naturalized, thus a harmonious combination of nature and human has been achieved. It means to encourage people to ponder on the interaction between human and nature in manifestation human permeation through nature. Shouldn't people think more about the scientific connotation of "taming the solidity of the world with its own tenderness" in present-day achievements of civilization that are incessantly accumulated in the recognition as well as reconstruction of nature by mankind?

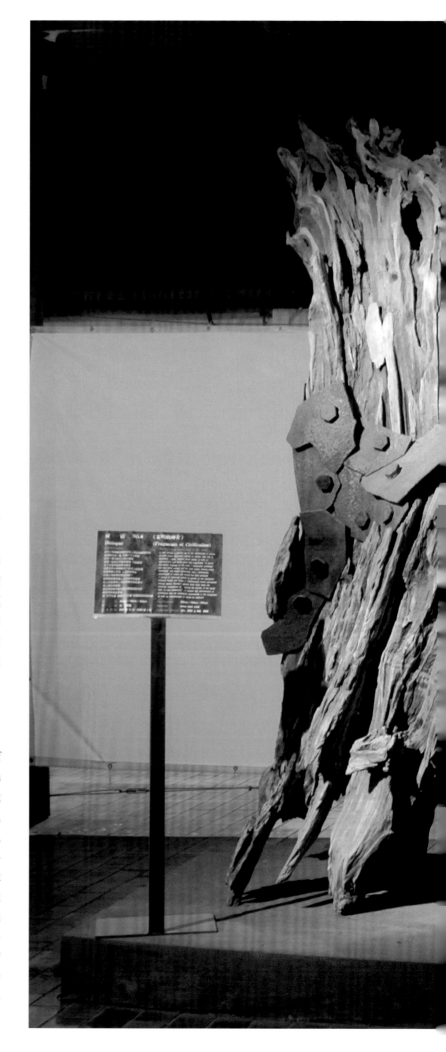

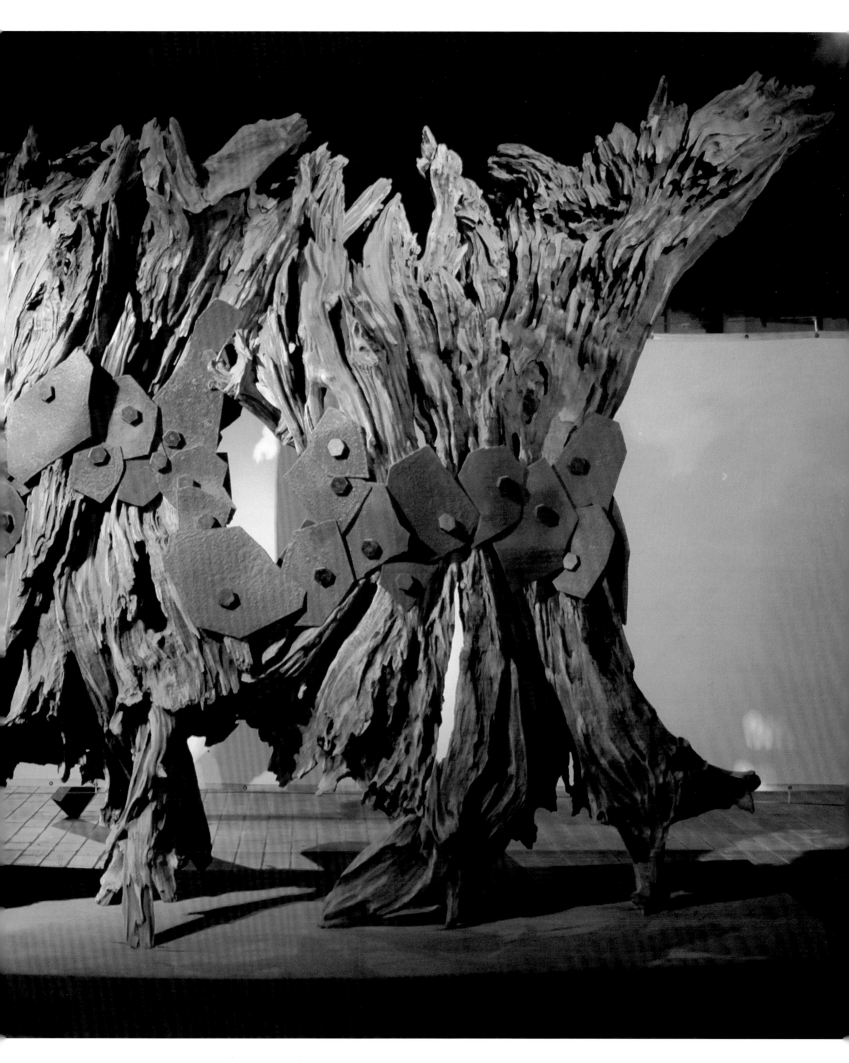

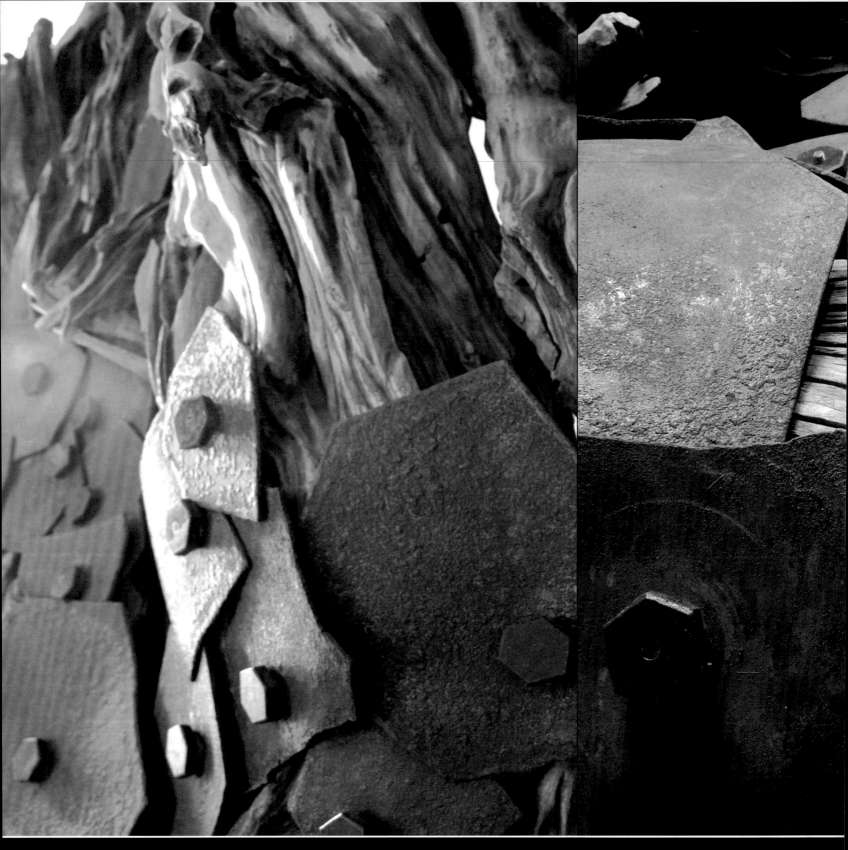

对话No.6（局部）

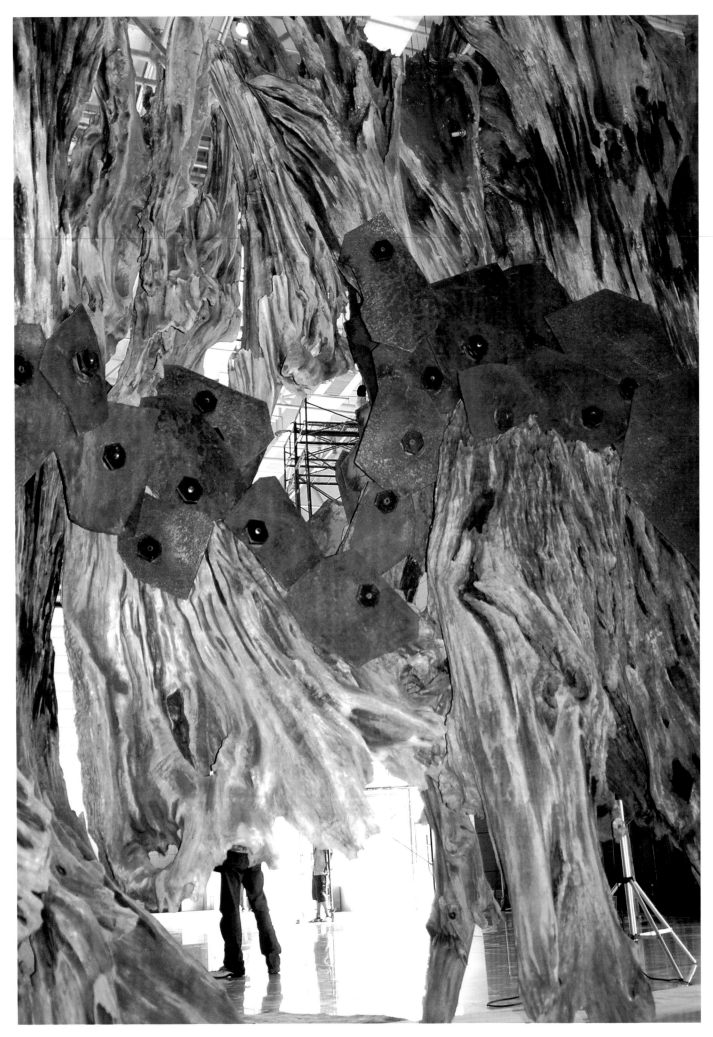

对话 No.6（局部）

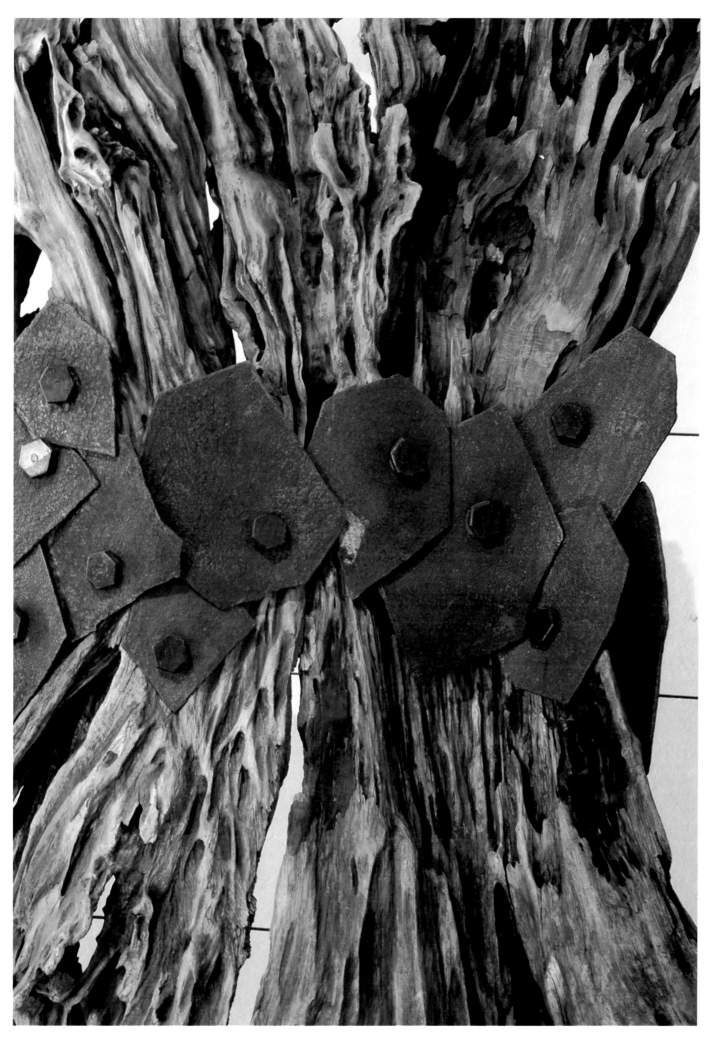

对话No.6（局部）

感 悟 系 列

我常问自己艺术创作的源泉是什么？
是心灵的感悟，
生命的体验，
是生活的历练和积蓄已久的内在激情和直觉感悟的激荡。

Comprehension Series

Time and time again I have asked myself: what is the source of art creation?
It's the comprehension of one's heart and our experiences in life;
it's the violent upsurge triggered by the collision
of life's inner activated passion and instinctive comprehension.

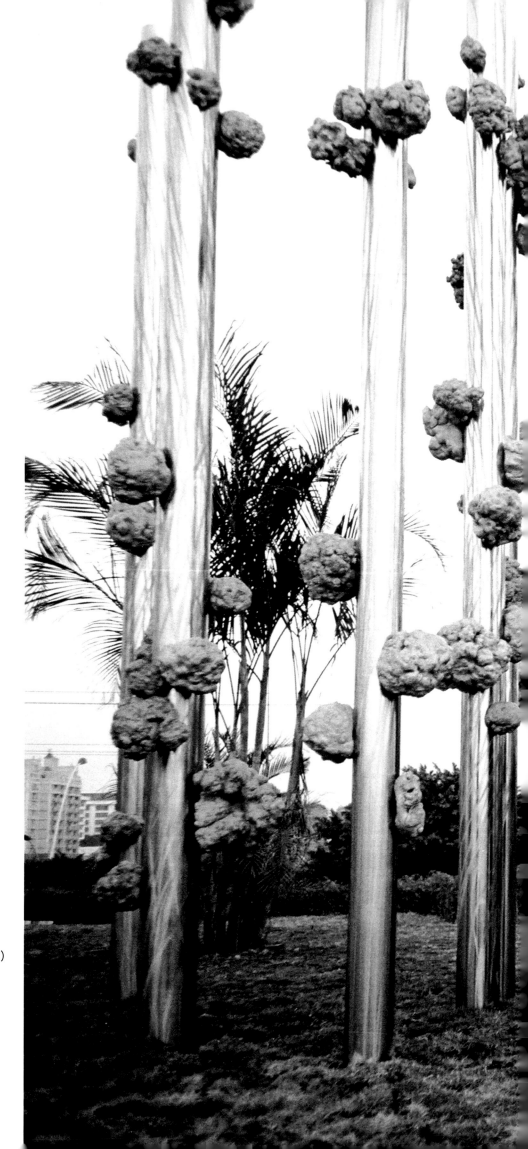

感悟NO1（海之梦）
Comprehension No. 1　（Dream of the Sea）

550cm × 850cm × 450cm
不锈钢管、原生性根瘤
Stainless steel tubes，Primary root nodules
2003

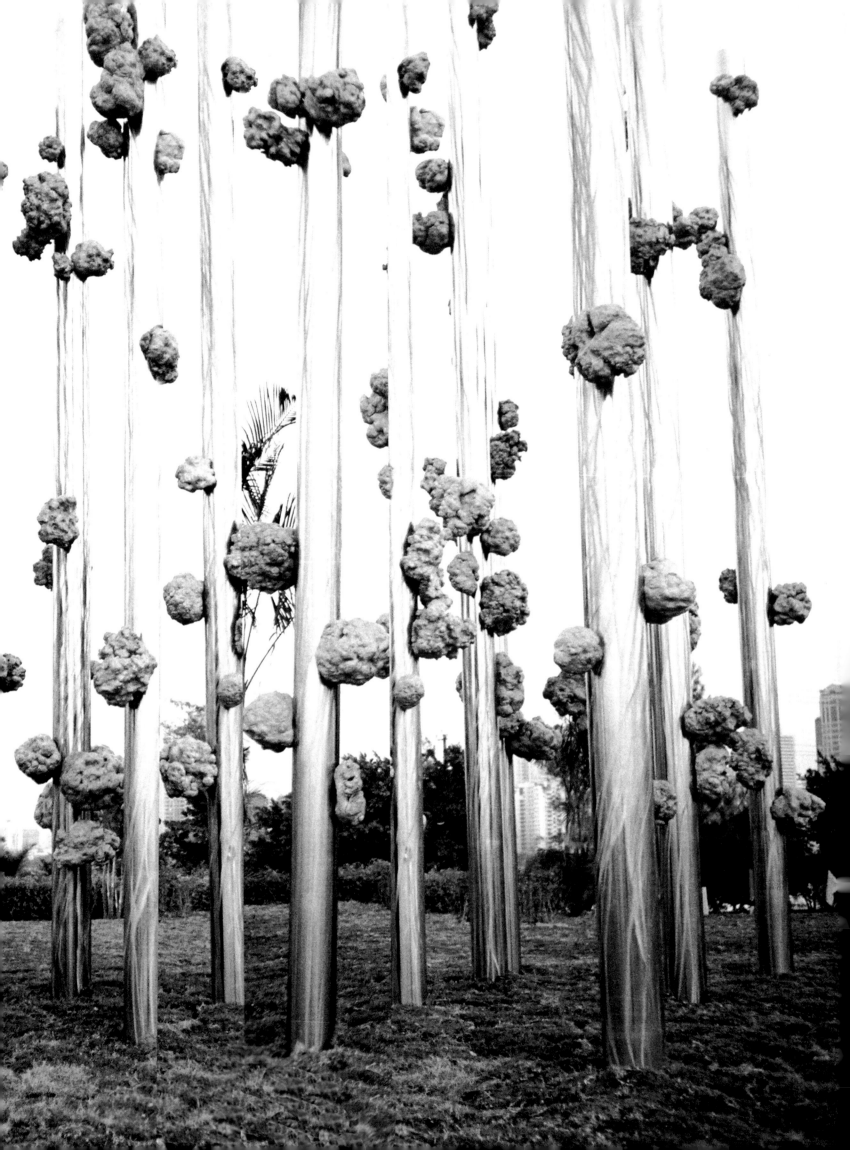

感悟NO1 （海之梦）

　　几百颗原生性根瘤体协调、得体地分布在21根不锈钢柱上。复杂的点、线、面构成，既要考虑疏密、集散、明暗、虚实，又要关照上下左右、四面八方的整体效果，通过点、线、面、色的各种对比产生海浪的节奏和音乐韵律。我对造型的变化规律进行了各个角度的切入，去探索它的形式语言。

　　"什么梦都随着时间的推移而逝去，只有大海的梦……"，那钢柱上晶晶亮亮的"线谱"和星星点点的"音符"奏响一曲永恒的欢歌。

Comprehension No. 1(Dream of the Sea)

　　With hundreds of primary root nodules properly distributed in a harmonious fashion on the 21 stainless steel tubes, the complicated dots, lines, surfaces, as well as density, collectiveness, light & shade, void & solid, up & down, left & right, and far & near brings it to completion. The piece highlights the musical beats and rhythms of waves via the contrast between dots, lines, surfaces, and colors. My multiangled penetration into the transformation of the rules of shapes helped me explore the language of its configuration.

　　"Whereas time sweeps away whatever dreams, only the dream of the sea…" Those shining on the "stave" of the steel pole and the dotted "musical notes" combine to present an eternal melody.

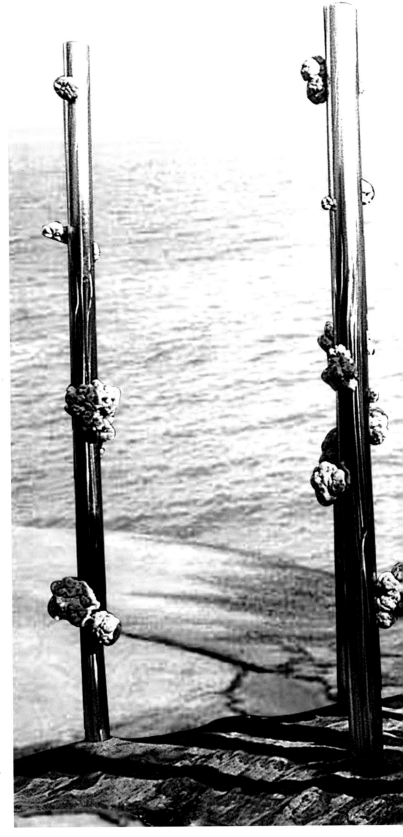

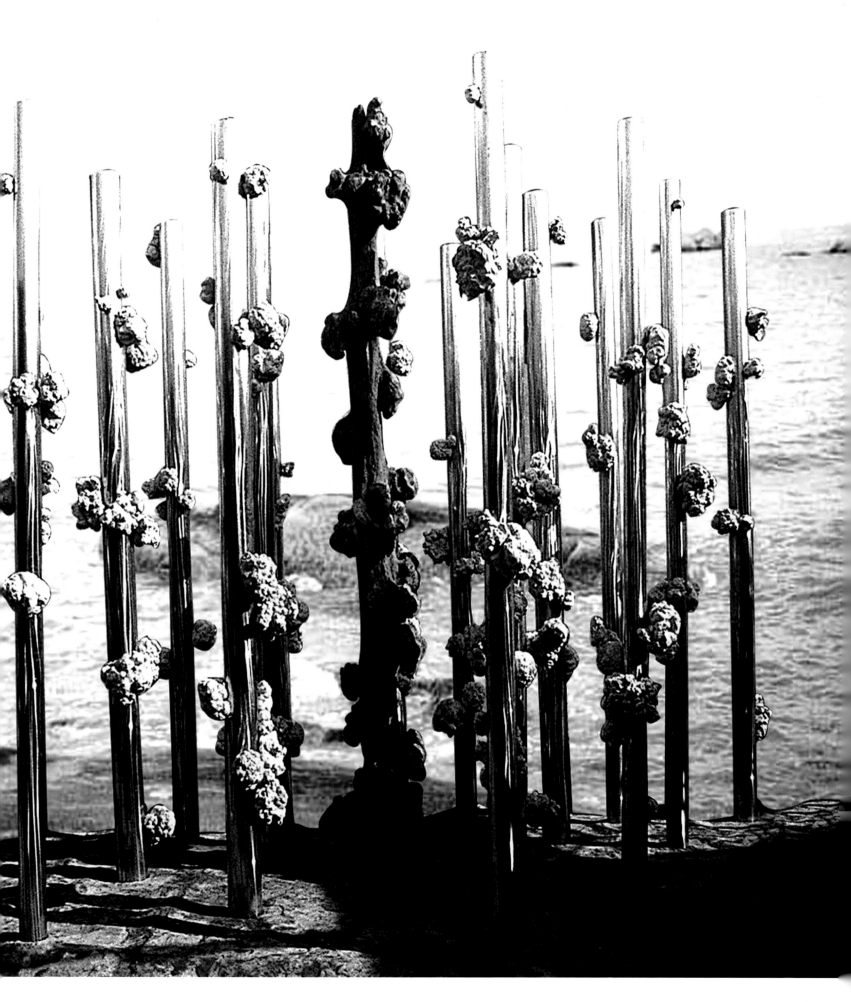

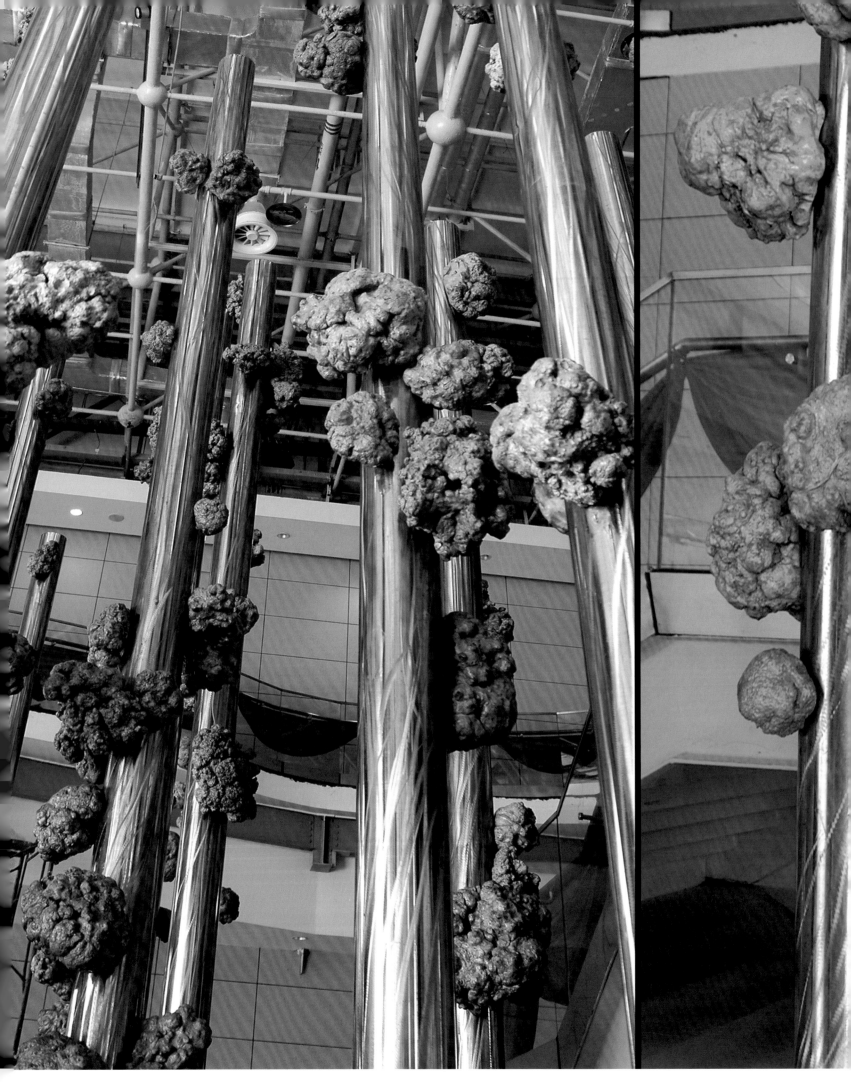

感悟 No.1（局部）

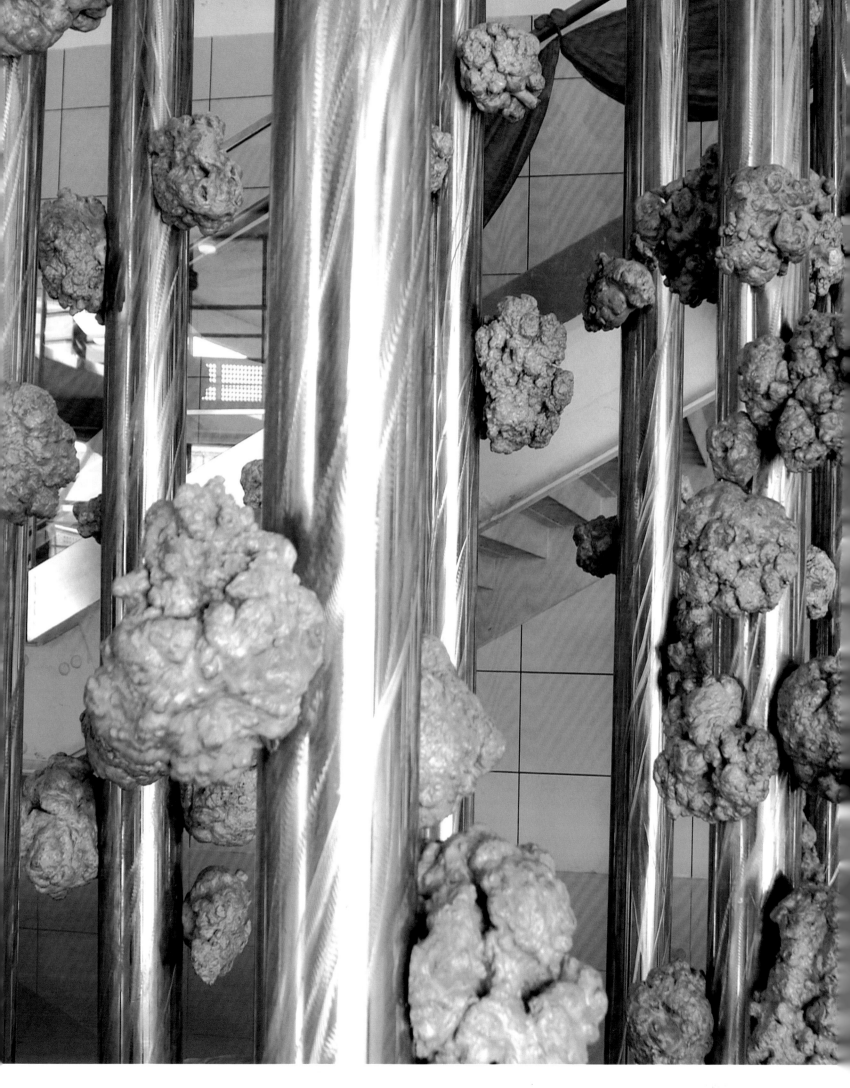

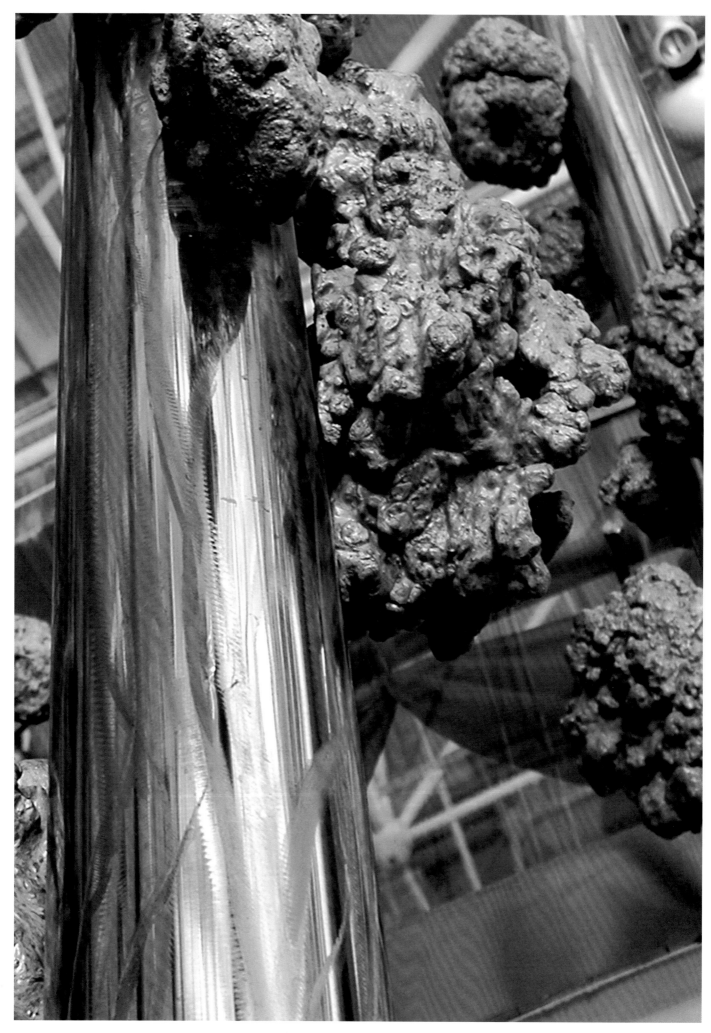

感悟 No.1（局部）

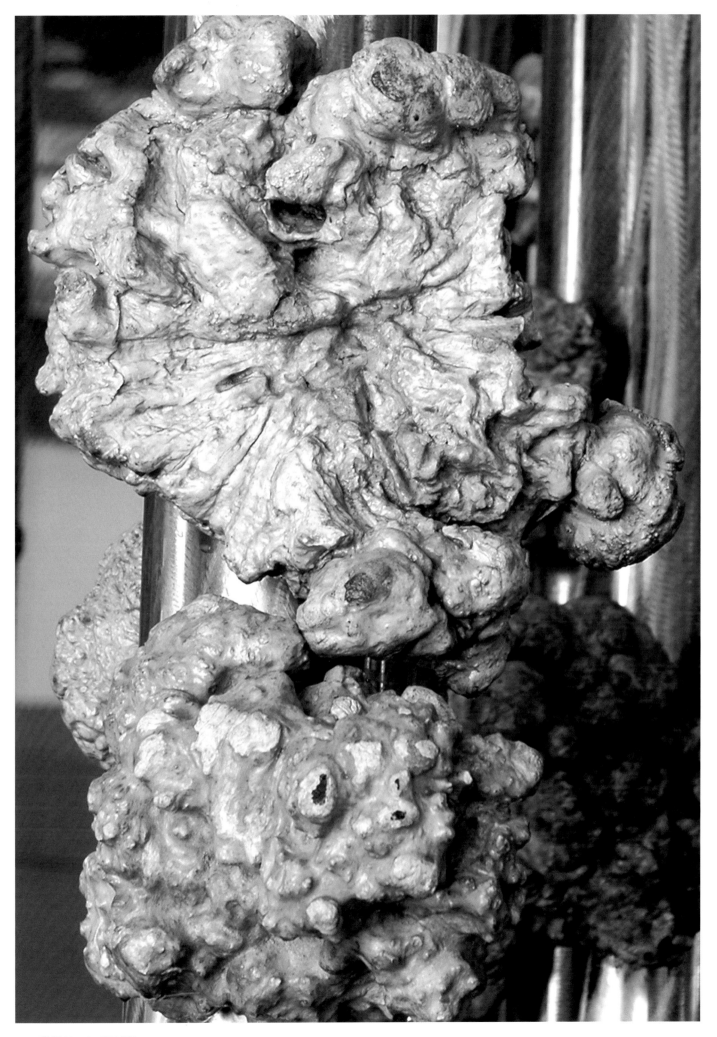

感悟 No.1（局部）

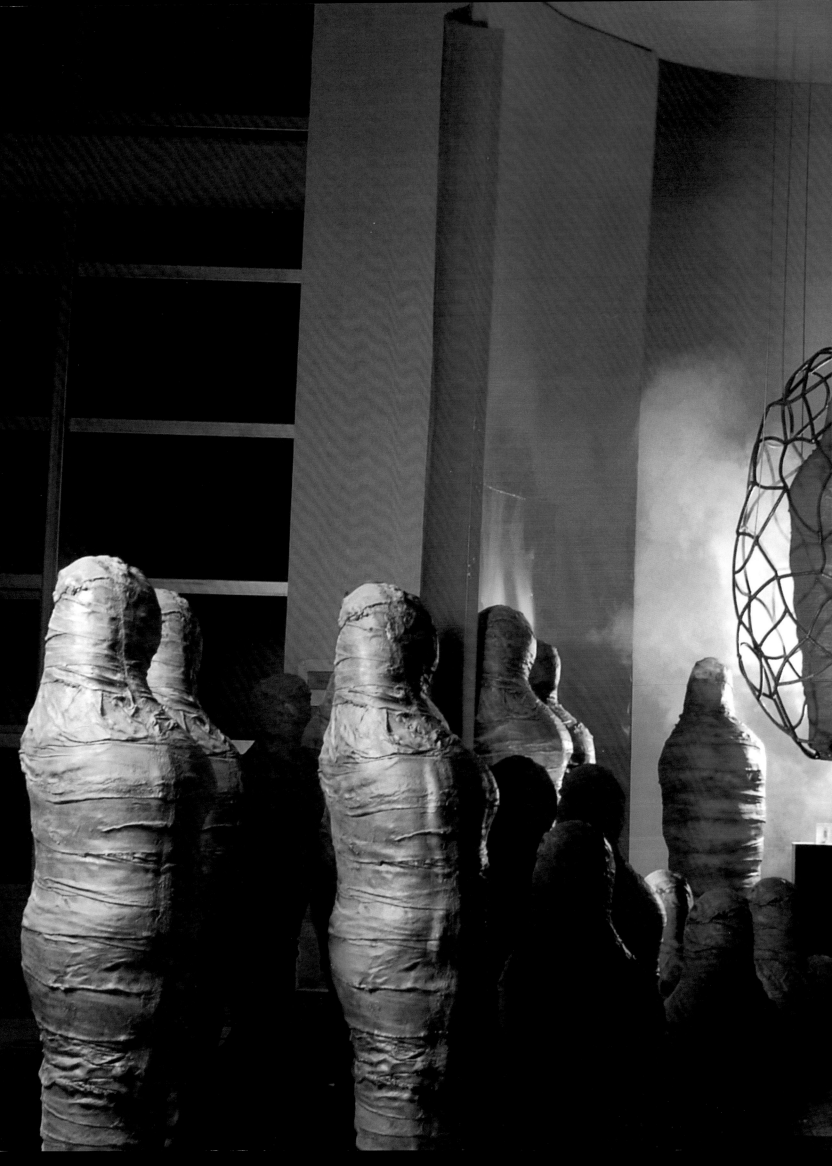

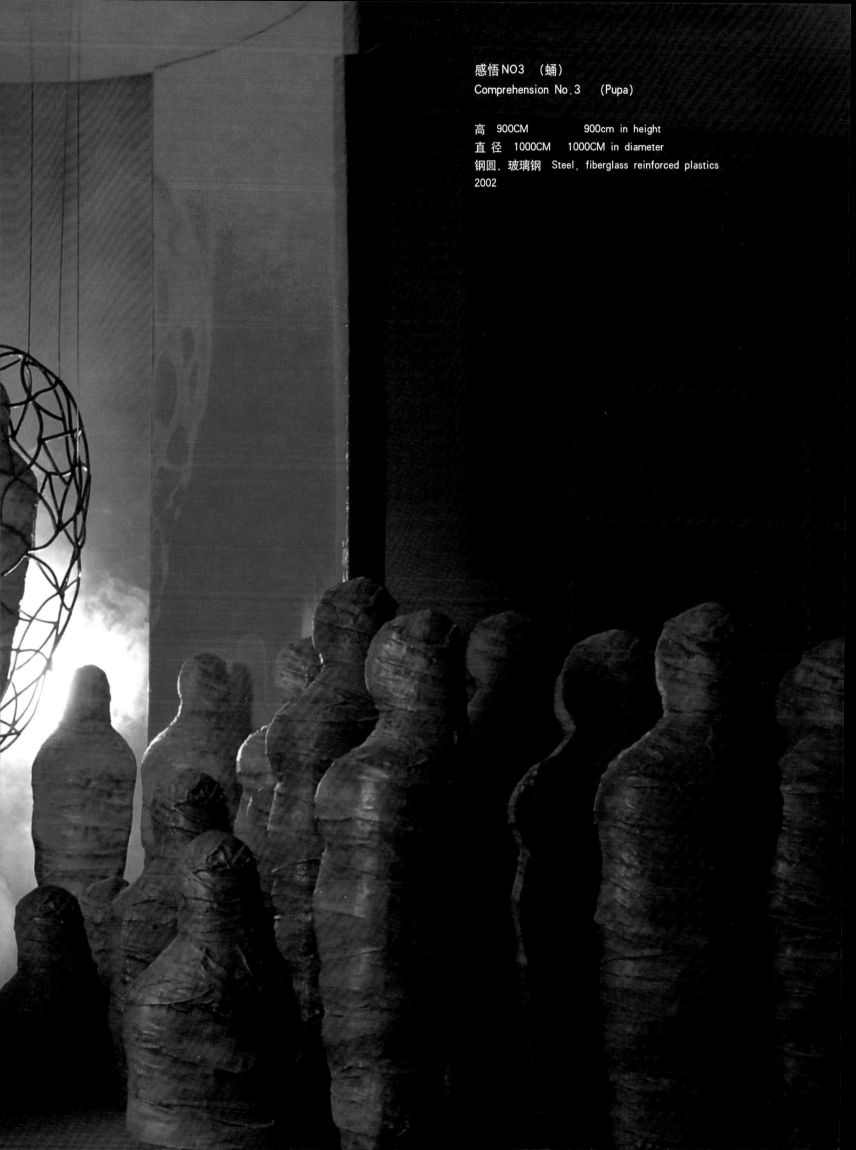

感悟NO3 （蛹）
Comprehension No.3 （Pupa）

高 900CM　　　　　900cm in height
直径 1000CM　　1000CM in diameter
钢圆、玻璃钢　Steel，fiberglass reinforced plastics
2002

感悟NO3 （蛹）

　　蛹人、粗糙麻布缠裹着的形体，有人说：红色的外衣下，生命在涌动，她蕴藏着巨大的能量。还有人说：她像是个木乃伊，怎么说她都是有生命的，曾经有过生命的东西。当我把一只紧紧贴在树杆上的茧扒下来的时候，就感觉到这只有两个拇指大小的茧里面软软的蛹在蠕动，那是个小生命，它作茧自缚，是自我保护？还是代谢休整？是在孕育新的生命，待机蝶化破茧而出。这种艰难的质变，是生命的轮回运动，人类何尝不是如此。我学做女娲，制作了无数红色的蛹人，它们注视着自己，注视着周边，也注视着这整个世界。

Comprehension No. 3 （Pupa）

　　The pupa beings, bodies wrapped in coarse sackcloth. Some say that there is a life wriggling underneath the red cover which holds in store great energy. Some say that it resembles a mummy, anyhow it had a life. When I pulled the cocoon off the trunk onto which it clung, I felt the movement of soft pupa in the thumb-sized cocoon. In the web of its own spinning, was the beginning of life being enmeshed or protecting itself and nourishing itself via metabolism? It is breeding a new life and will break out of the cocoon to become a butterfly at the right time. Such tough qualitative change is the rotation of life that human beings undergo as well. I played NWa to create many red cocooned beings and made them stare at themselves, the surroundings, and the whole universe.

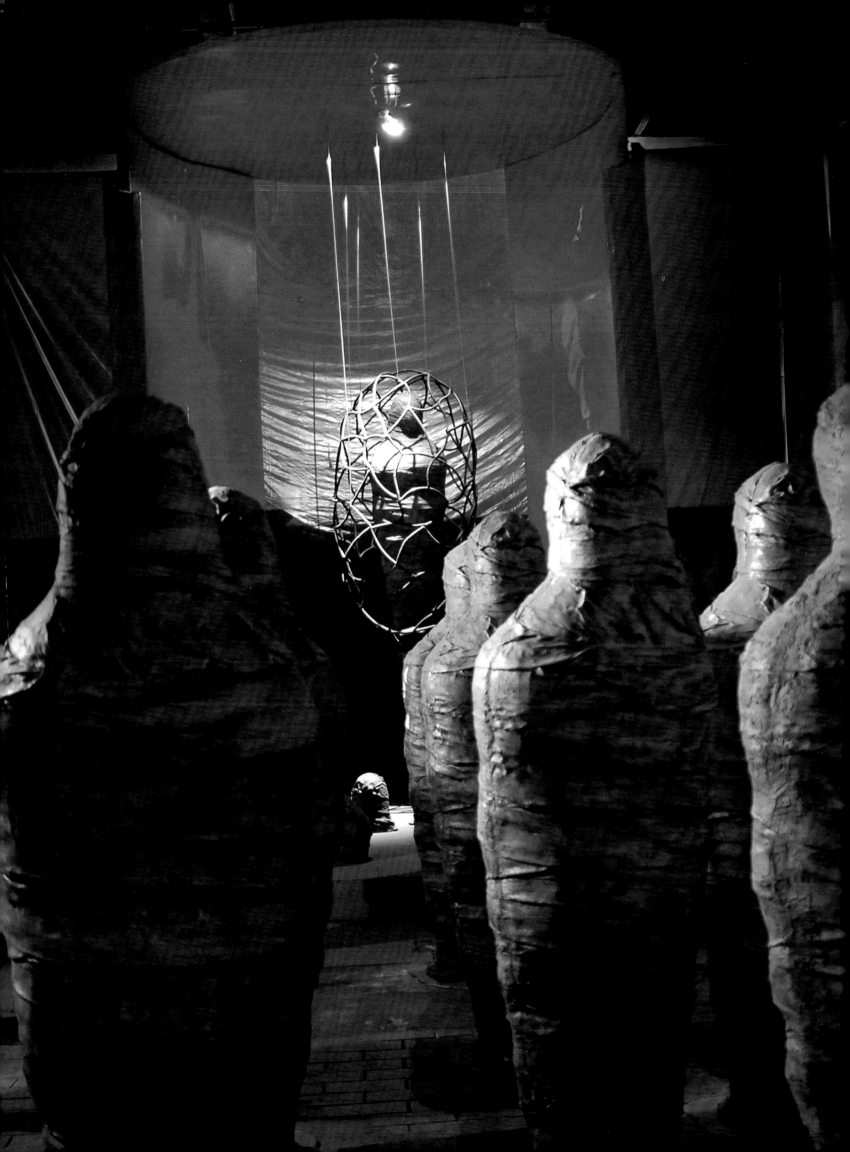

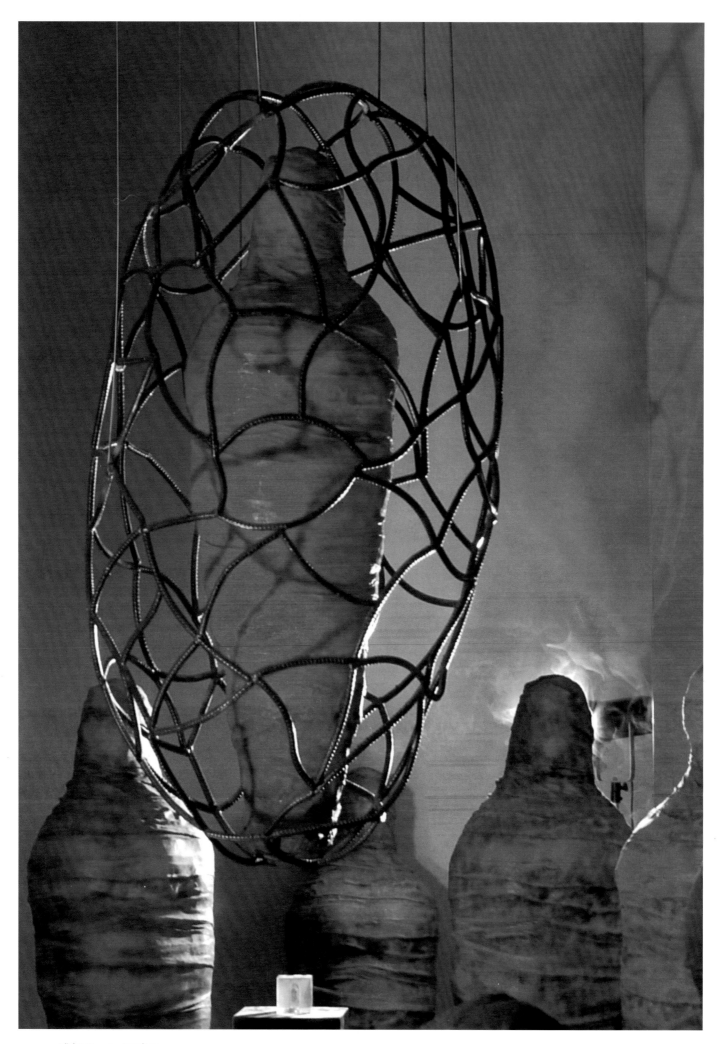

感悟No.3（局部）

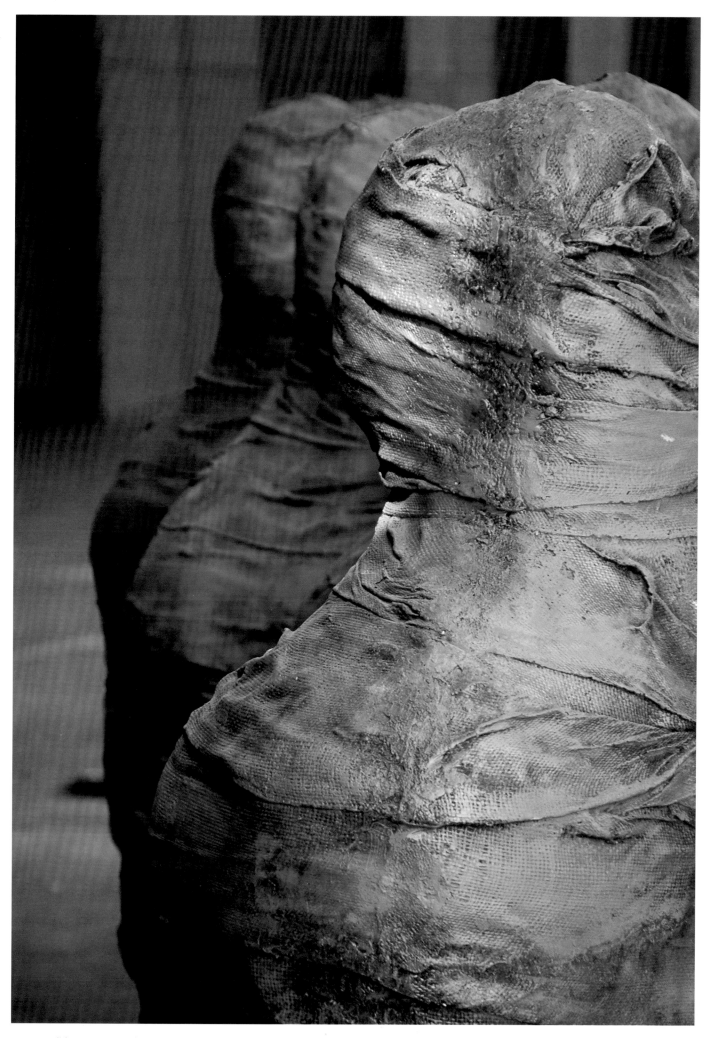

感悟No.3（局部）

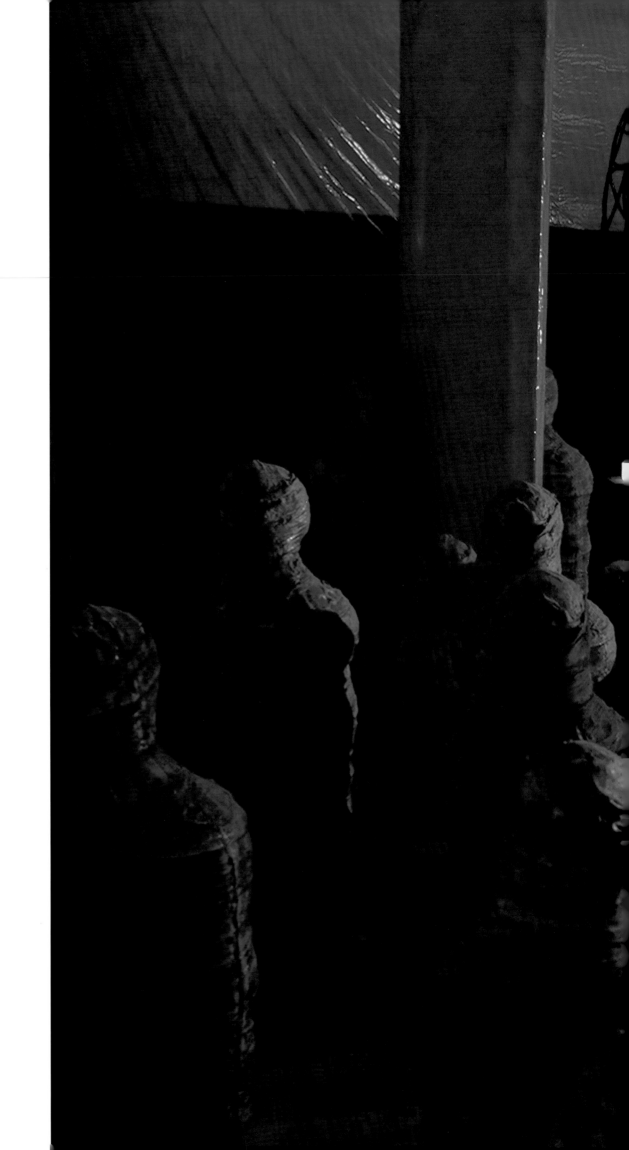

感悟No.3（局部）

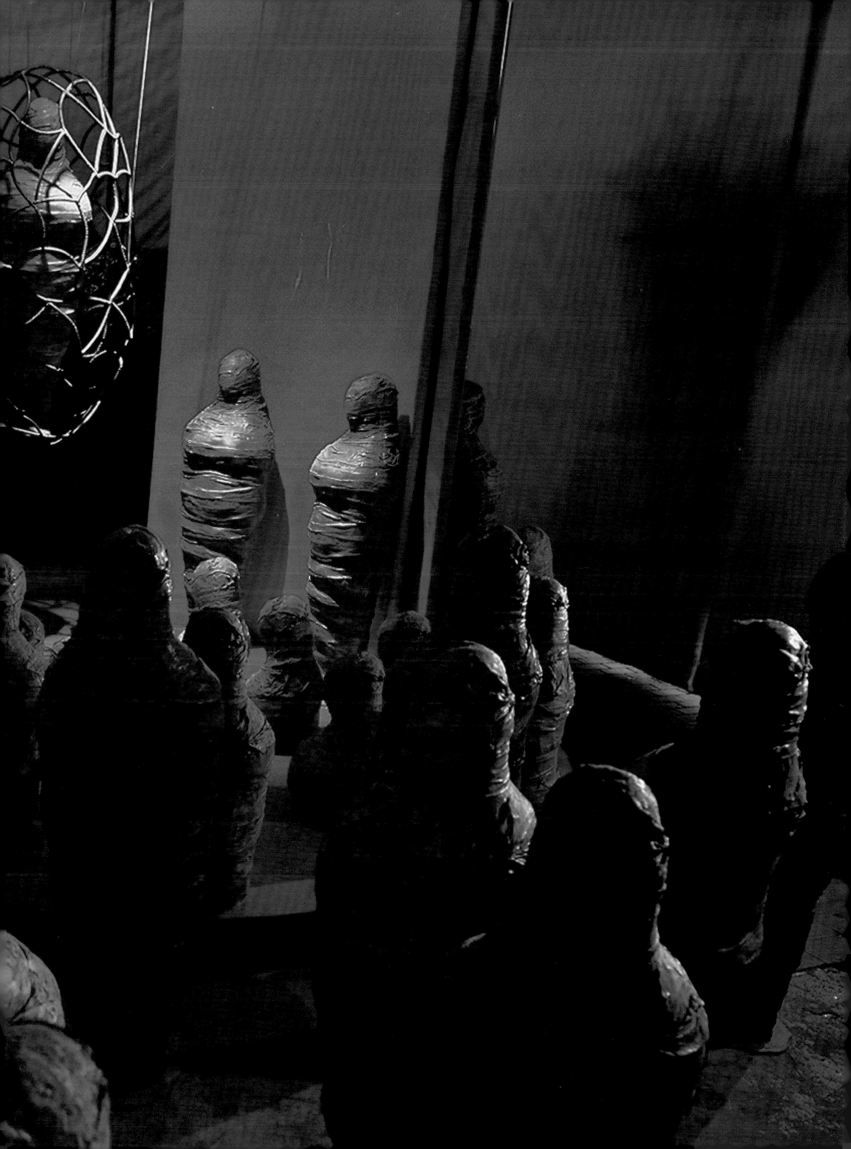

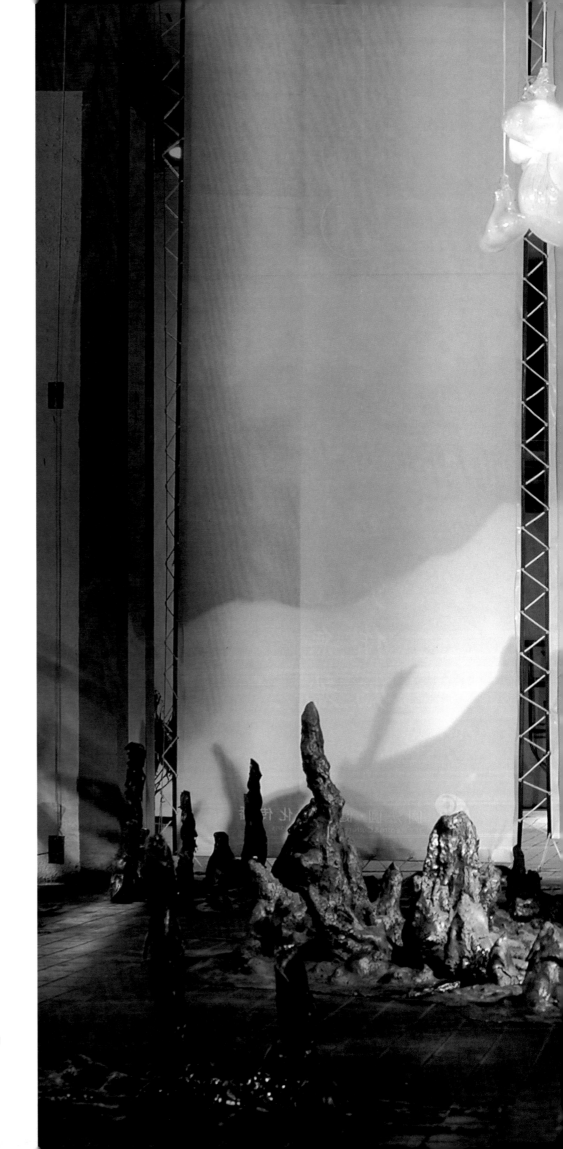

感悟NO8（星云）
Comprehension No.8: Nebula

700cm × 900cm × 900cm
玻璃、树脂、木　Glass，resin，wood
2002

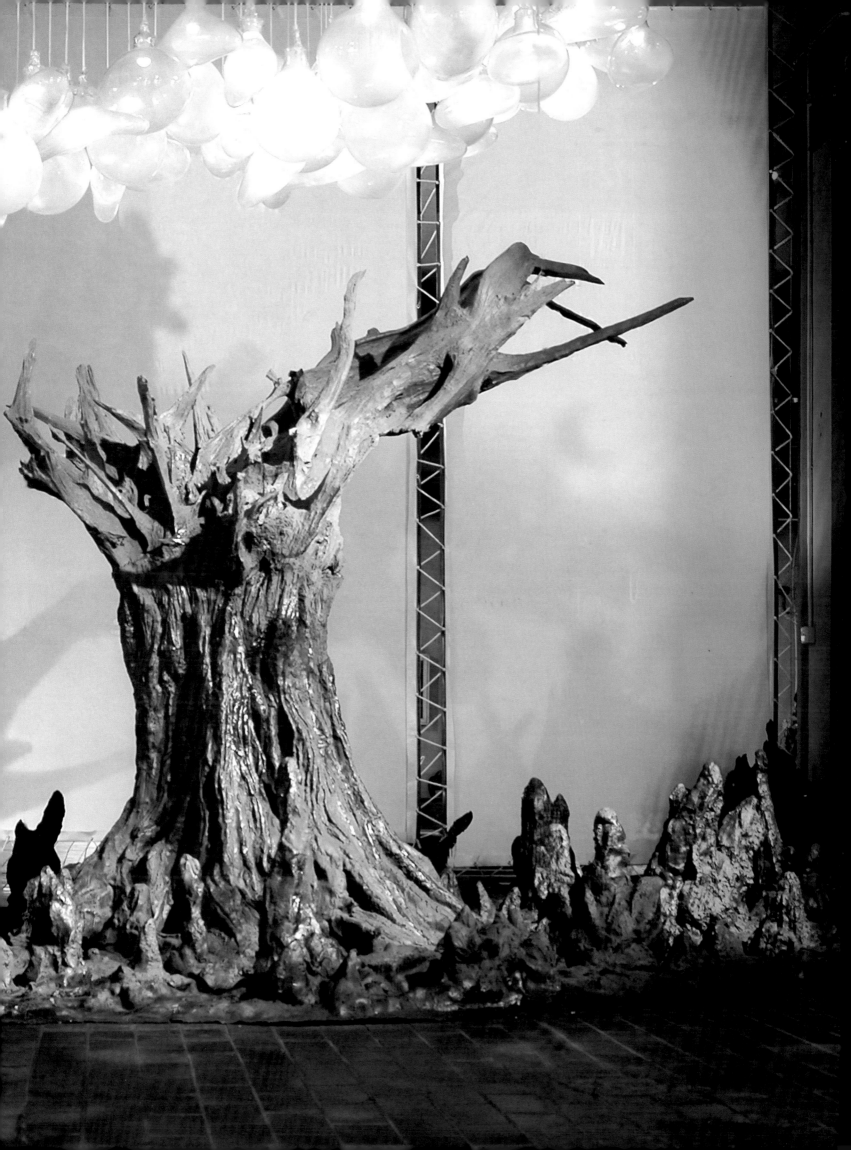

感悟 NO 8 （星云）

　　在这矛盾复杂的空间里，无法用语言表达内心的激荡。情感是乏力的，只有那精灵的天空才会给你带来希望。

Comprehension No. 8　Nebula

　　In such a complicated space full of contradiction, words fail to express the thoughts surging in mind. With feeble emotions, only the spirits in heaven can extend hope to you.

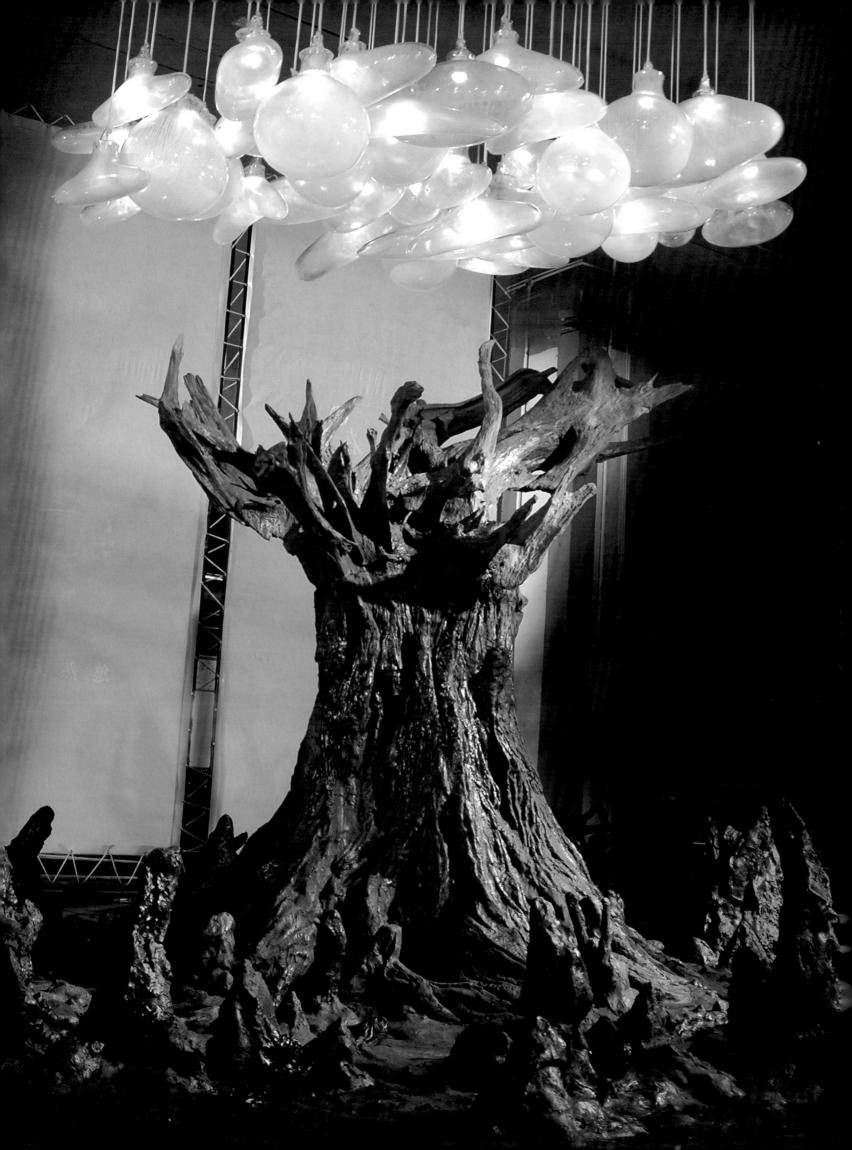

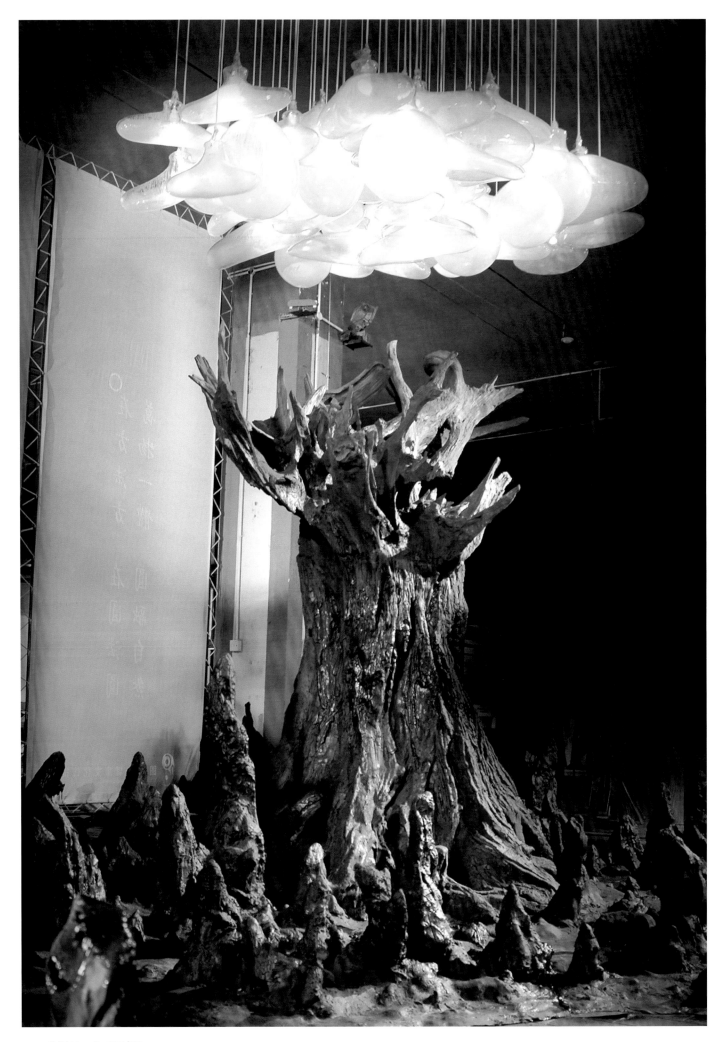

感悟No.8（局部）

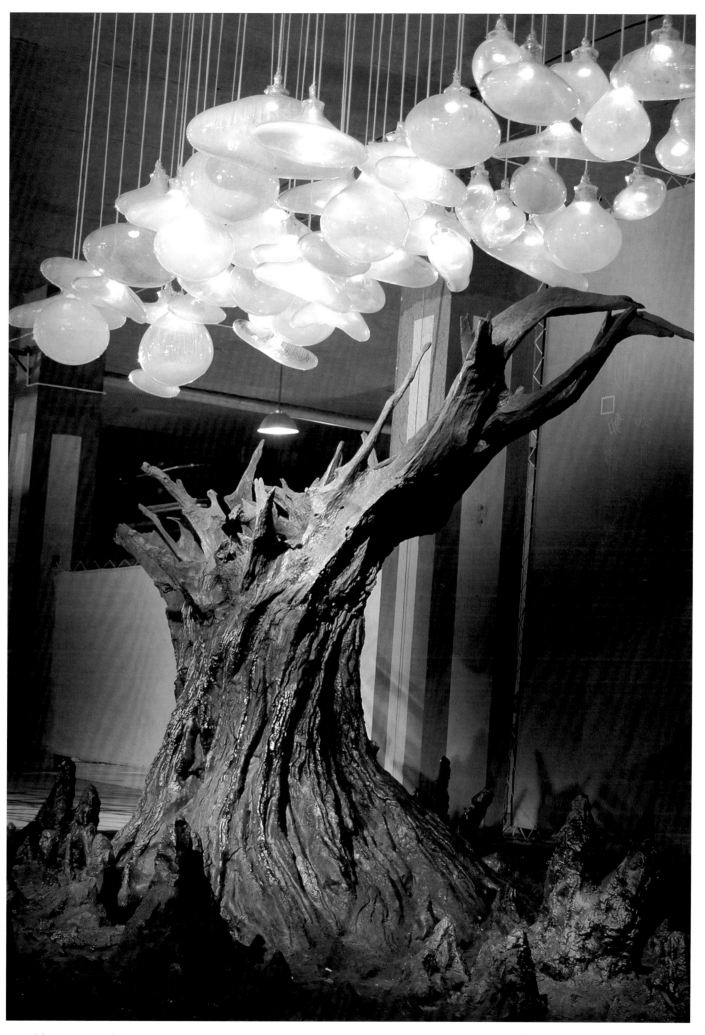

感悟 No.8（局部）

裂 变 系 列

宇宙生活巨流的意识充盈于万物之中，
各种力量在互动、在生发、在孕育、
扩张、收缩、挤压、撕扯、绞缠，
从一种形态向另一种形态演变。

Disintegration Series

Many thousands have been endowed through awareness of a tumultuous life in the today's world.
They develop from one form to another via interaction,
through growth, inoculation, expansion, contraction,
and intrusion being torn and twisted by various forces.

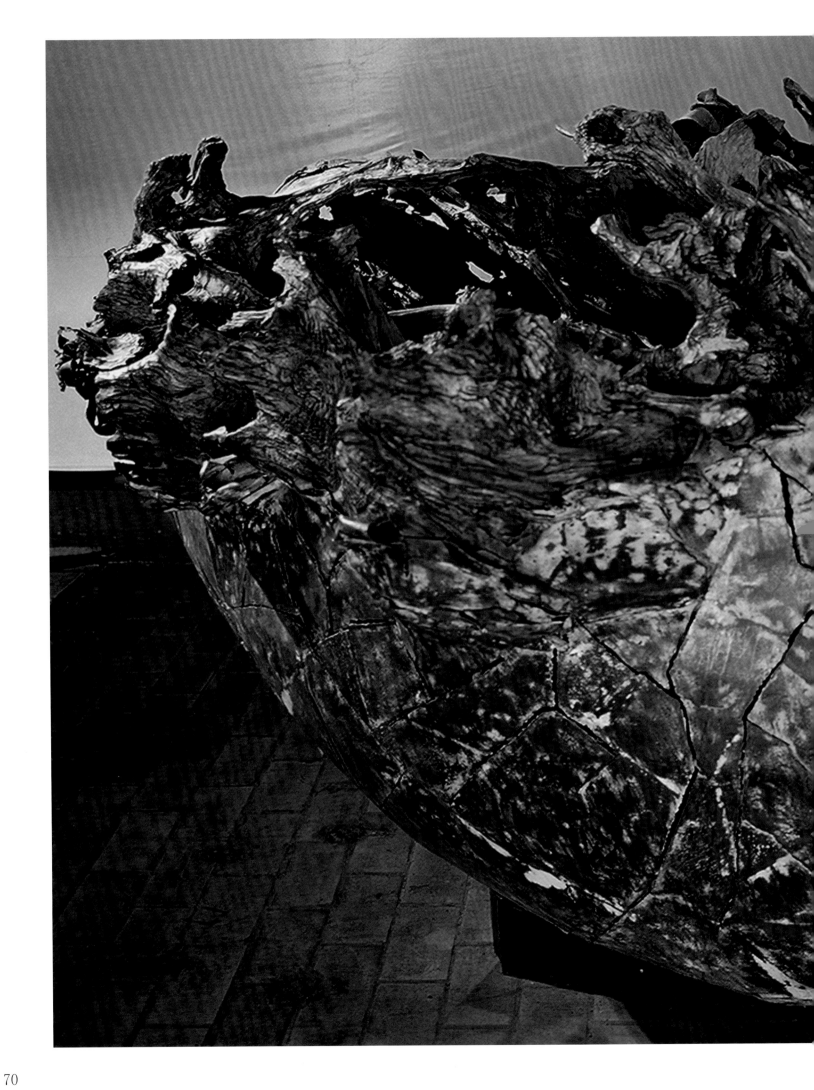

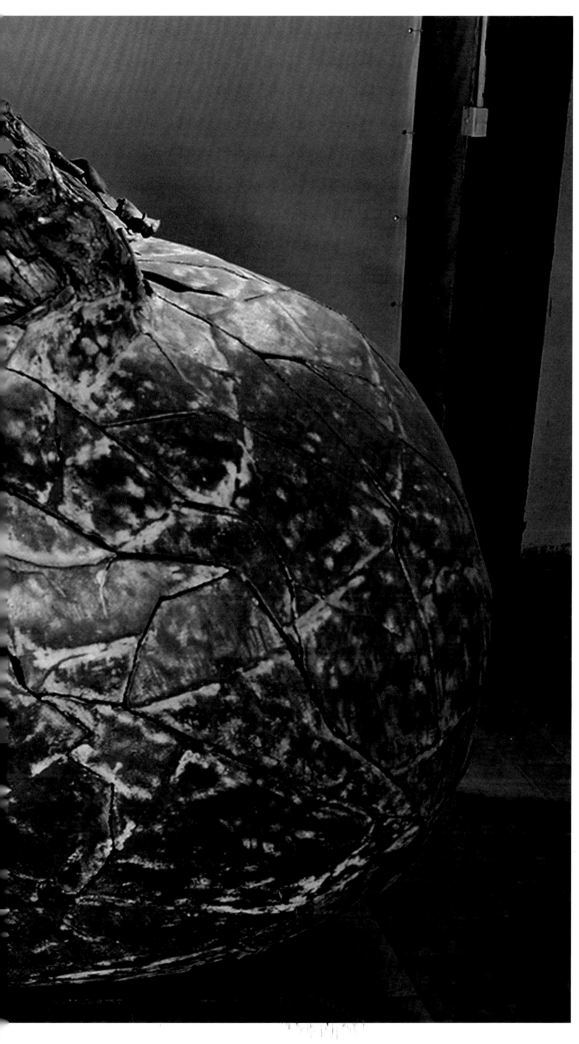

裂 变 NO1
Disintegration No.1

直径 Diameter 180cm × 250cm
铁板、木 Iron sheets, wood
2004

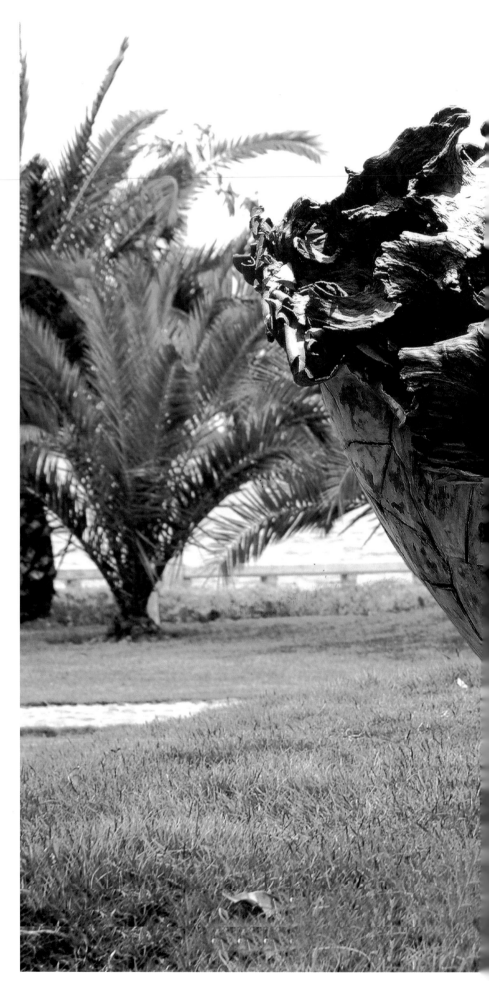

裂变NO1

从物质的完整到裂变的激荡中成形，来证明创造与毁灭这两个宇宙趋势之间并不存在矛盾，旧的东西遭毁灭时，也就是新的东西诞生之日的哲理。

制作时，如何使铁板与木头完美的结合，铁木难辨，我付出了血的代价，脑袋被尖锐的铁板扎了一个窟窿，鲜血顺着额头流下⋯⋯

Disintegration No. 1

From integrity to disintegration, it is proved that the two trends of creation and destruction of the universe are not so contradictory.Extermination of the old suggests the birth of the new, such is the laws of nature….

In the process of designing, I achieved a perfect integration of the iron sheets and wood at the expense of a bleeding head, which was struck by the sharp iron sheet and resulted in blood dripping down my forehead…

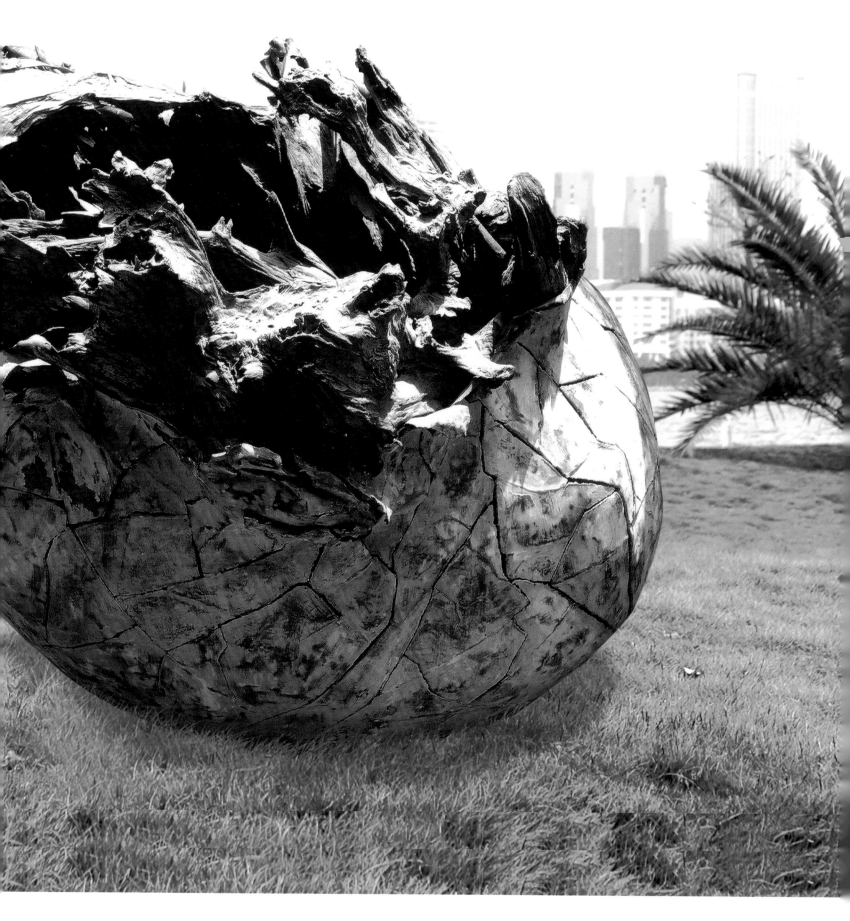

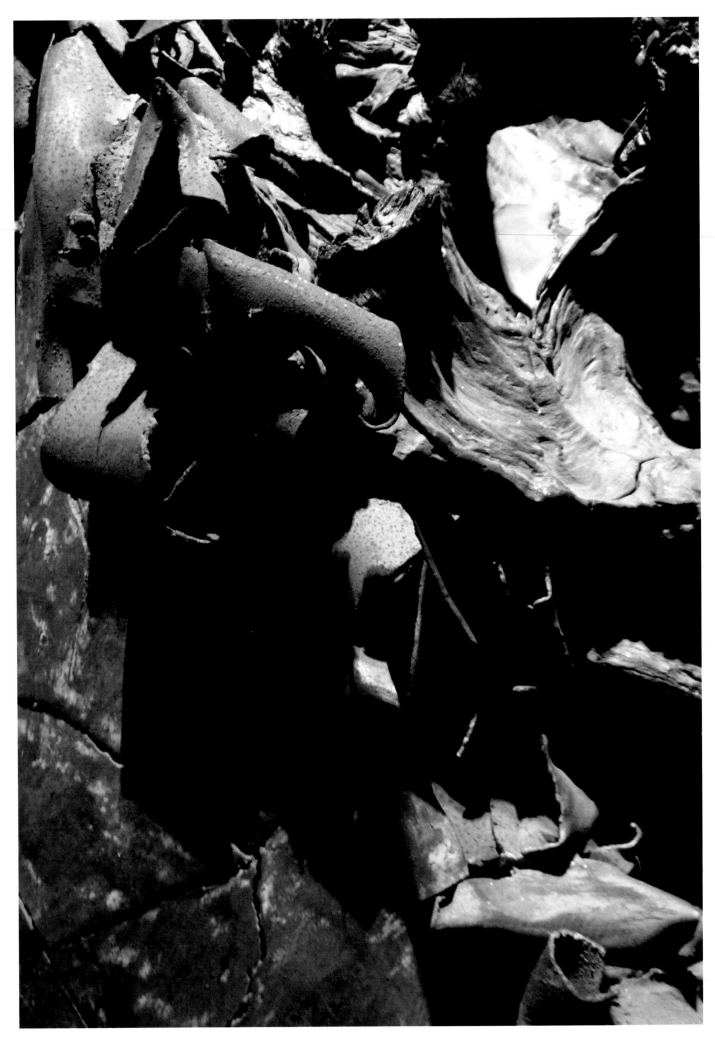

裂变No.1（局部）

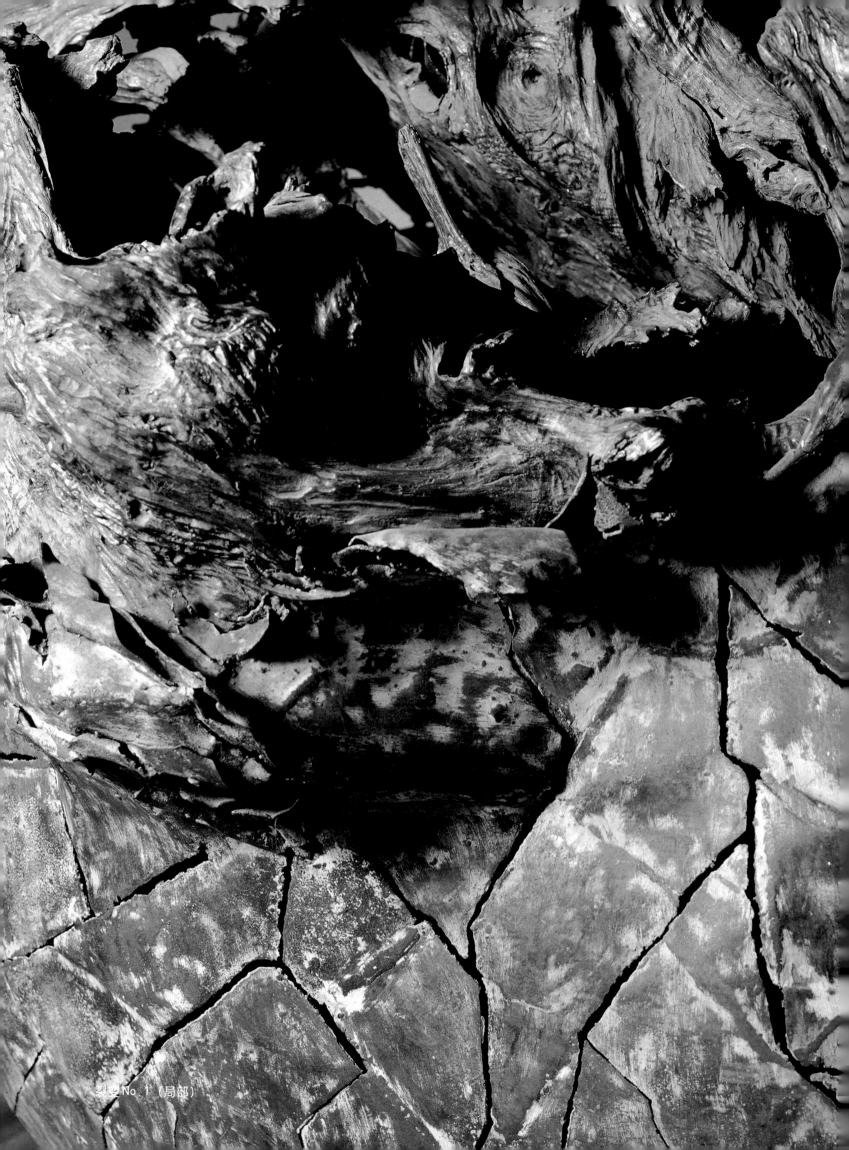

裂変 No. 1（局部）

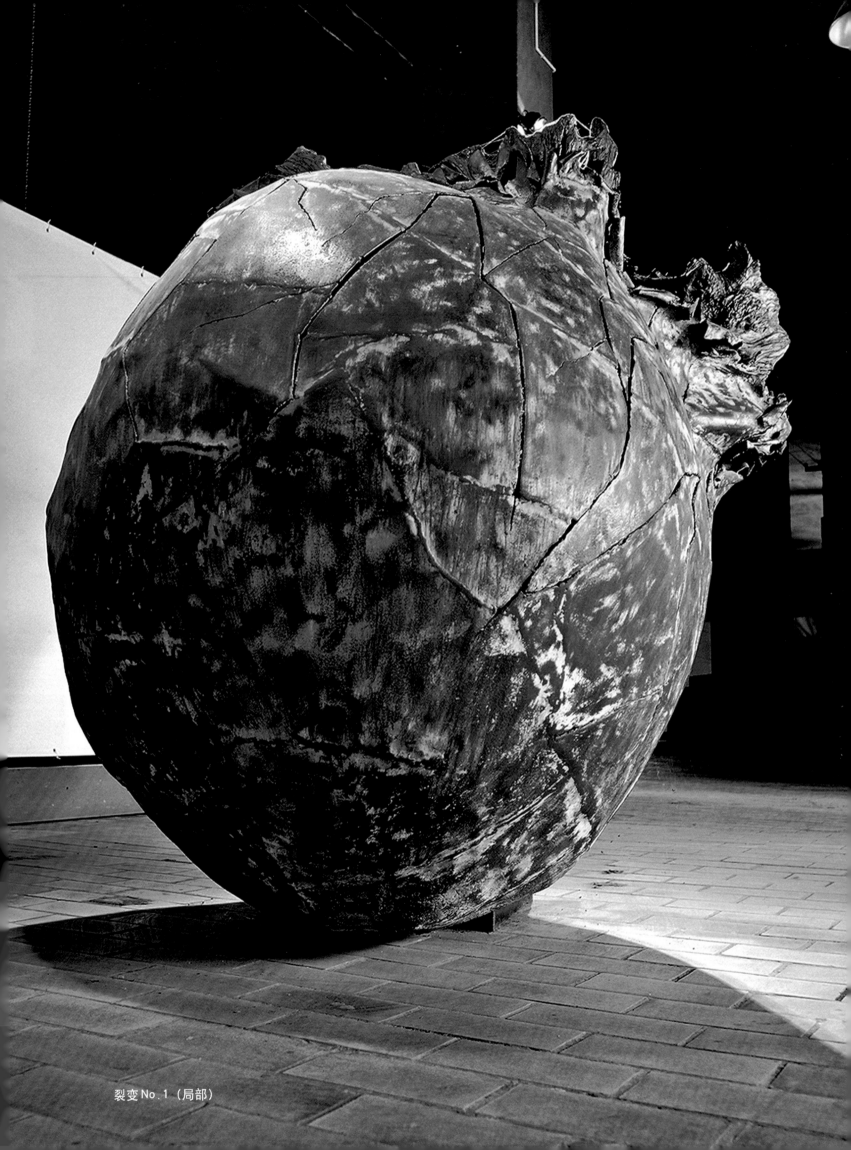

裂变 No.1（局部）

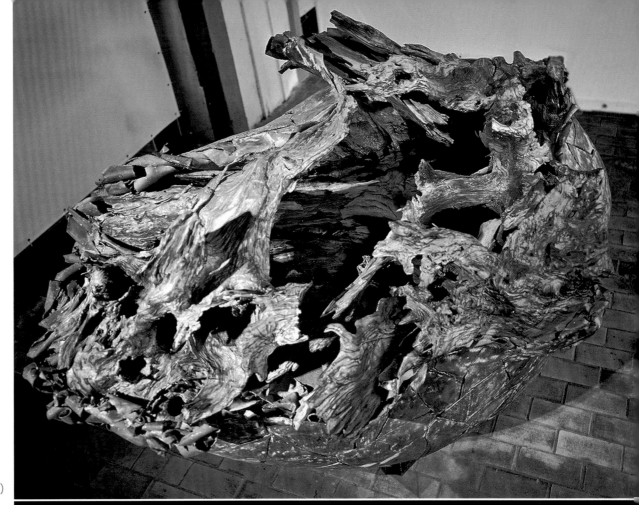

裂変No.1（局部）

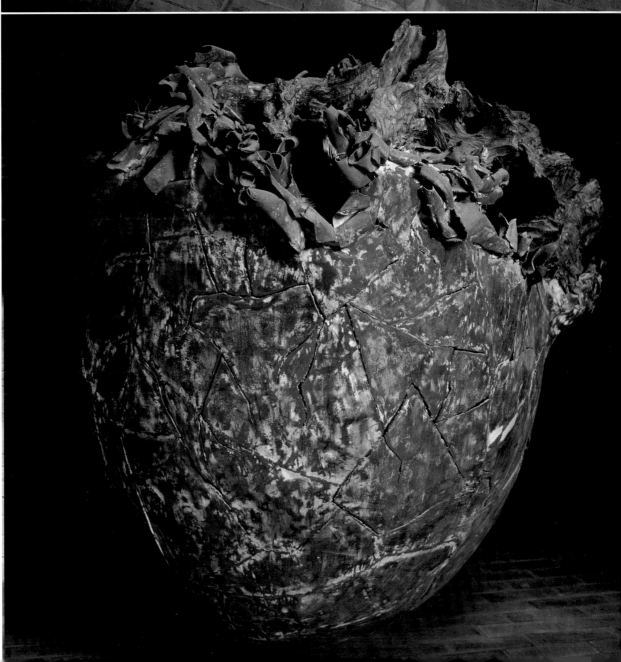

裂変No.1（局部）

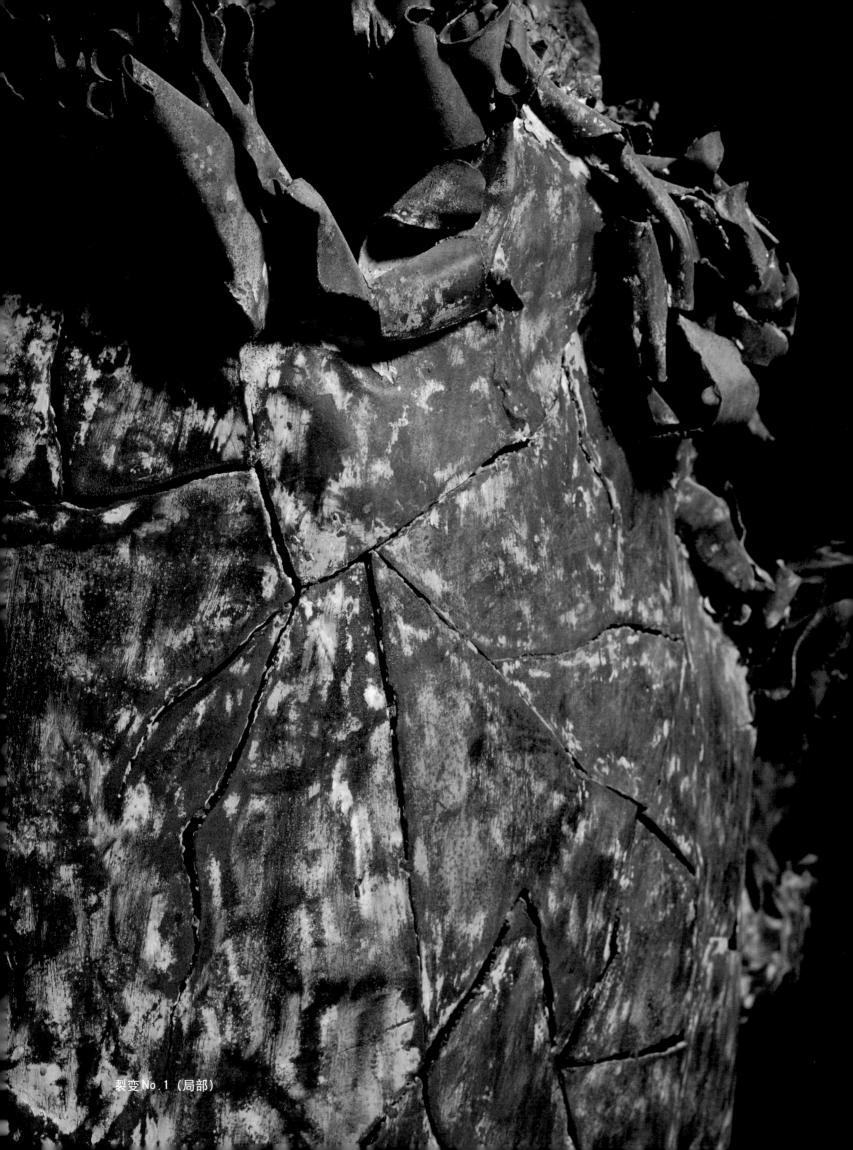

裂变 No.1（局部）

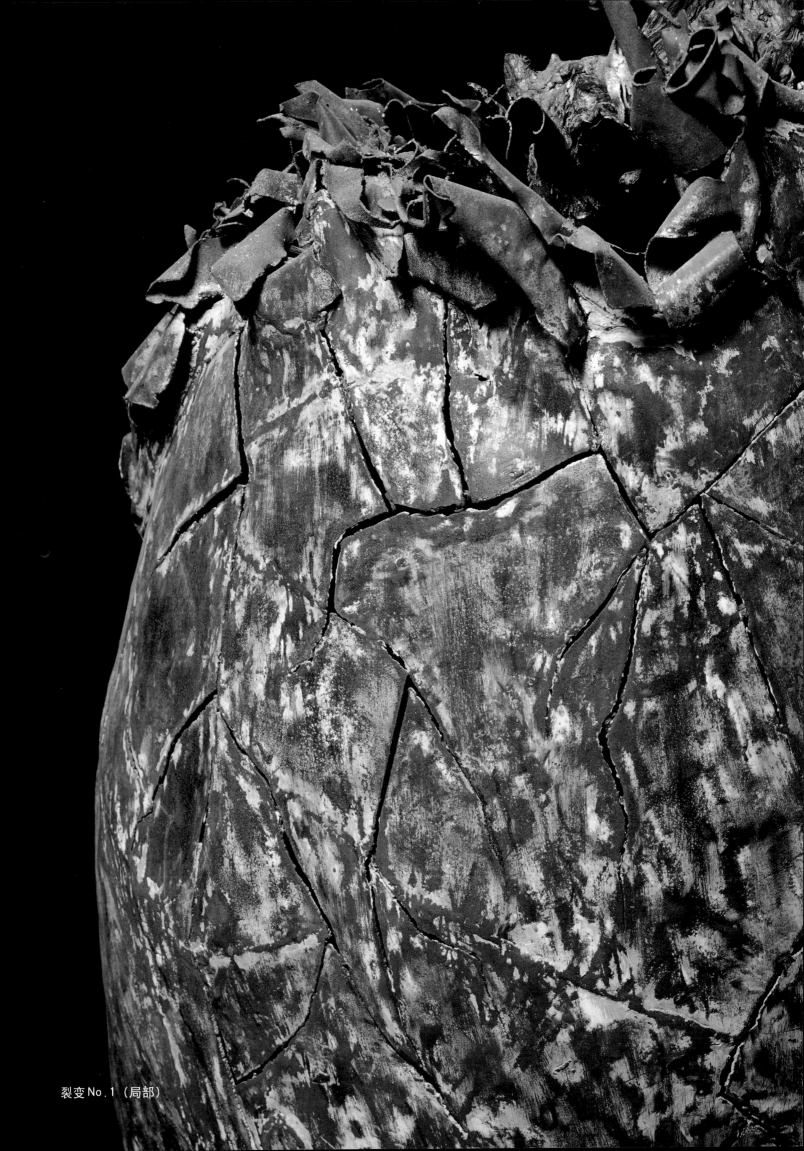

裂变 No.1（局部）

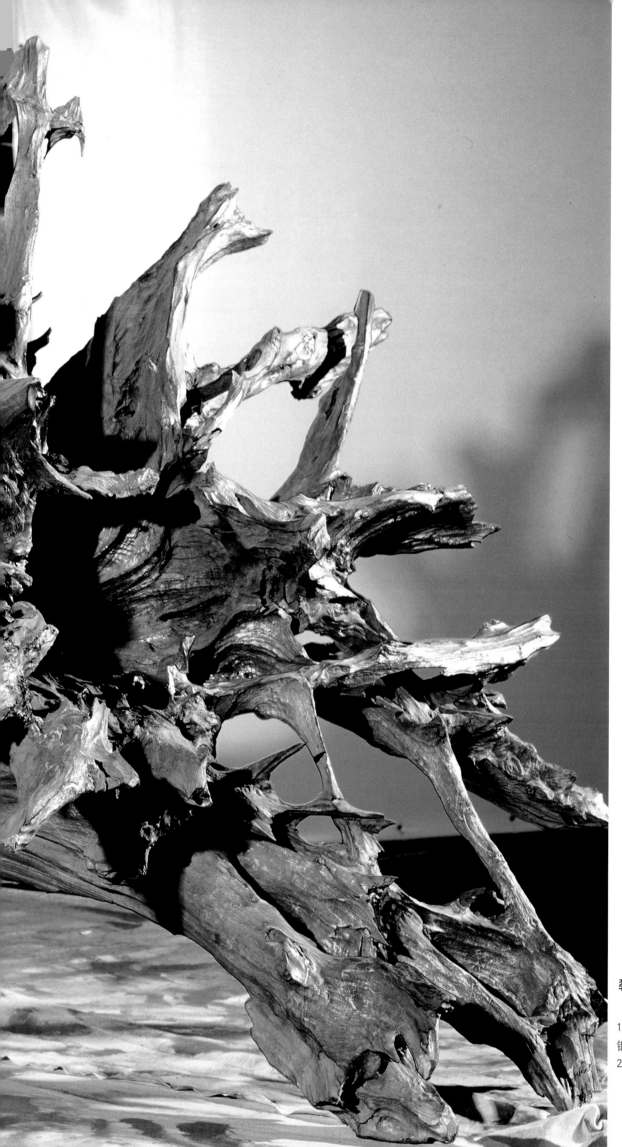

裂变NO2　　Fission NO.2

170cm × 250cm × 170cm

钢筋、木　Reinforced，wood

2004

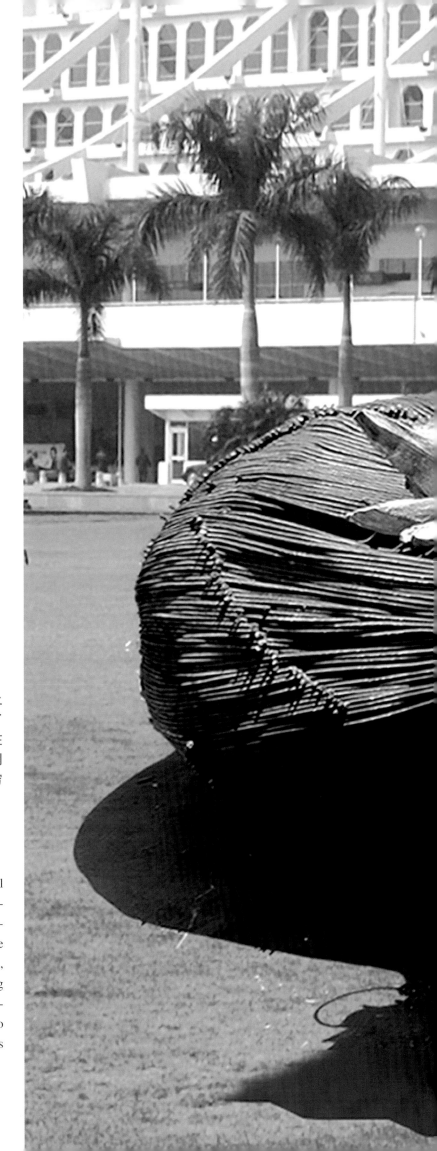

裂变 NO2

　　百年"残骨"是物质转化的产物。为了强化物质结构上的变化，实现形式和内容的统一，我用无数线状钢筋嵌入了木质内，示意物质逐渐衍化、裂变的运动。表现异质元素在力的作用下，时而嵌入融为一体，时而激荡变形，从聚集到扩散，从简单到复杂，从完整到裂变，从无序到有序，无穷无尽。

Disintegration No. 2

　　The century-long "ruin" has been the result of substantial transformation. To highlight the structural transformation of substances within a combination of forms and content, I made numerous linear concrete and iron segments and embedded them into the wood. This signified the gradual derivation and fission of substances, showing the endless process of heterogeneous elements being merged into an integral arrangement. At times, the impulse to transform the piece from aggregation to dispersion, simplicity to complexity, unity to fission, and from disorder to order is overwhelming.

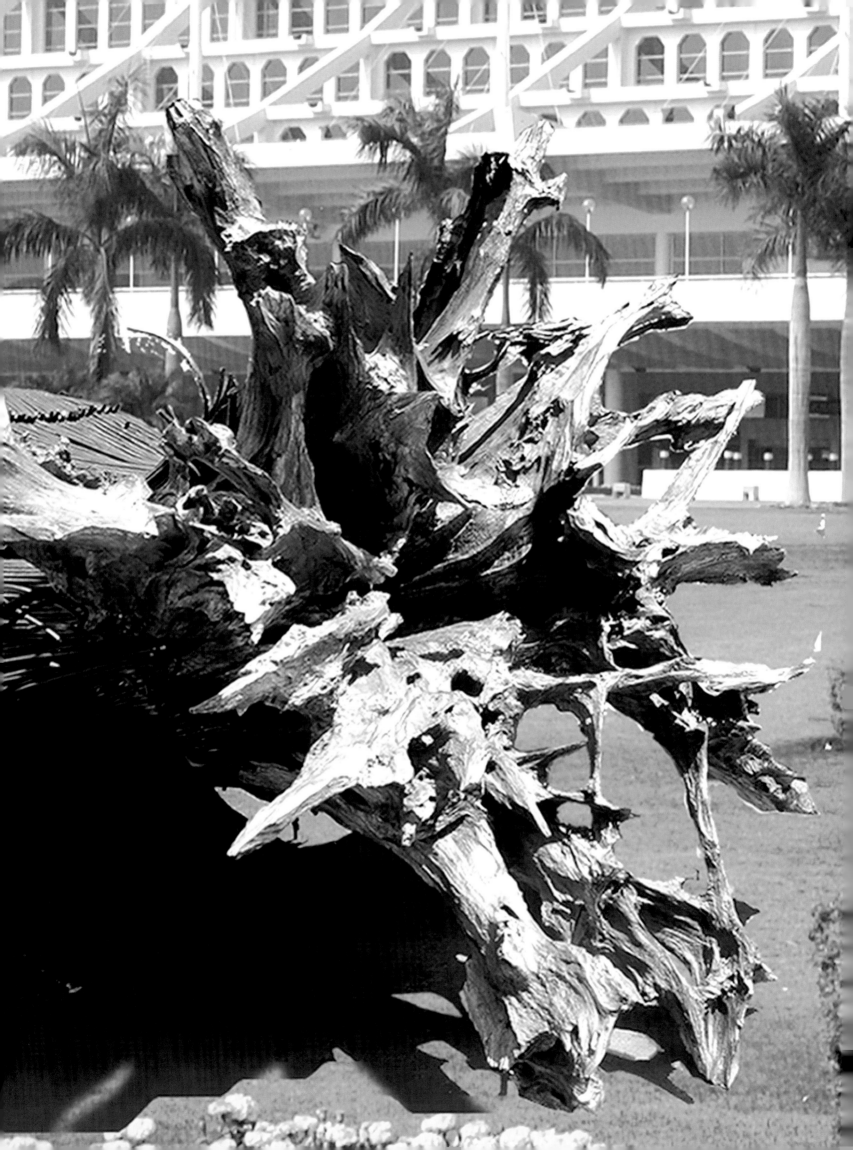

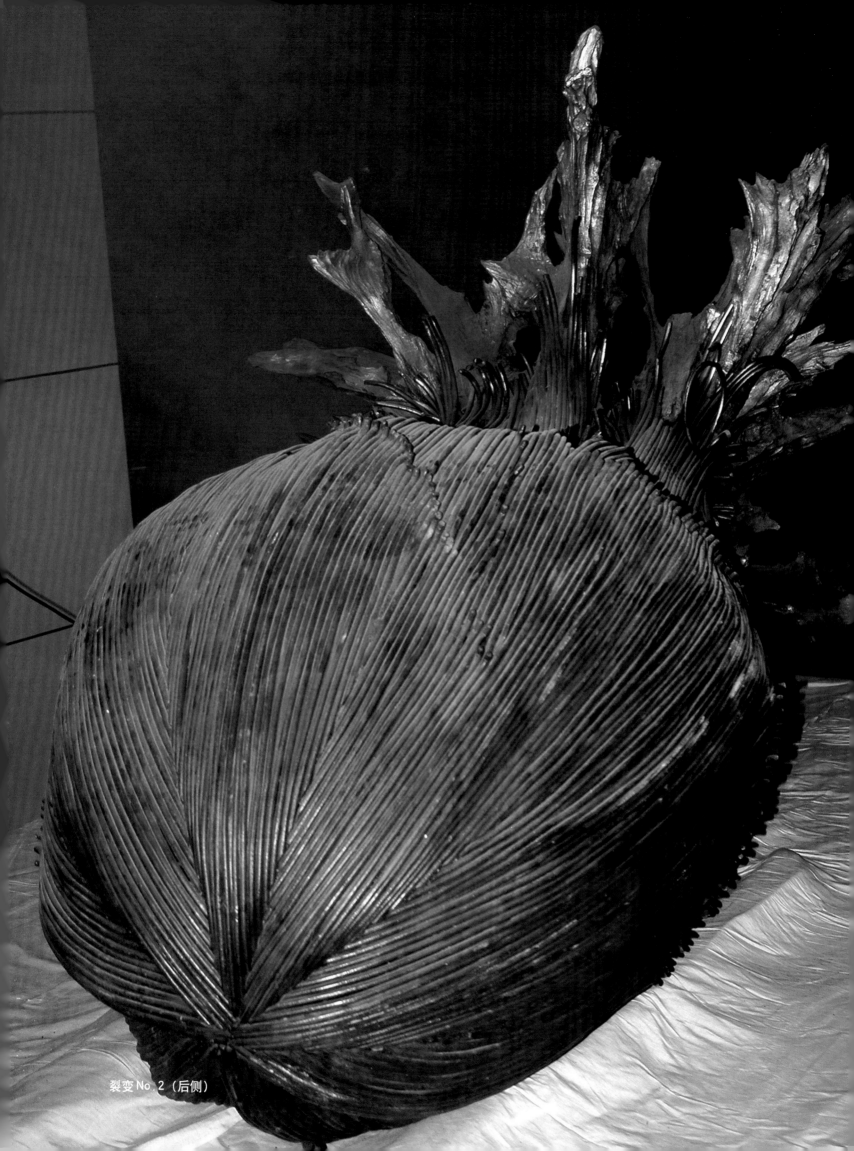

裂变No. 2（后侧）

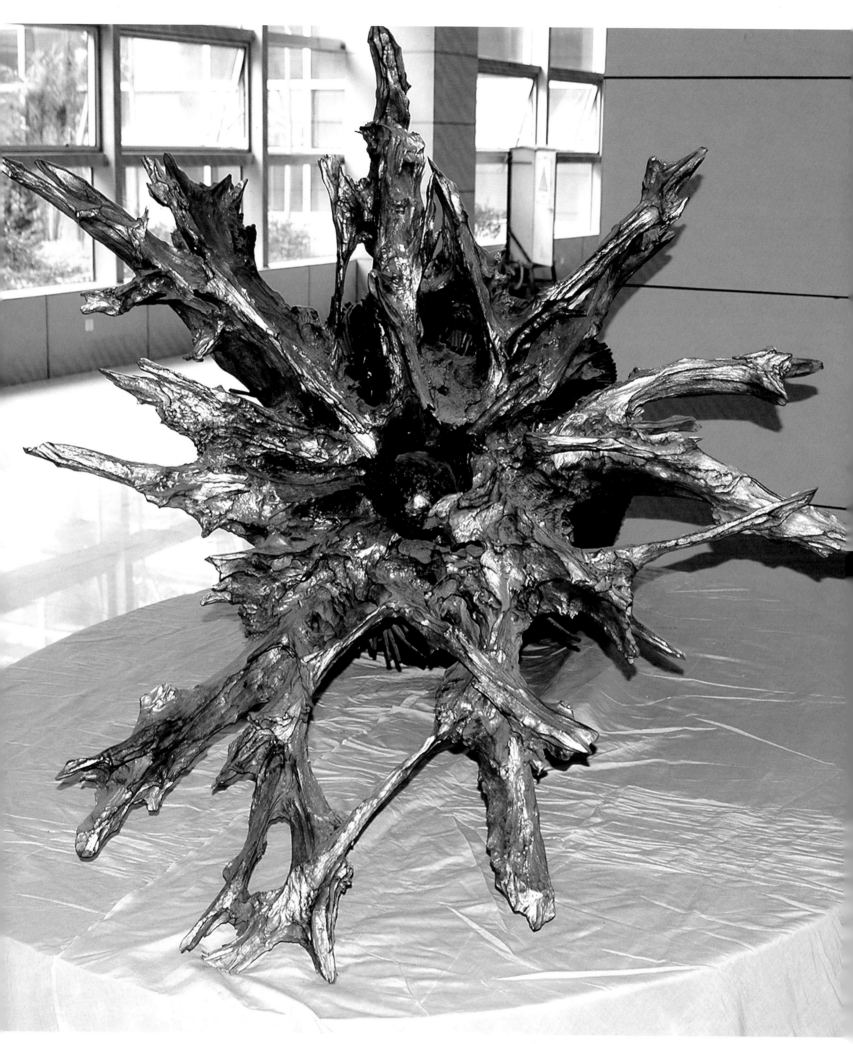

裂变No.2（前侧）

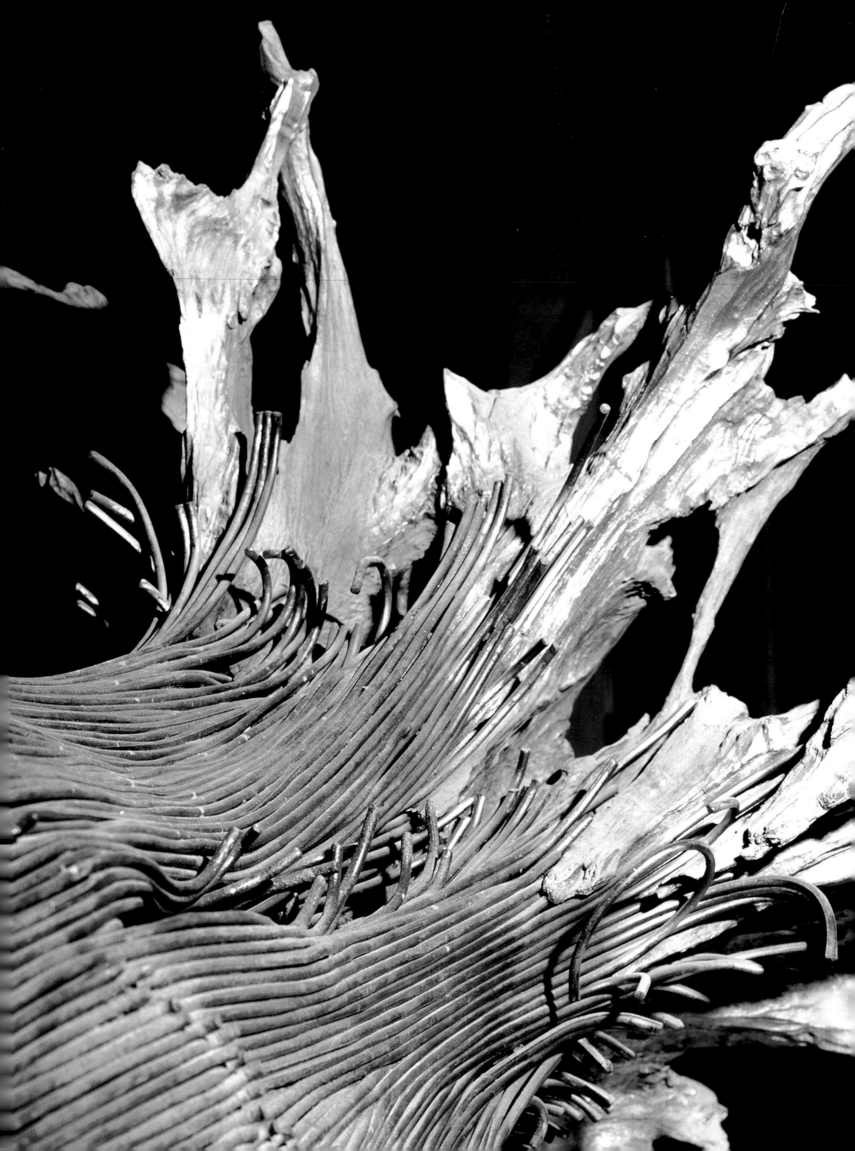

裂变No.2（局部）

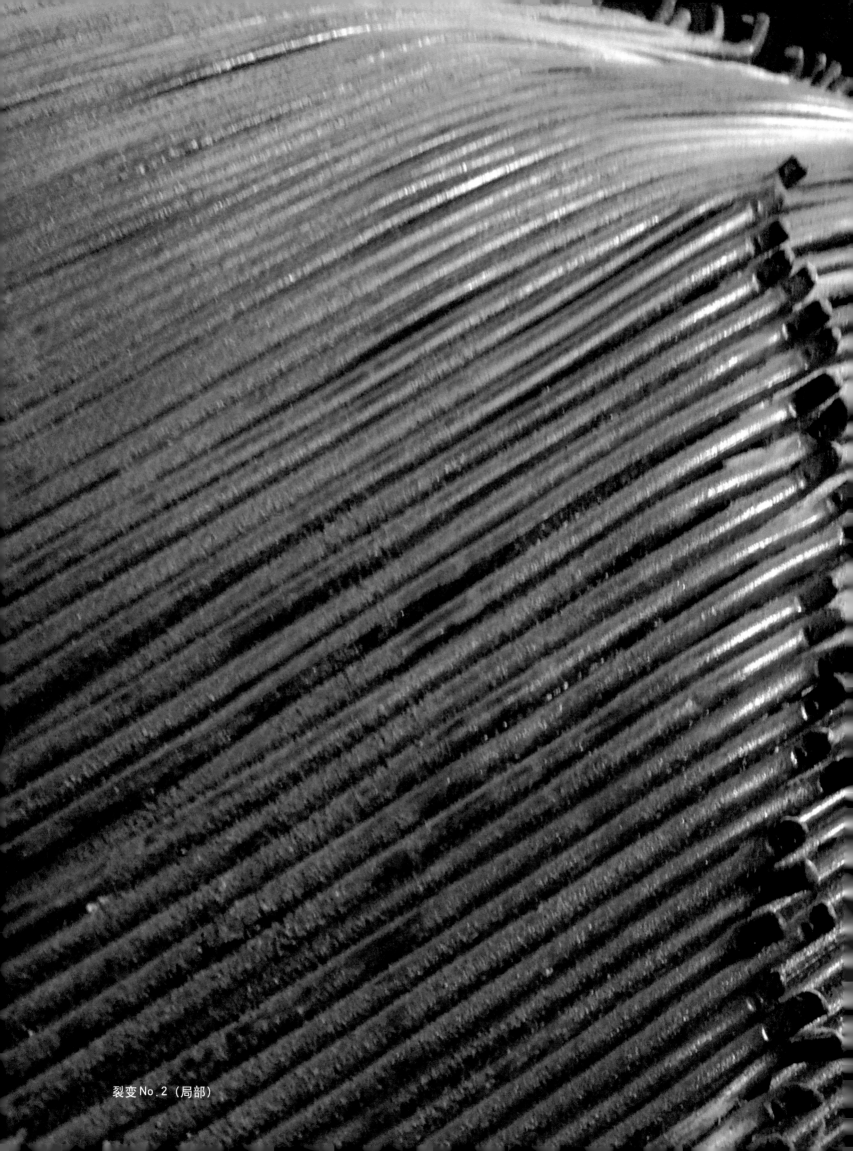

裂变 No.2（局部）

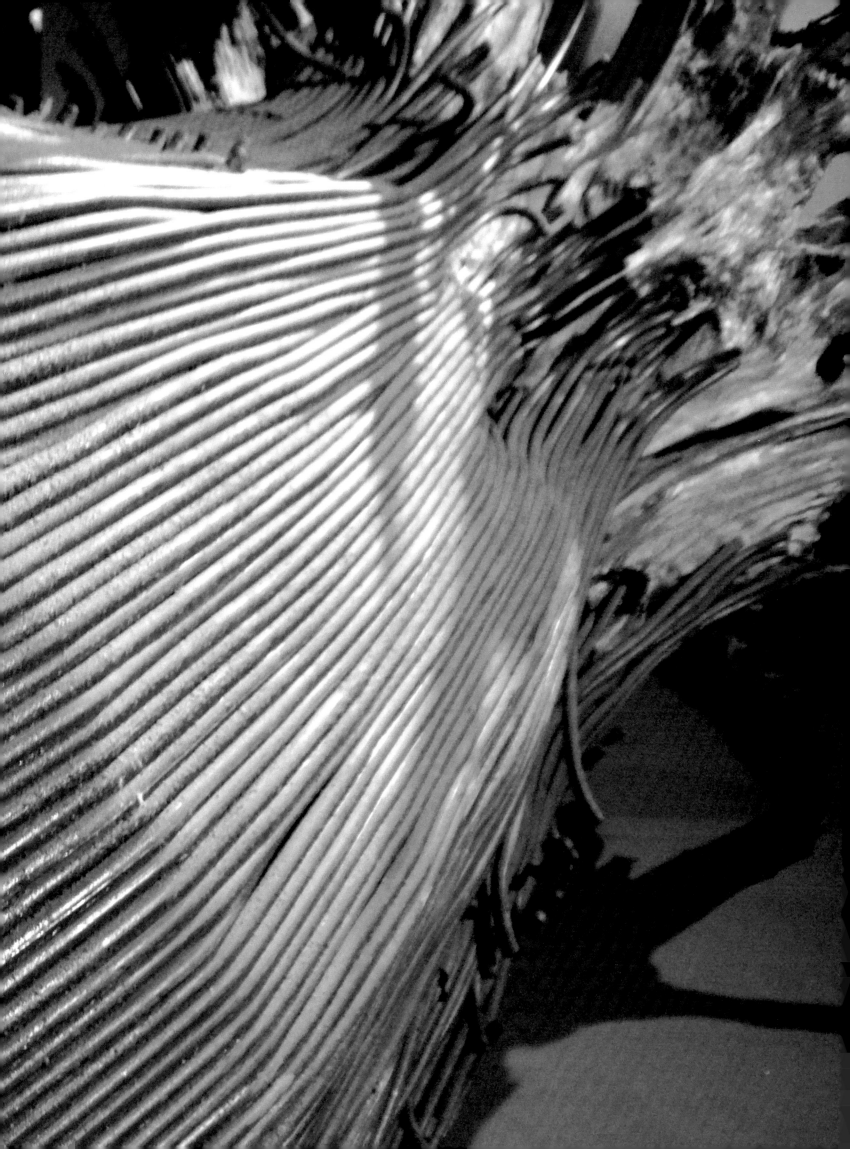

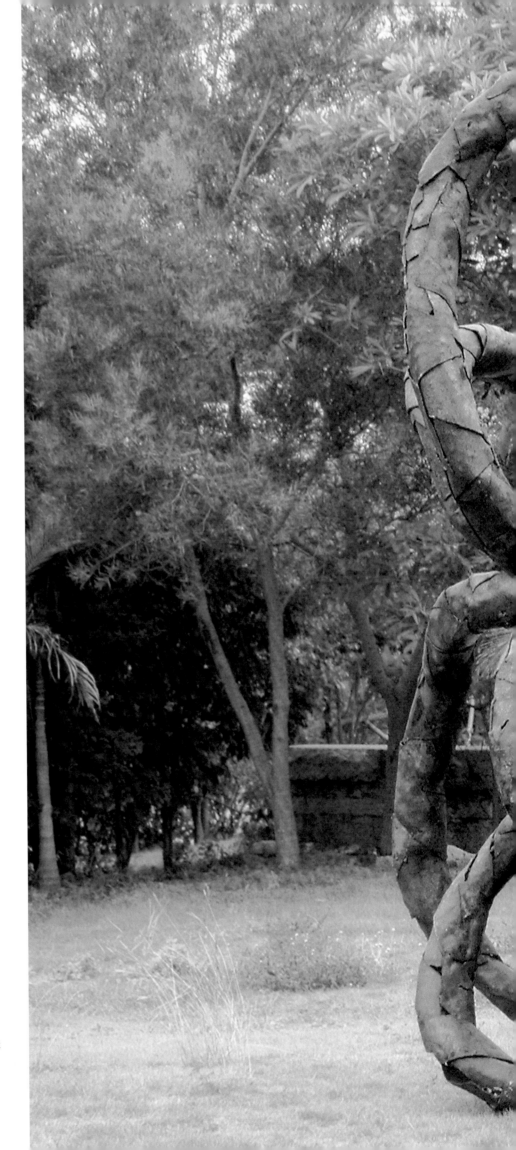

裂变NO3 （律动）
Disintegration No.3 (The Rhythm)

270cm × 250cm × 200cm
木、钢筋、铁板　Wood, Reinforced, Iron sheet
2005

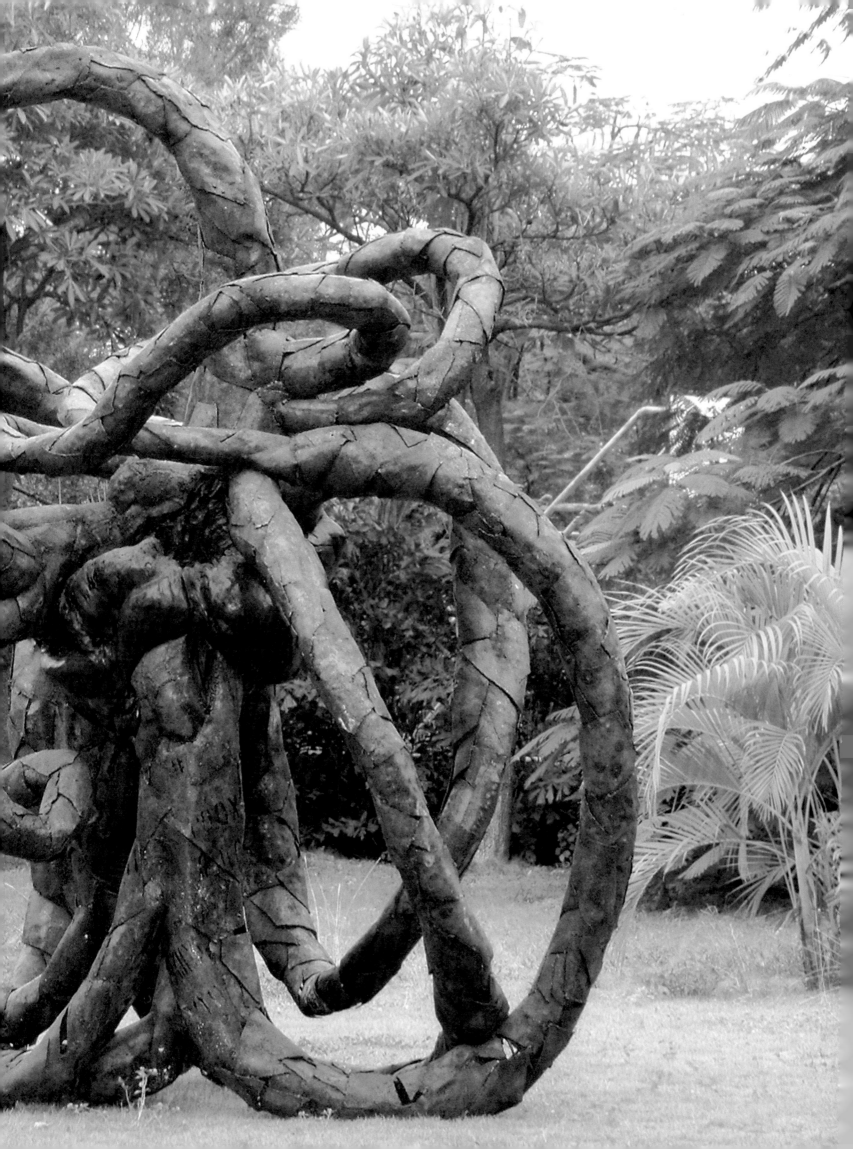

裂变NO3 （律动）

　　作品的完成，一是"请"白蚂蚁帮忙主体部位的造化，三年来定时观察，适可而止，造化成如今层叠多姿的肌理效果；二是顺着主体凸起部位延伸，用铁板焊接成触角。后来发现居然与心脏的主要动、静脉，血管数量和部位相似。作品主要表现宇宙生活巨流充盈万物之中，各种力量在互动、生发、扩张、挤压……从一种形态向另一种形态演变。

Disintegration No. 3 （The Rhythm）

I owe completion of the piece first to the termites' efforts on the body. In the past 3 years, I had been keeping an eye on them and regularly making adjustments until the multi-layered texture was formed. Then, I extended the bulging parts of the body and wielded the iron sheets to form antenna, only to find that it resembled a heart in both the numbers and positions of the arteries, veins, and blood vessels. The piece is meant to show that various forces have been acting, generating, expanding, and crushing upon each other in this universe filled with lives... that is the evolution from one shape to another.

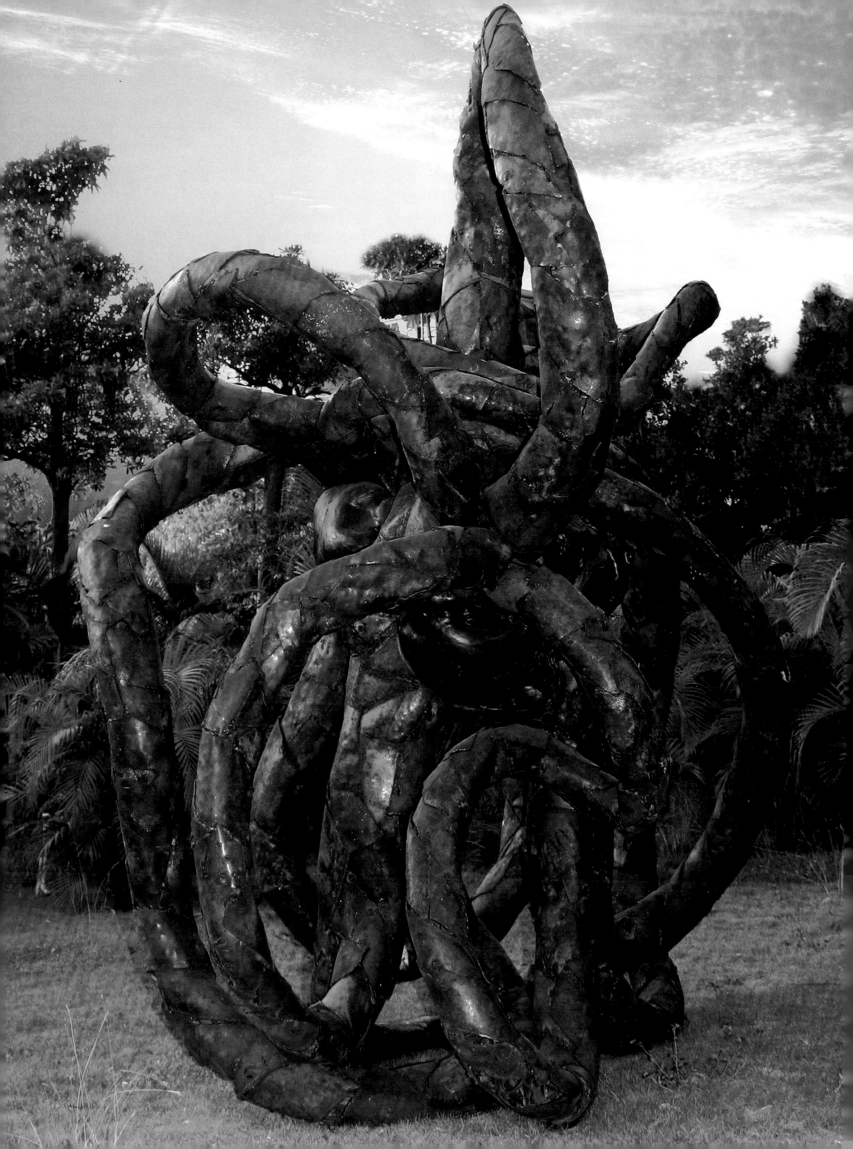

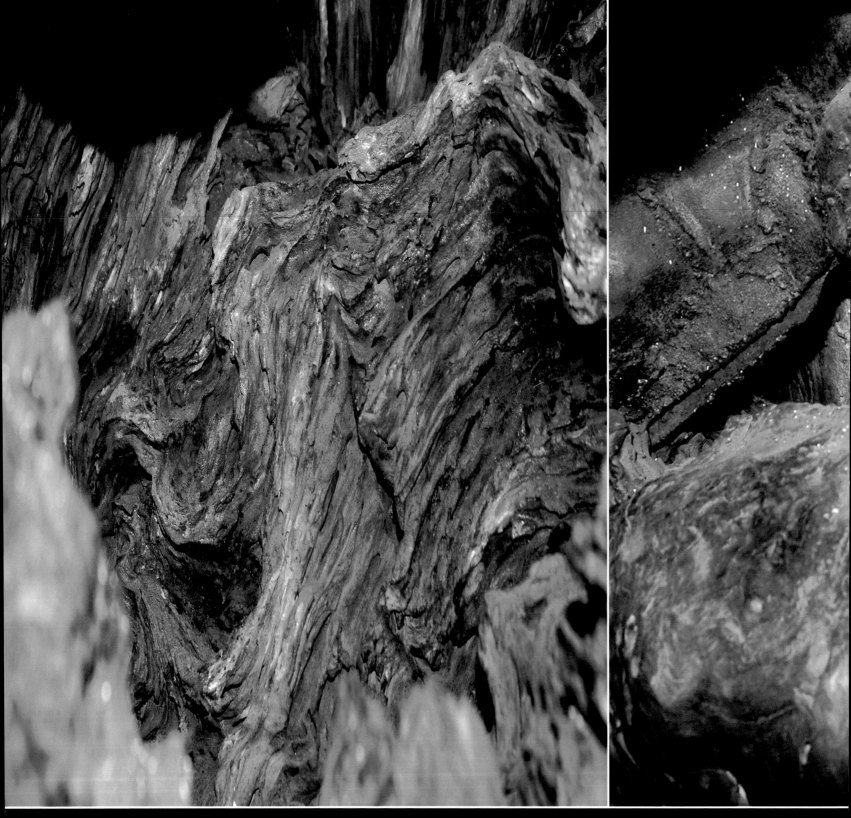

裂変No.3（局部）

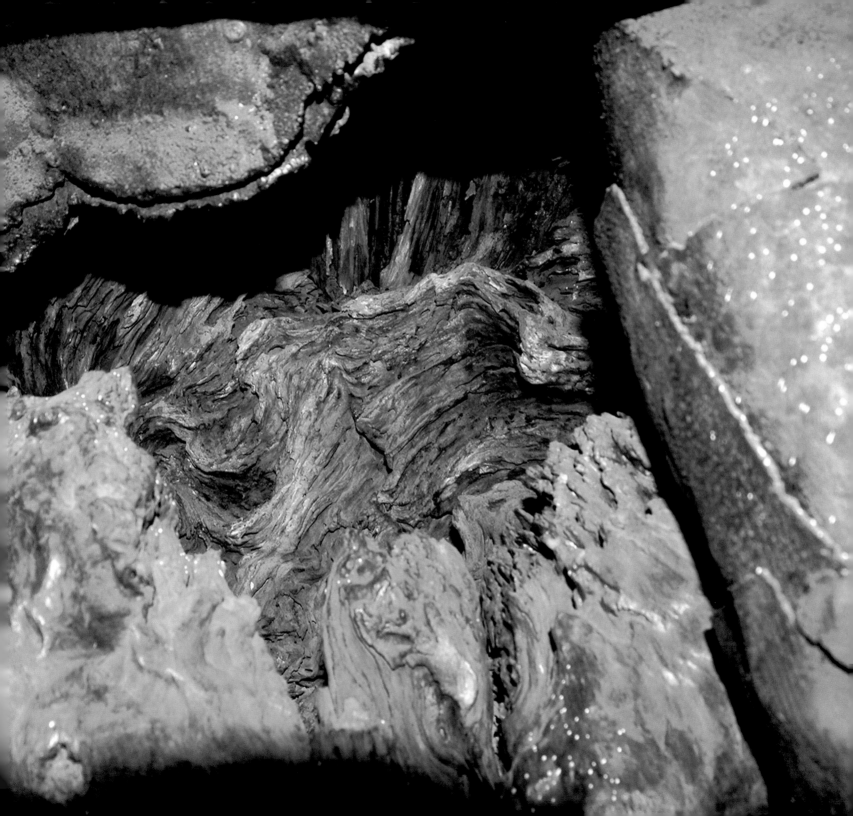

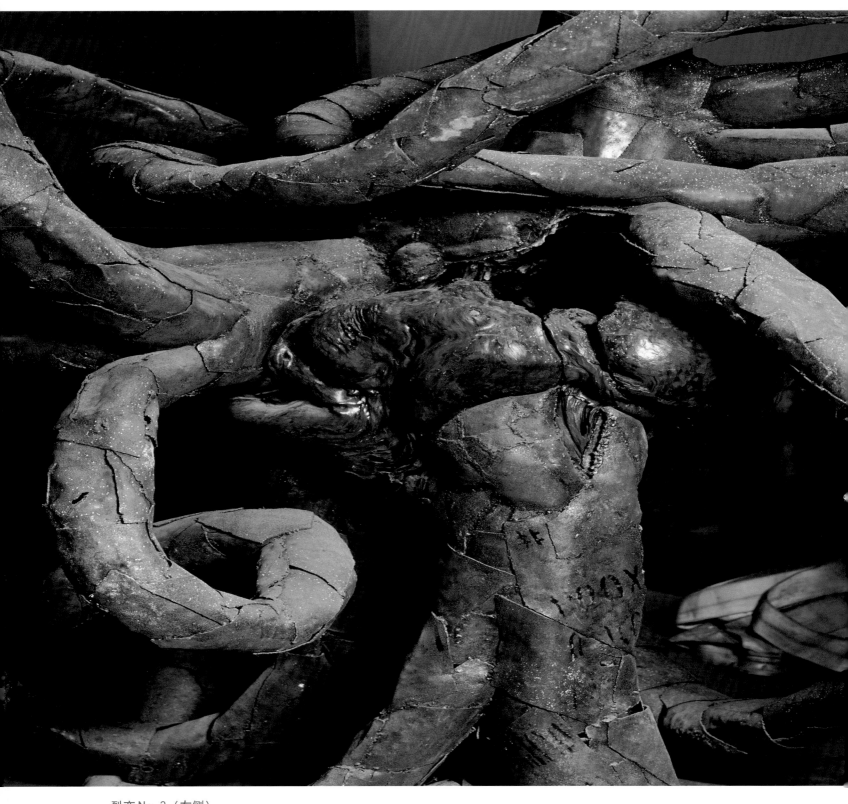

裂变No.3（左侧）

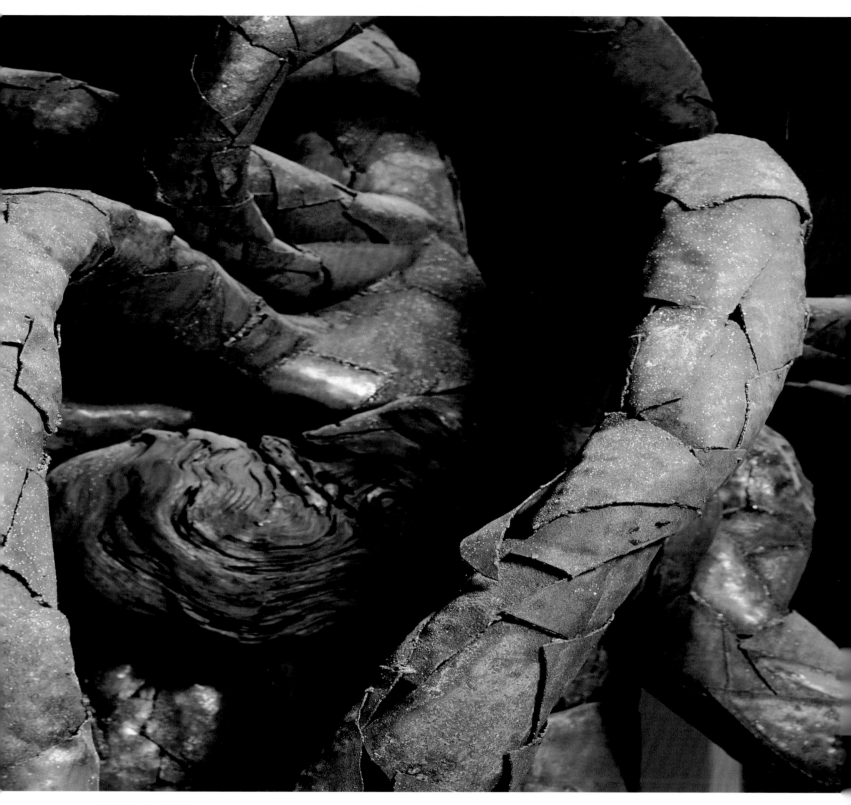

裂变No.3（右侧）

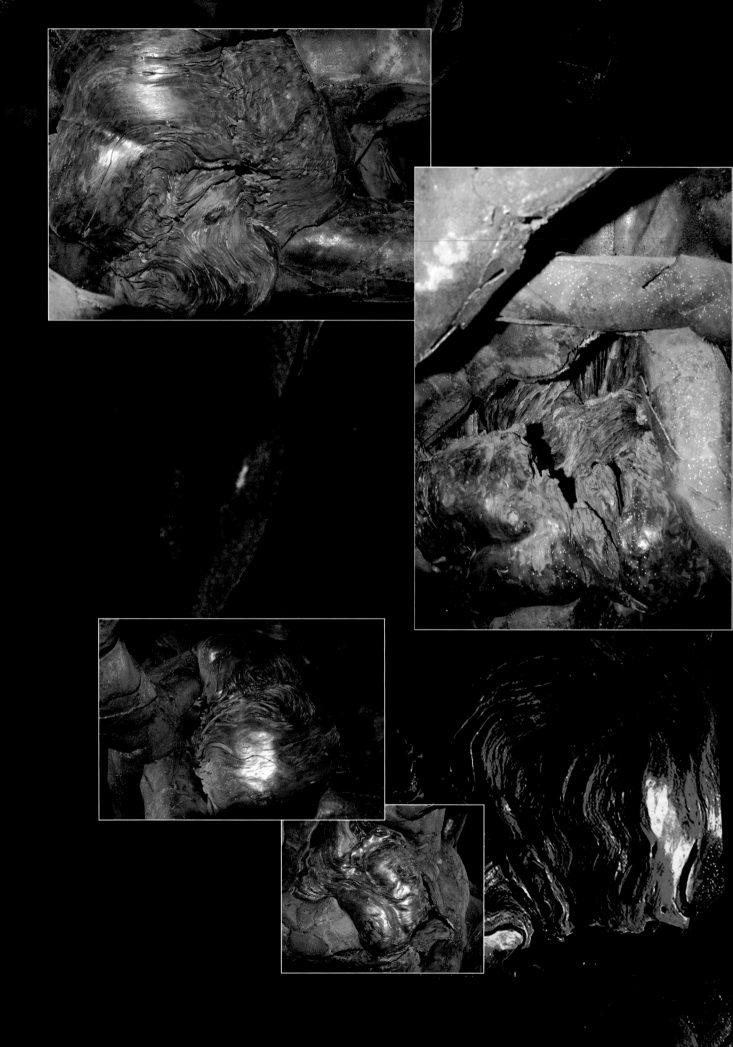

裂变No.3（局部）

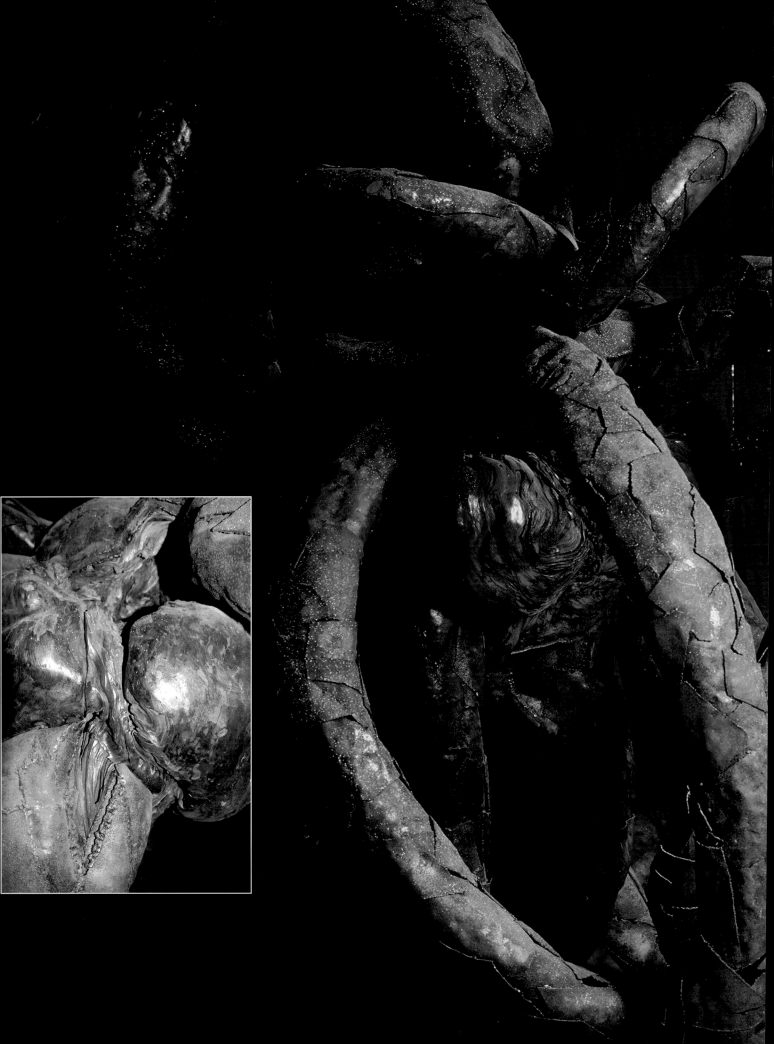

蜕 变 系 列

水平面吸引着我们的视野，
所有的物象渐渐远去，
就像海市蜃楼，
渐渐永恒的蜕变。

Metamorphosis Series

Our eyes'being attracted to the horizon as
everything is fading away.
Like a mirage,
the gradually eternal metamorphosis.

蜕变NO3（殇）
Metamorphosis No.3　Fantasy

直径／Diameter　145 × 120 cm
钢筋、铁板、木瘤
Reinforced，iron sheets，gnarls
2005

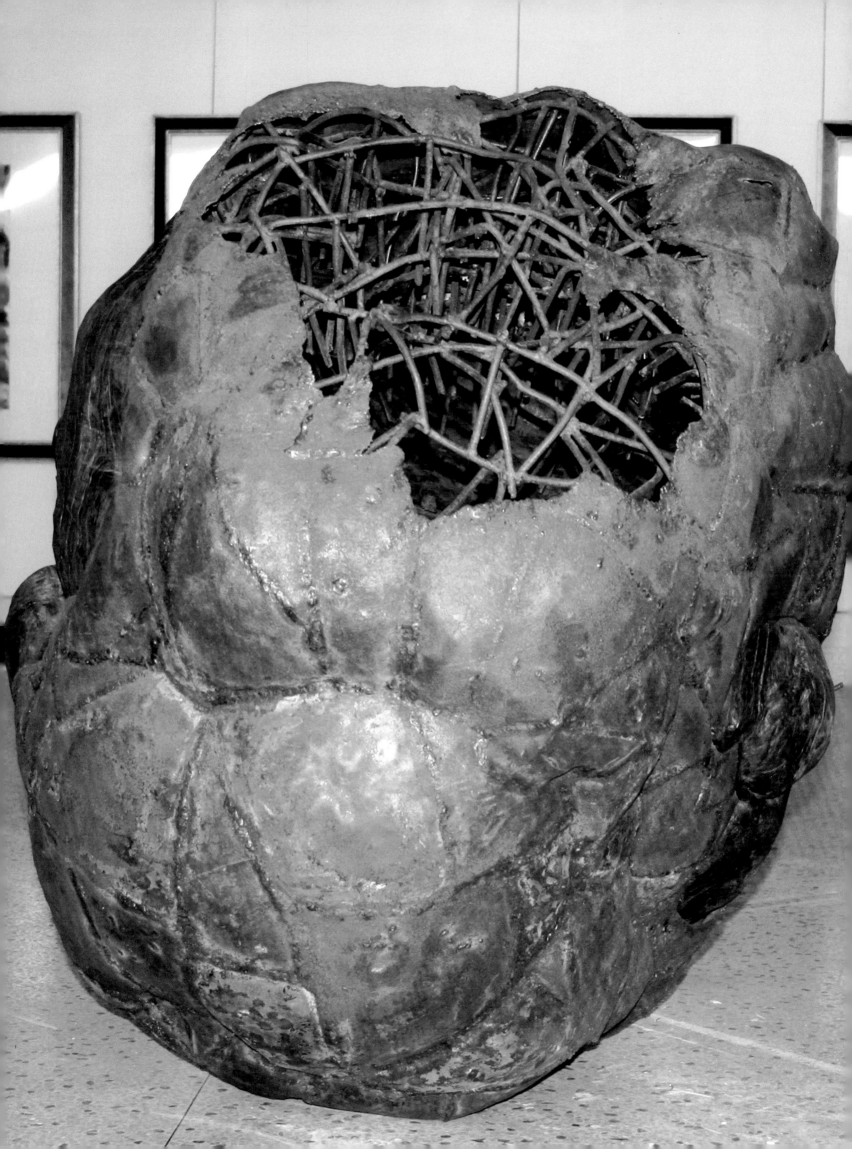

蜕变NO3（殇）

　　作品主要元素大木瘤曾经历了两次自然造化、两次创作。第一次造化是百年长成大木瘤；第二次造化是第一次创作即将完成的时候，大木瘤遭噩运被一粒小焊渣焖烧10个小时成了躯壳……几个月后，我让它重新"复活"，纳入蜕变系列。
　　这是人文的蜕变还是自然的蜕变？是人文与自然默契的经典，是劫后逢生，生命的永恒。

Metamorphosis No.3: Fantasy

　　Two huge natural gnarls are the key components of the piece, First, its natural growth through the ages, then second, its being burnt to near ruins by the tiny welding spatters from more than 10 hours during its completion… several months later, I "revived" it and included it in the Metamorphosis series.
　　Is it human metamorphosis or a natural one? It is classic of the cooperation between nature and humanity, symbolizing survival of a disaster and the permanence of life.

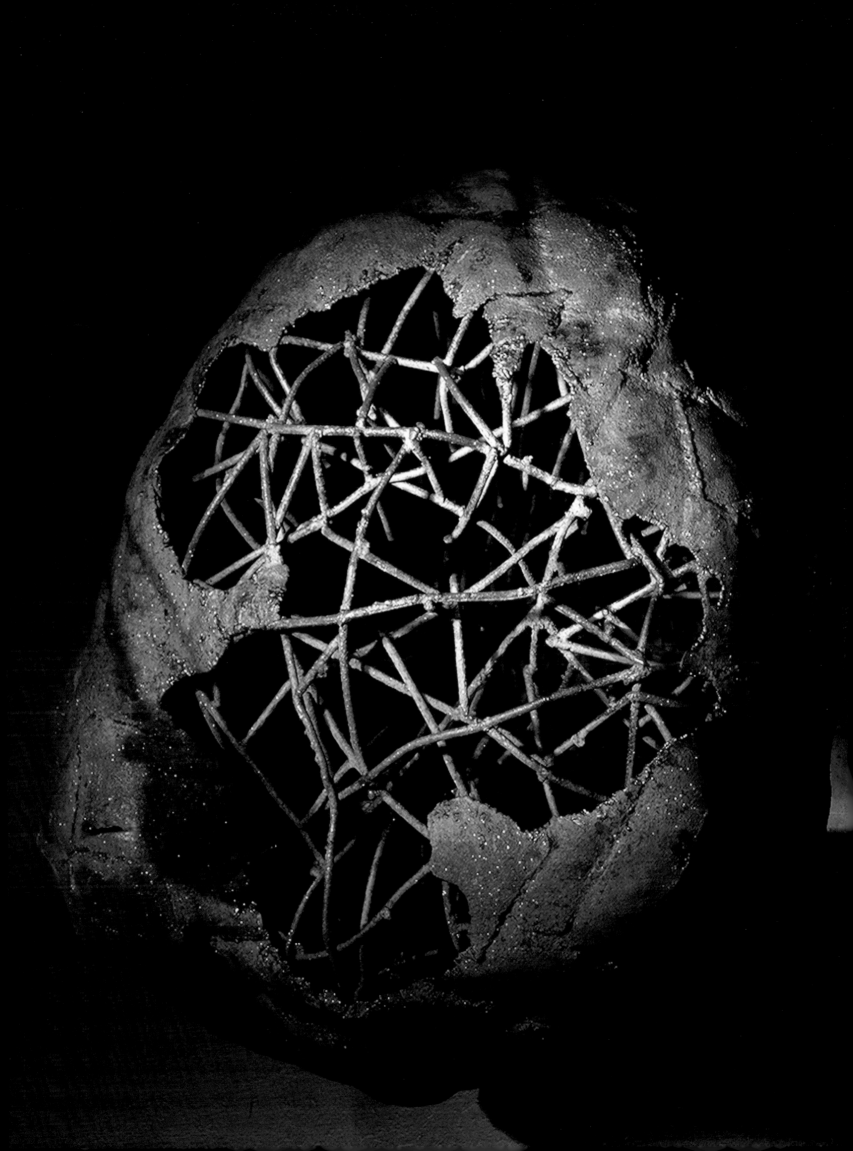

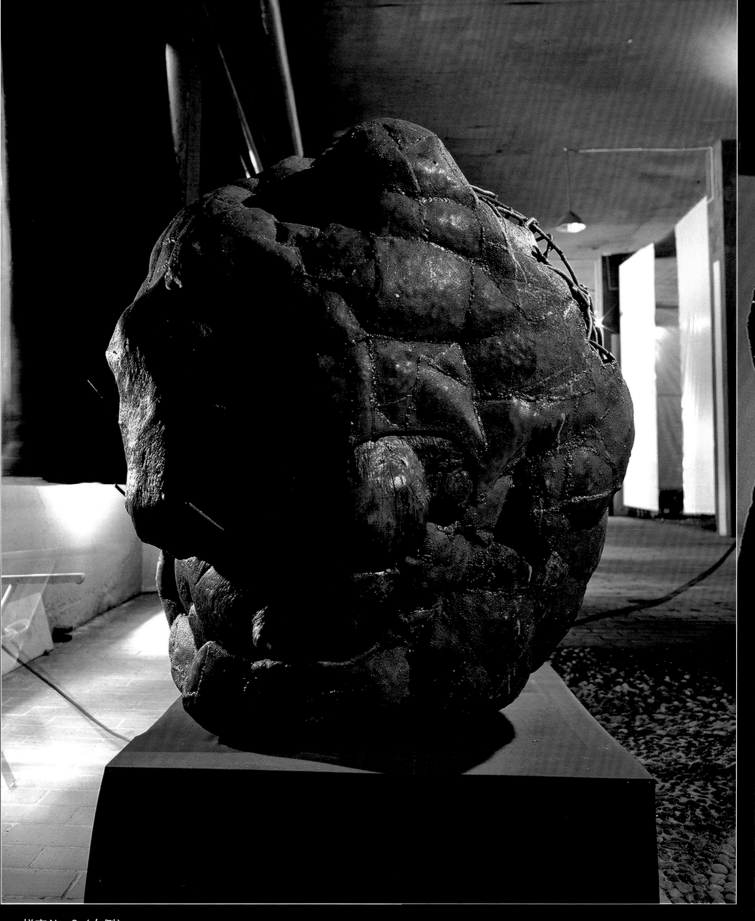

蜕变 No.3（右侧）

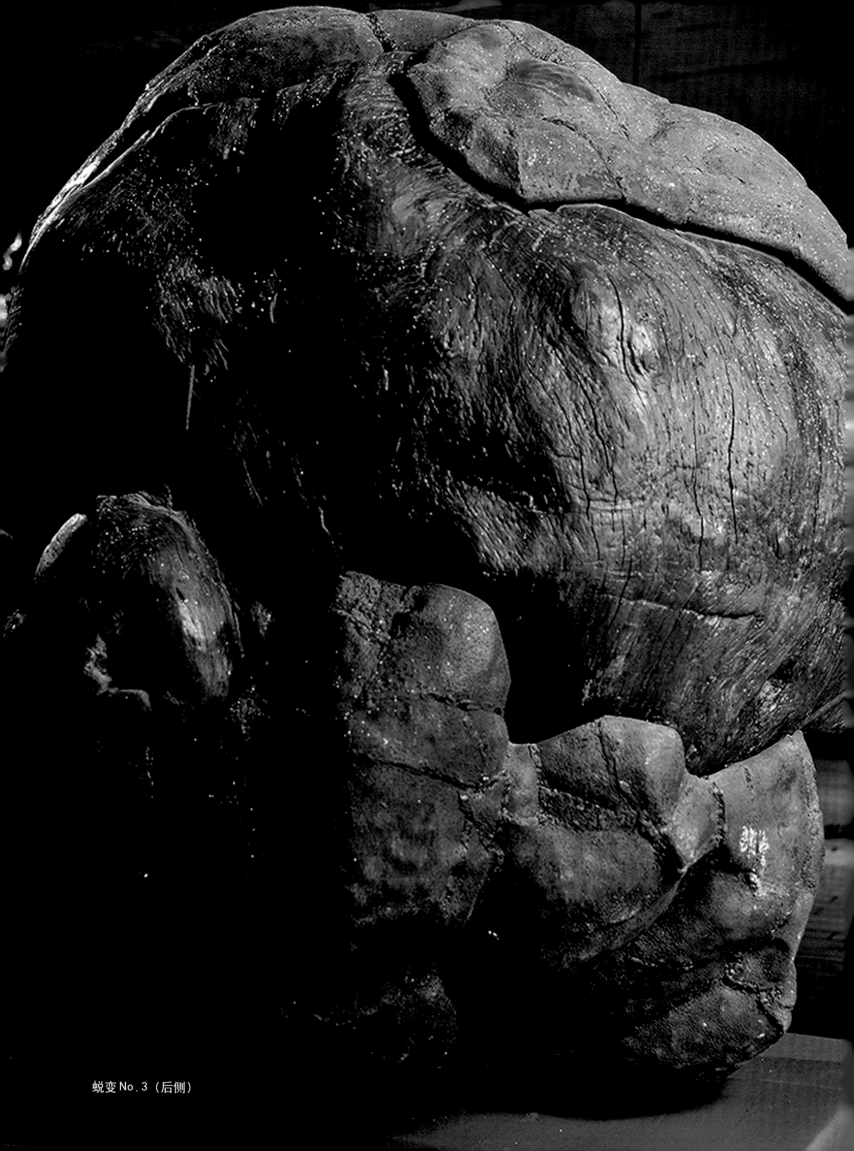

蜕变 No.3（后侧）

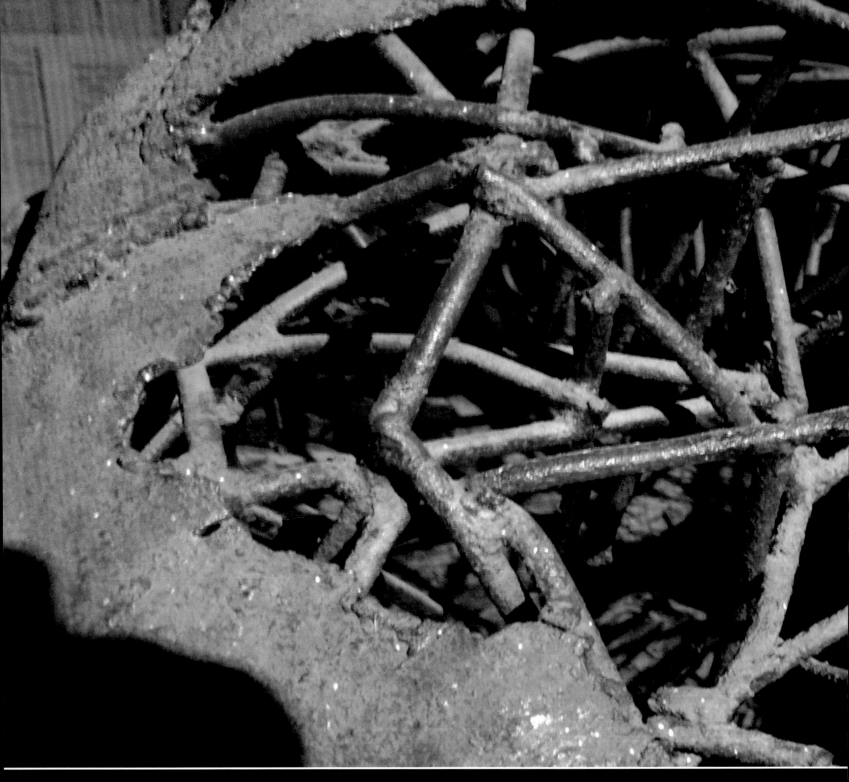

蜕变No.3（局部）

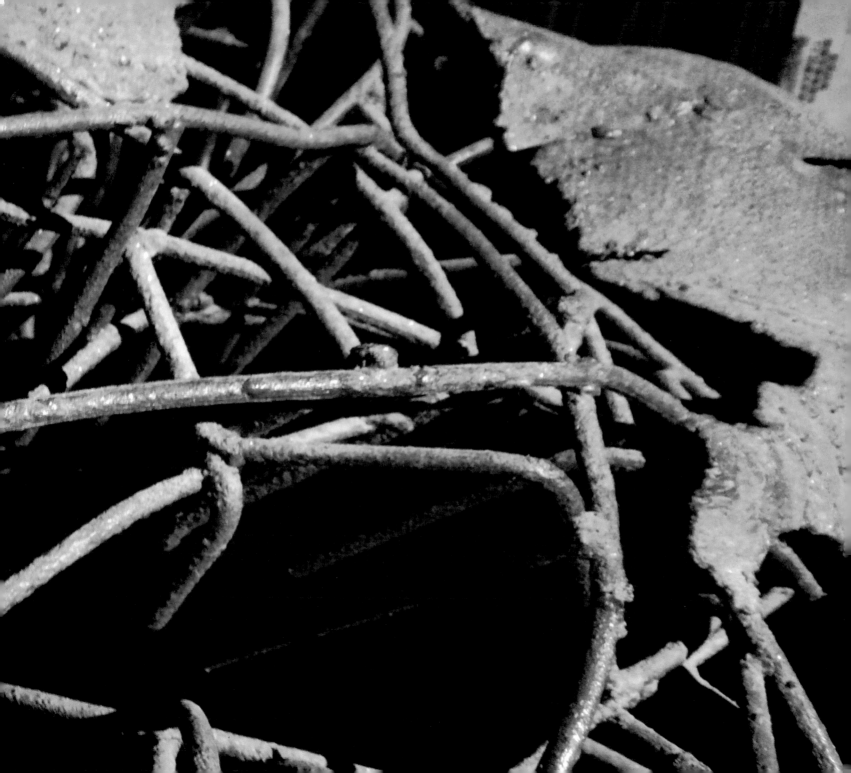

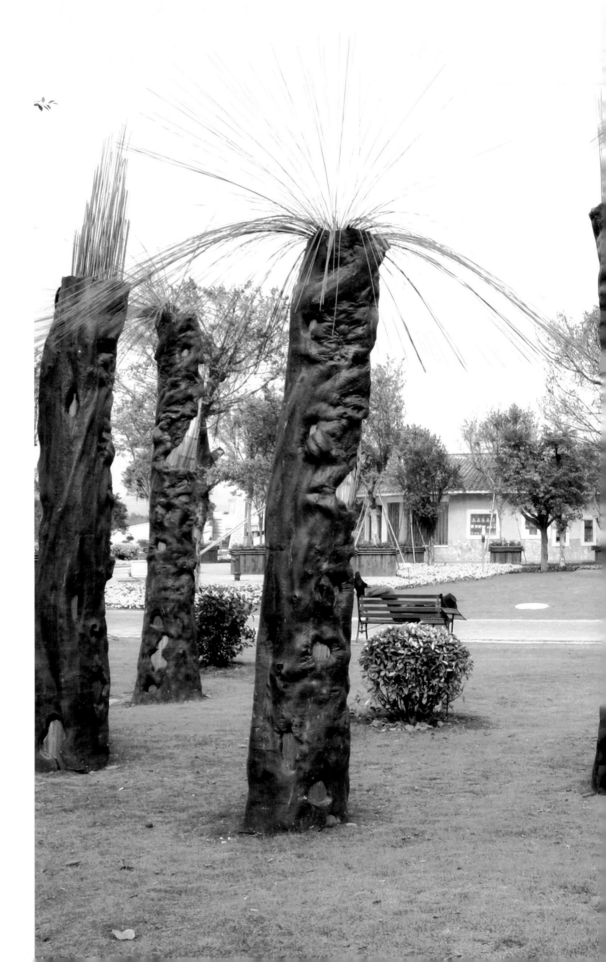

蜕变 NO 5
Metamorphosis No.5

直径／Diameter　100 × 550 cm
（单／for each）
木、树脂、不锈钢
Wood，resin，stainless steel
2006

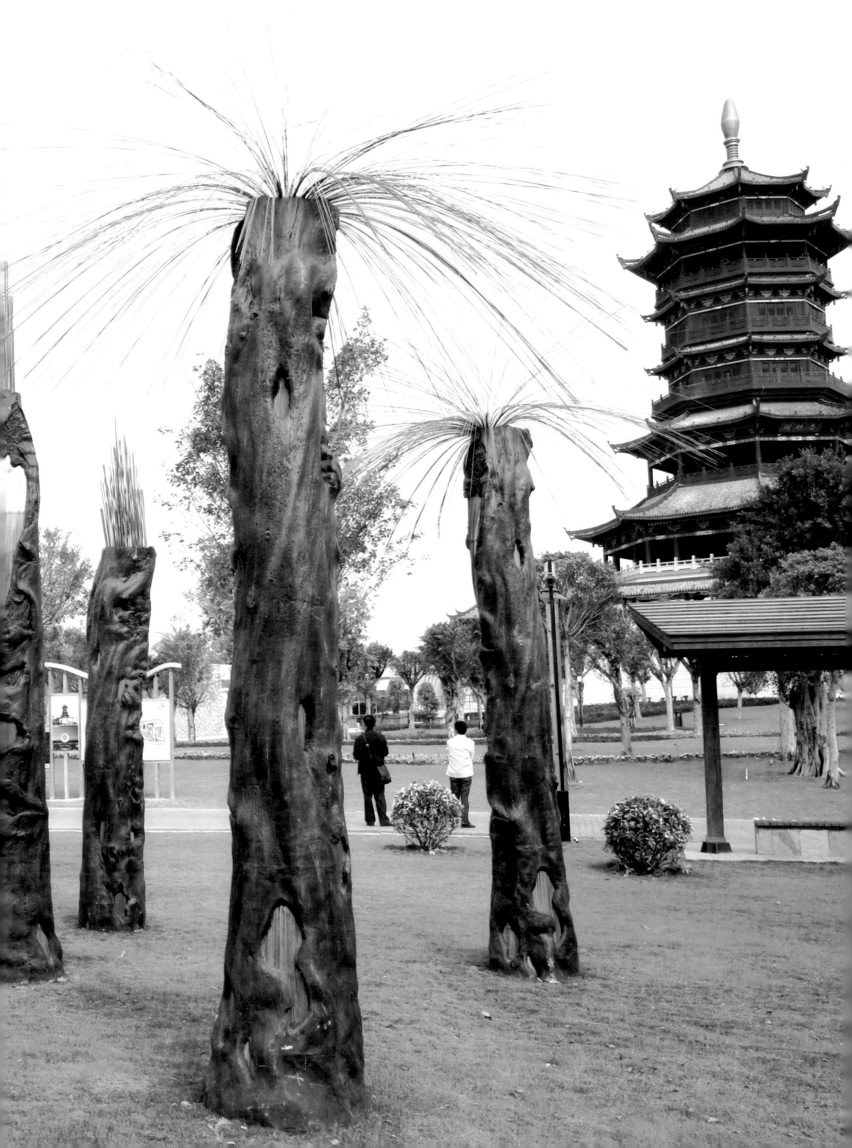

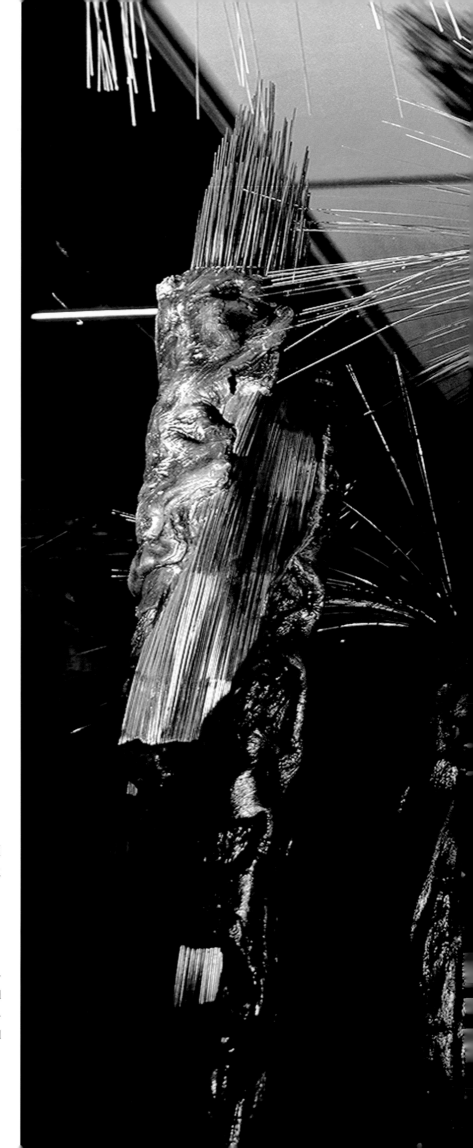

蜕变 NO5

　　生命的克隆、基因的选择……无限制的欲望驱使着生产与消费的膨胀，一种进步与负面同构的社会后果使理性秩序的信念受到破坏。

Metamorphosis No.5

　　Clone of life and the choice of genes... The unrestricted desires lead to the expansion of production and consumption, of which the social consequence is the progressive interweaving of regression. Thus, causing an end to the notion of a rational order.

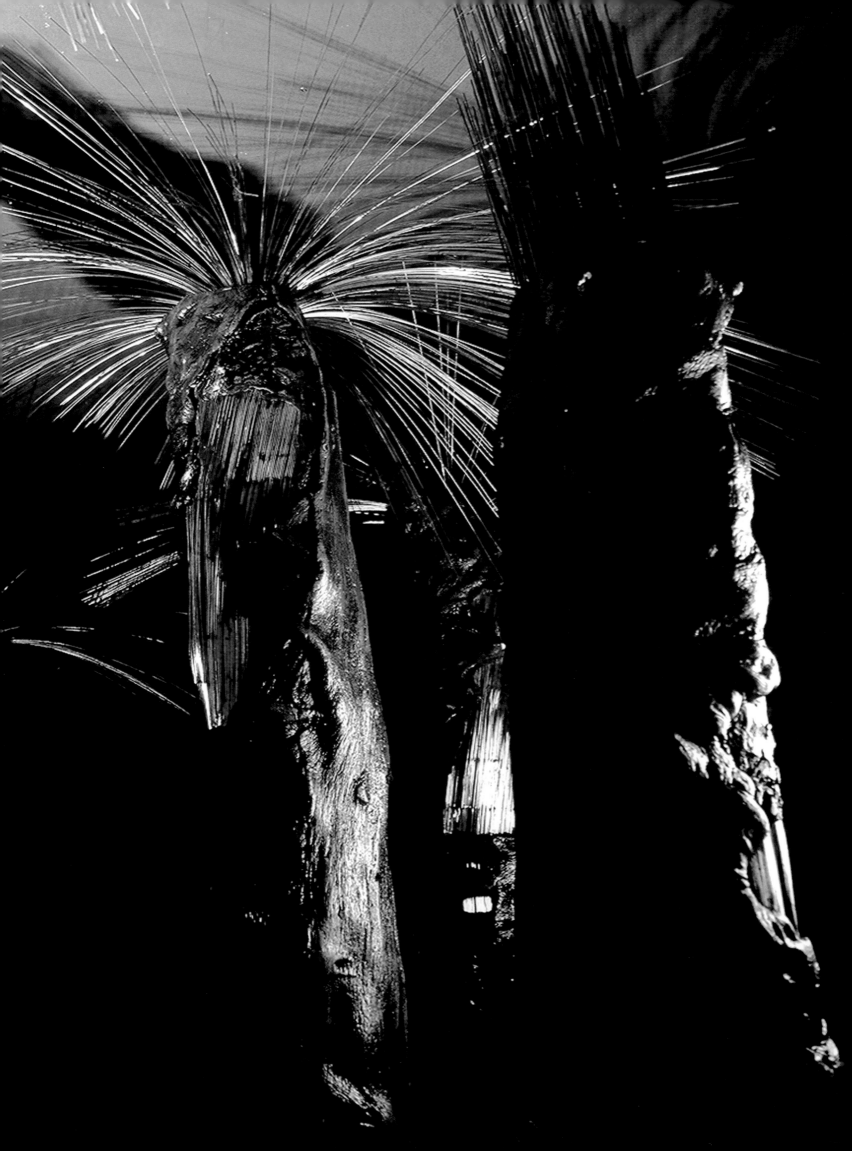

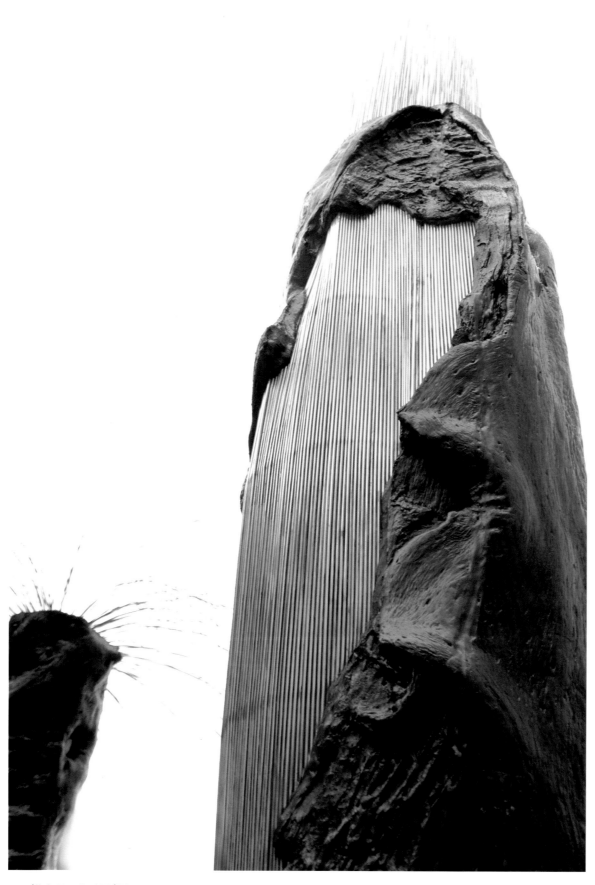

蜕变 No.5（局部）

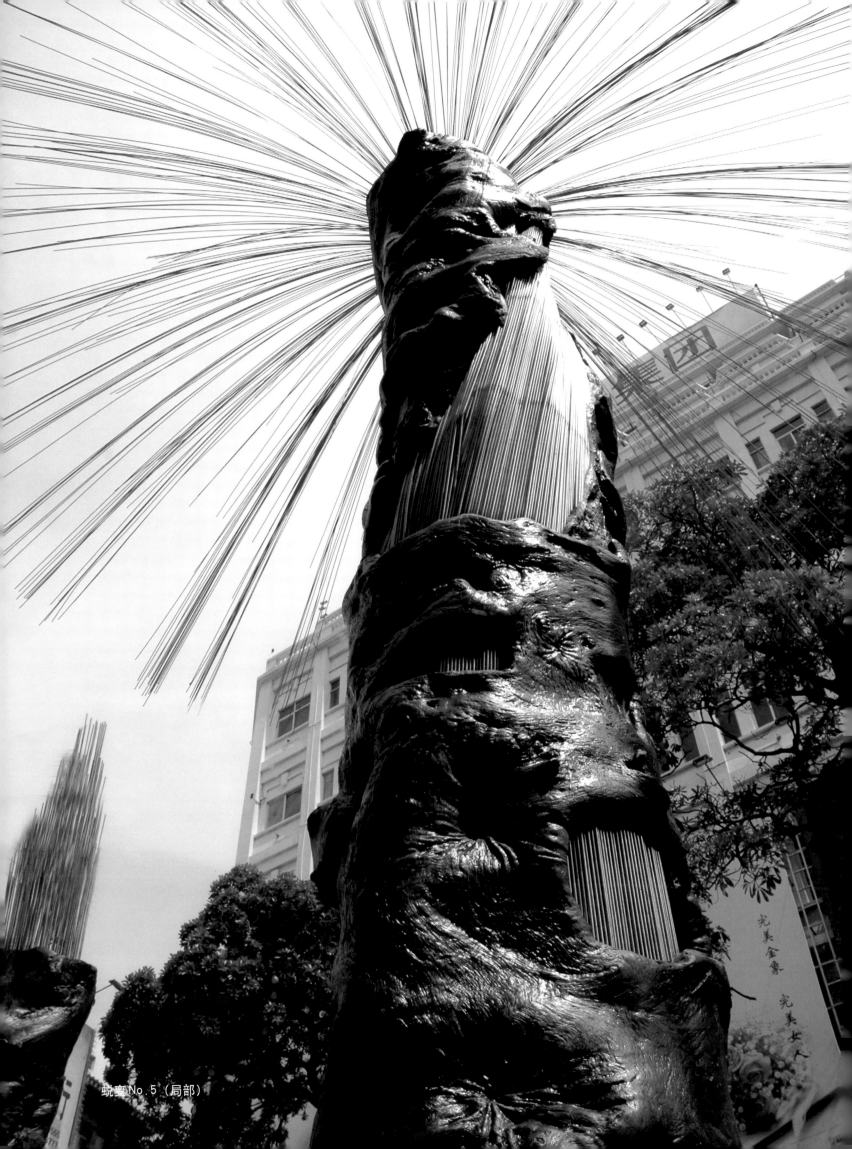

蜕变 No.5（局部）

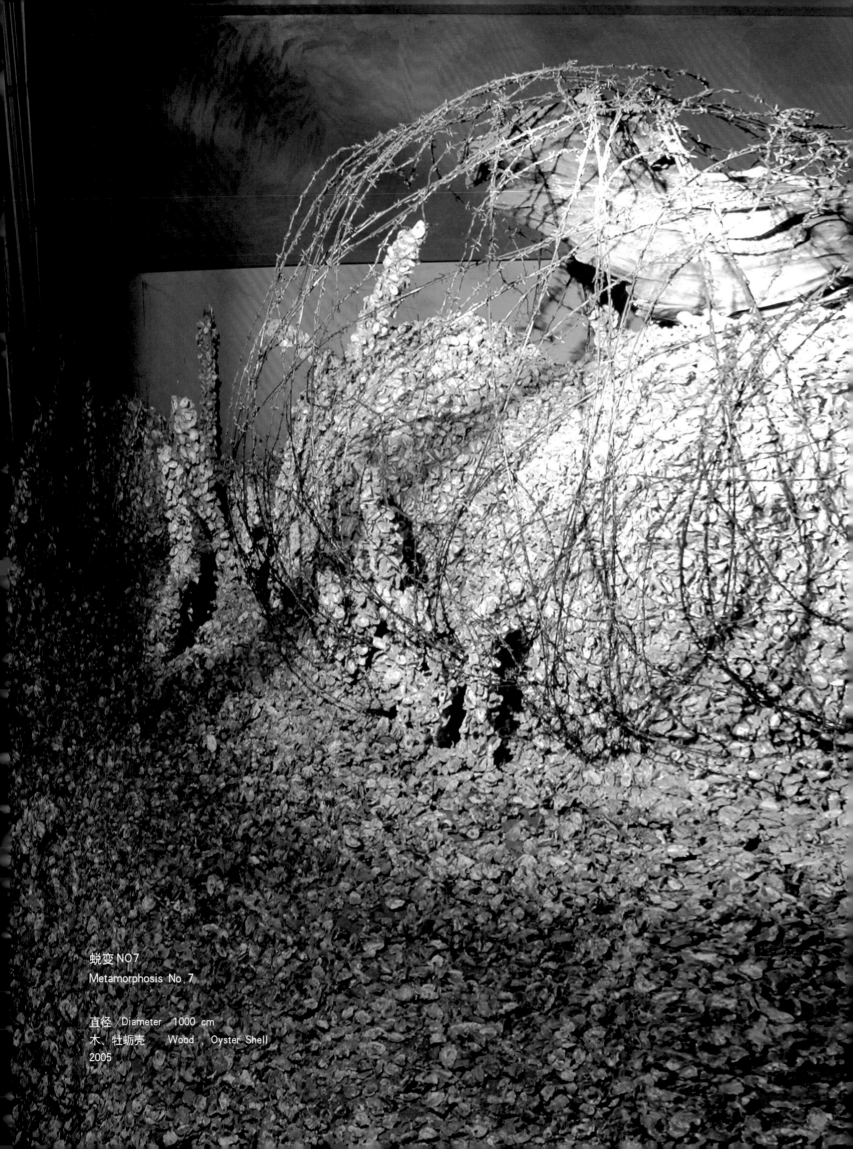

蜕变 NO7
Metamorphosis No.7

直径／Diameter 1000 cm
木、牡蛎壳 Wood , Oyster Shell
2005

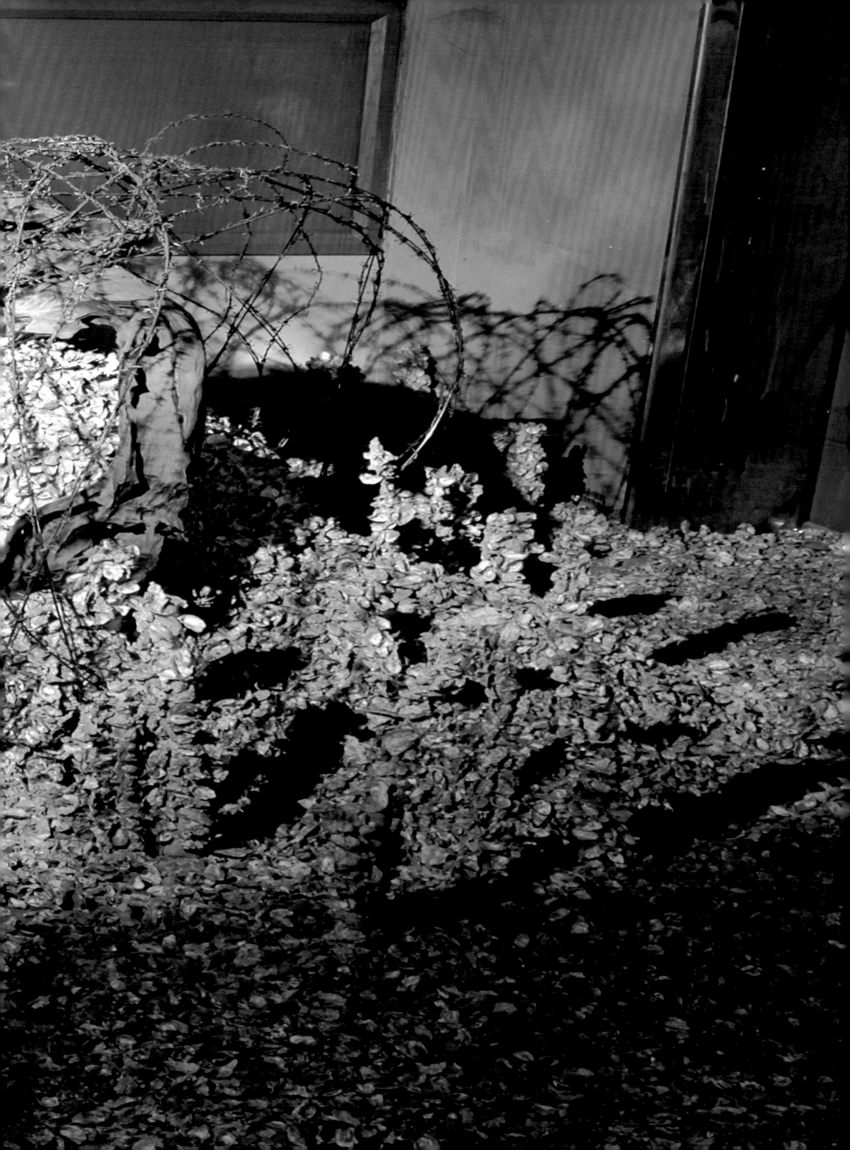

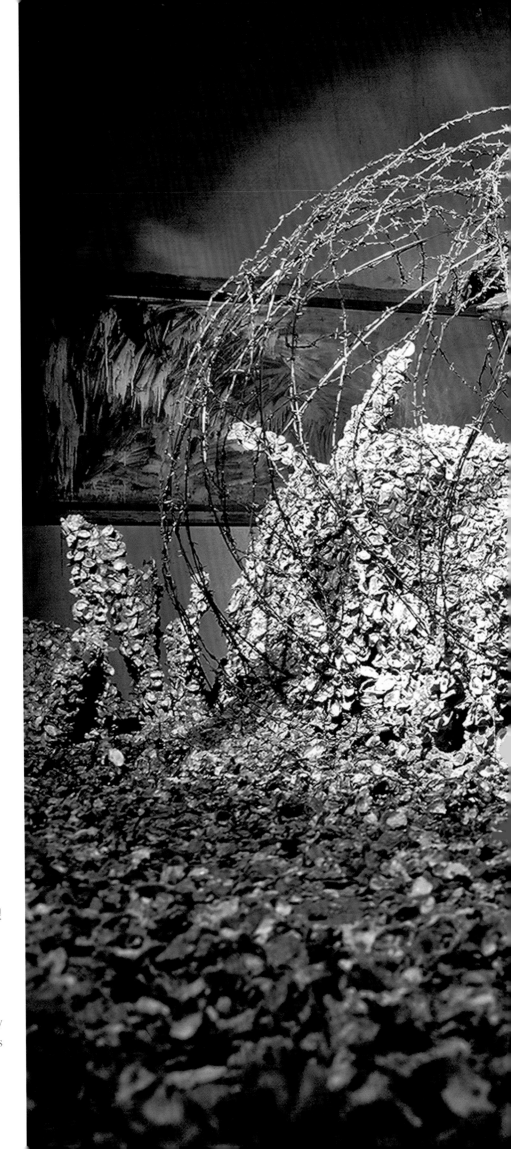

蜕变 NO7

　　荒芜、枯竭并非是命运的驱使，是欲望
编织的牢笼，禁锢了人类自身……

Metamorphosis No.7

　　Desolation and saplessness is not driven by
the so-called fate; it is the cage woven by desires
that imprisons human beings themselves.

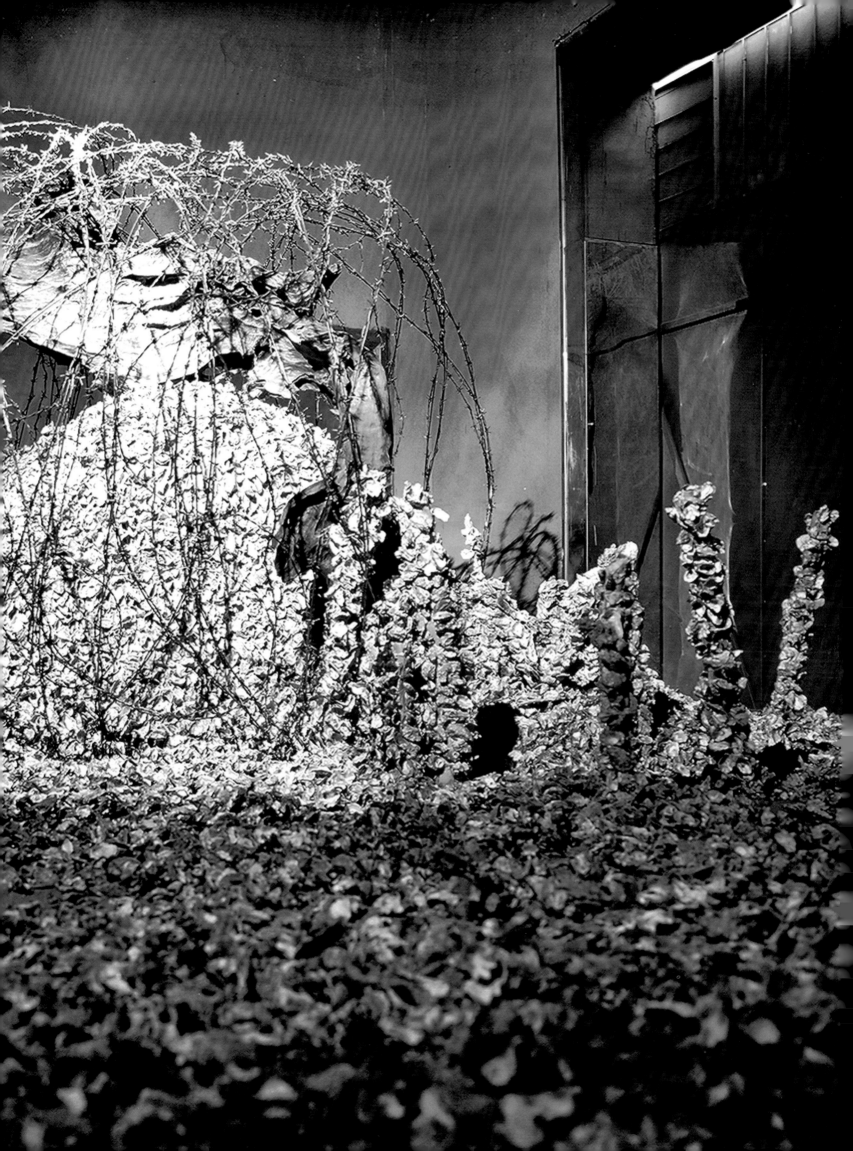

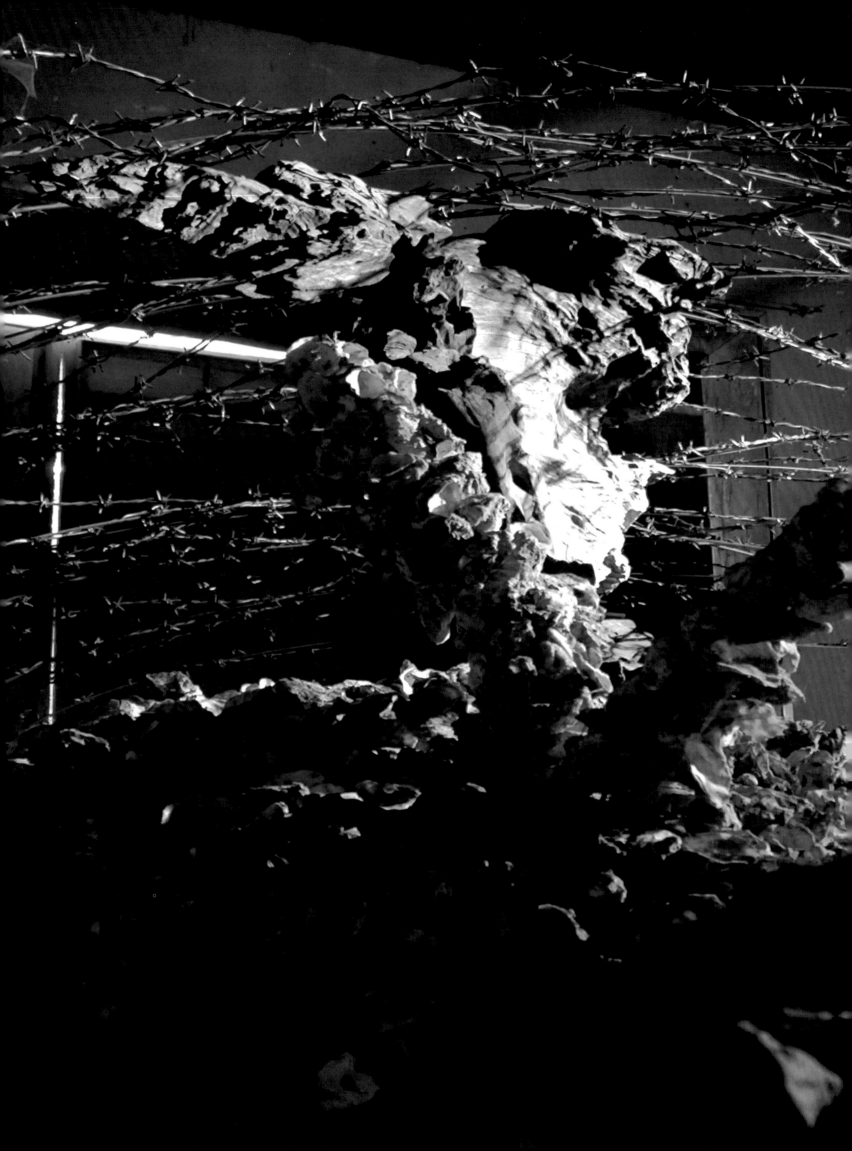

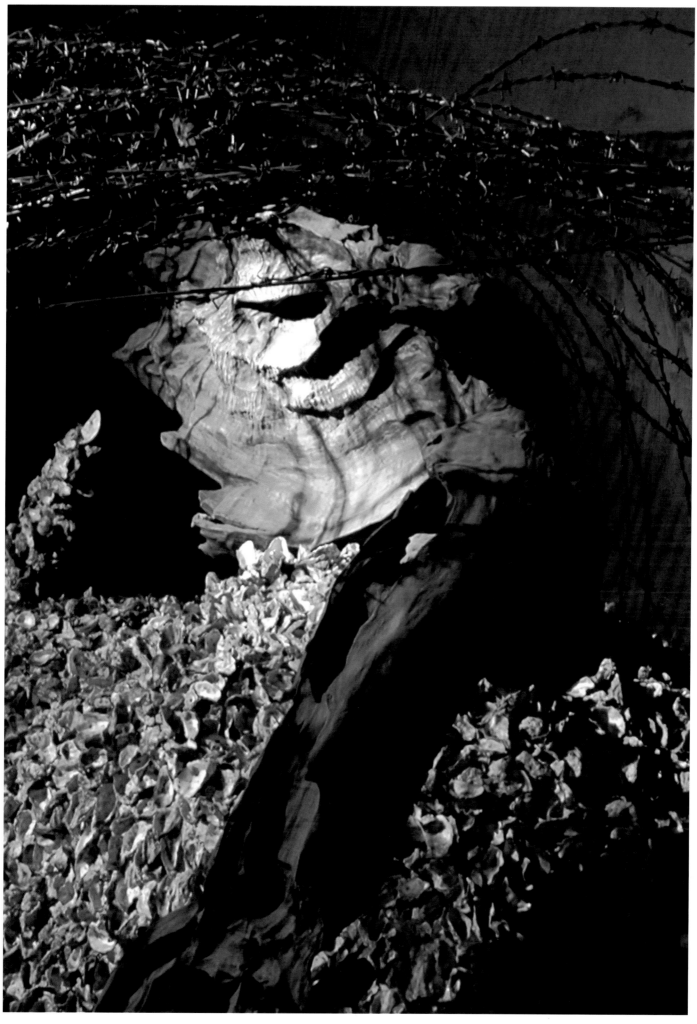

蜕变 No.7（局部）

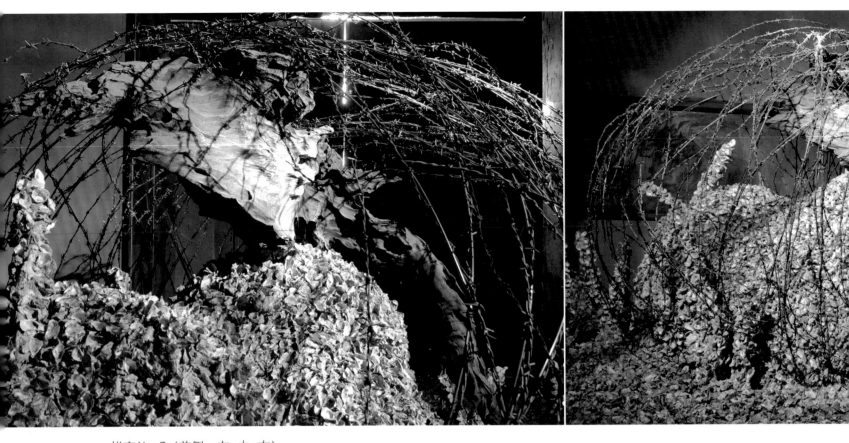

蜕变No.7（前侧：左 中 右）

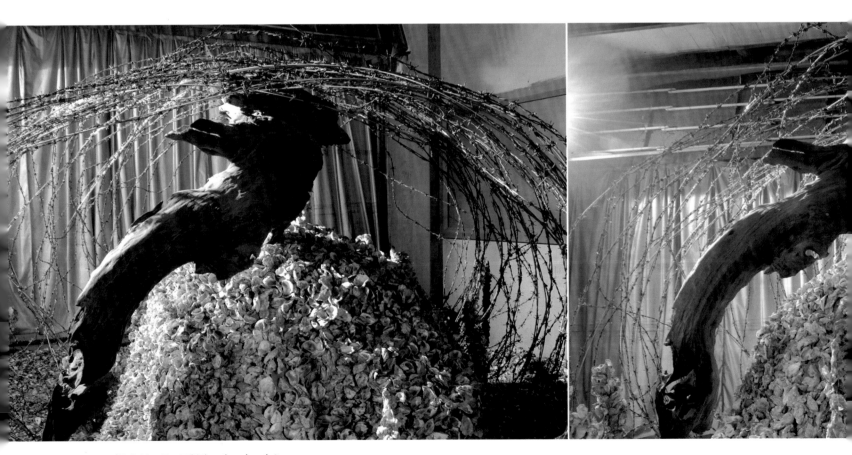

蜕变No.7（后侧：左 中 右）

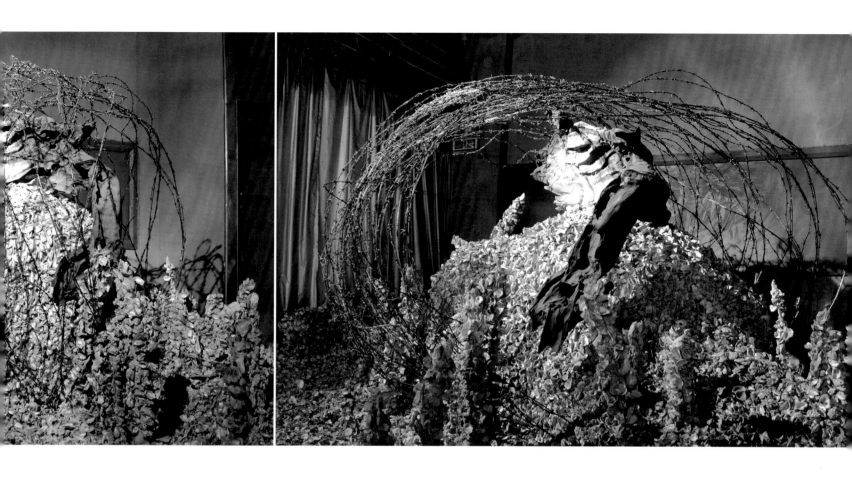

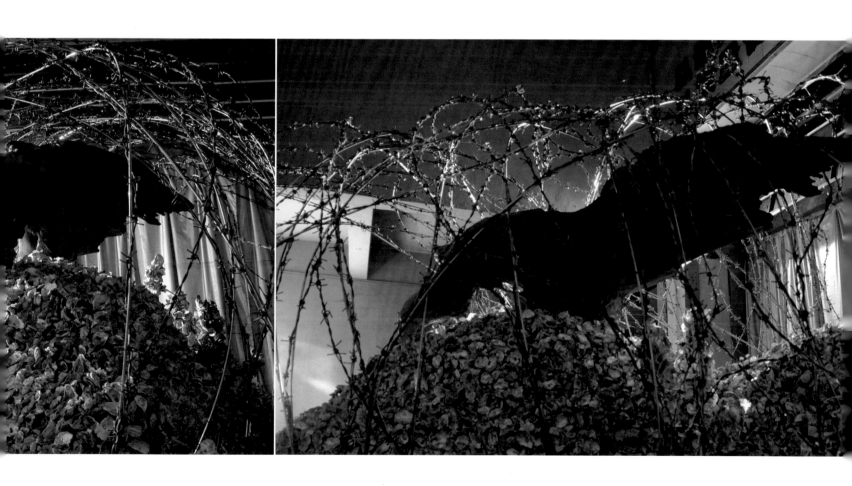

穿 行 系 列

我喜欢从一种形式的角度去体现出某种原始的力量，
那是一种自由生活的生存空间，
它包含着诸多的个人情感和意志，
在现实的繁华与浊流中，
穿行到另一个精神的心灵世界。
从《穿行》作品中我发现了自我与宇宙，
更印证人生的玄奥与困惑。

Voyage Series

I enjoy revealing certain primitive power by way of certain form.
It is a living space for free life,
comprising a multitude of personal sentiments and wills,
allowing one to cross through the current of prosperity
and turbid of reality to a spiritual world.
From the Voyage series, I see the real me and the universe,
and further verify the abstruseness and perplexity characteristics of life.

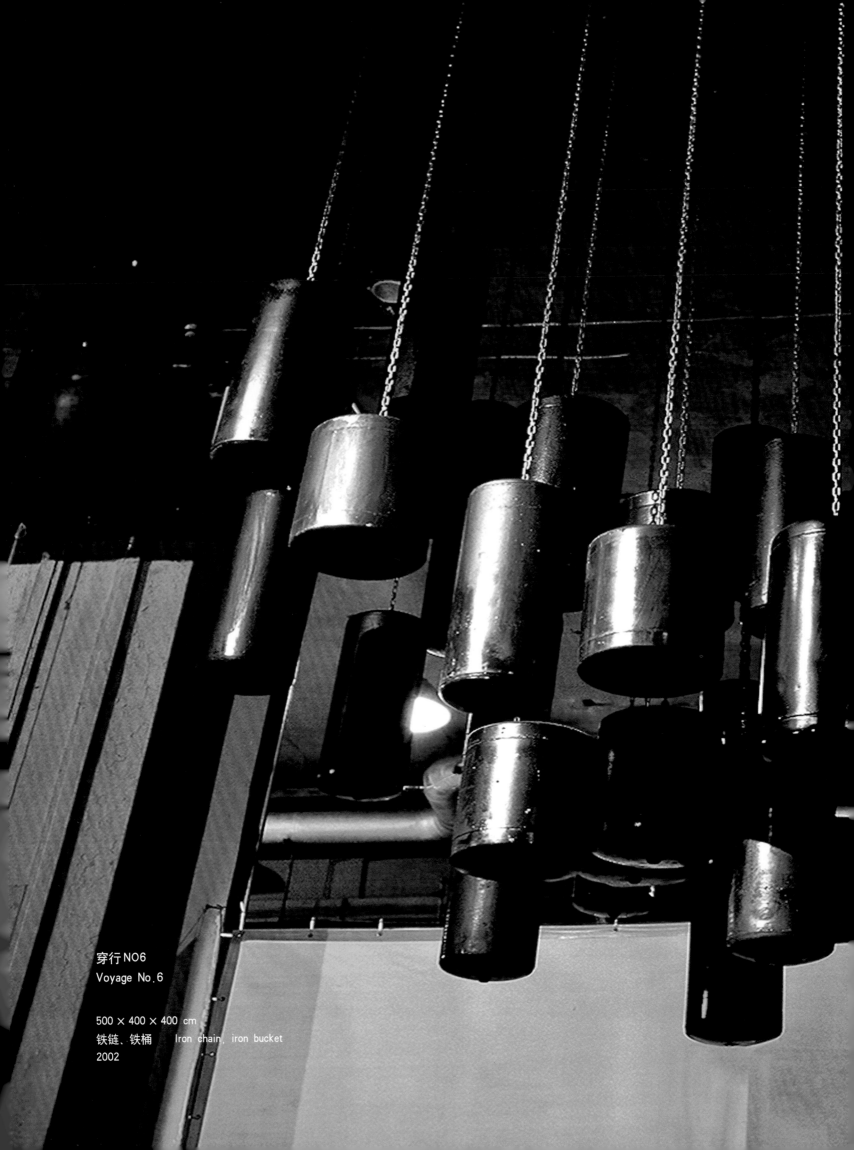

穿行NO6
Voyage No.6

500 × 400 × 400 cm
铁链、铁桶 Iron chain, iron bucket
2002

穿行NO6

　　用抽象的手法抽离东、西方文化中击打乐器和
管弦乐器真实形象的具体细节，强化构成元素的精
神效果，力创宇宙气场中的"和音"。

Voyage No. 6

　　With specific details of actual percussion, wind and
string instruments from eastern and western cultures, I
used this in an abstract sense, to reinforce the spiritual
effect of the components, which is the aim of the piece and
to strike a "harmonious tune" in the universe.

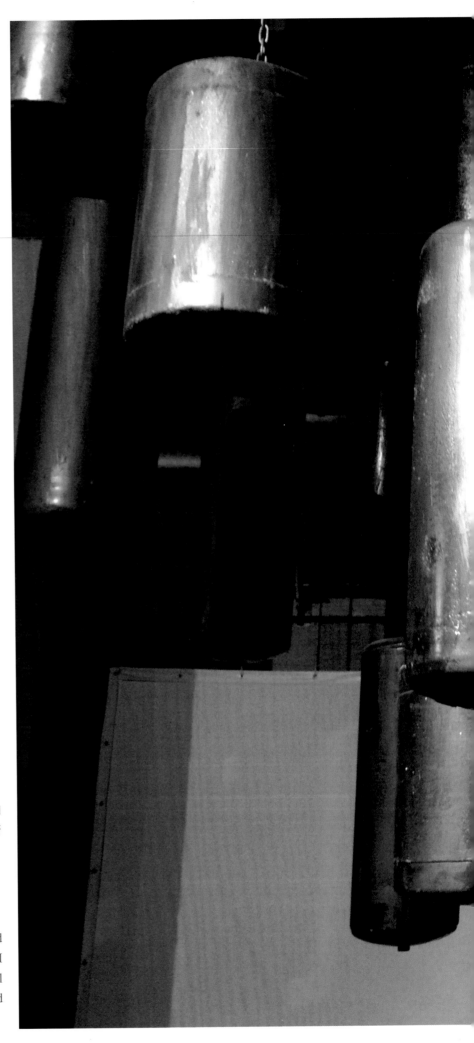

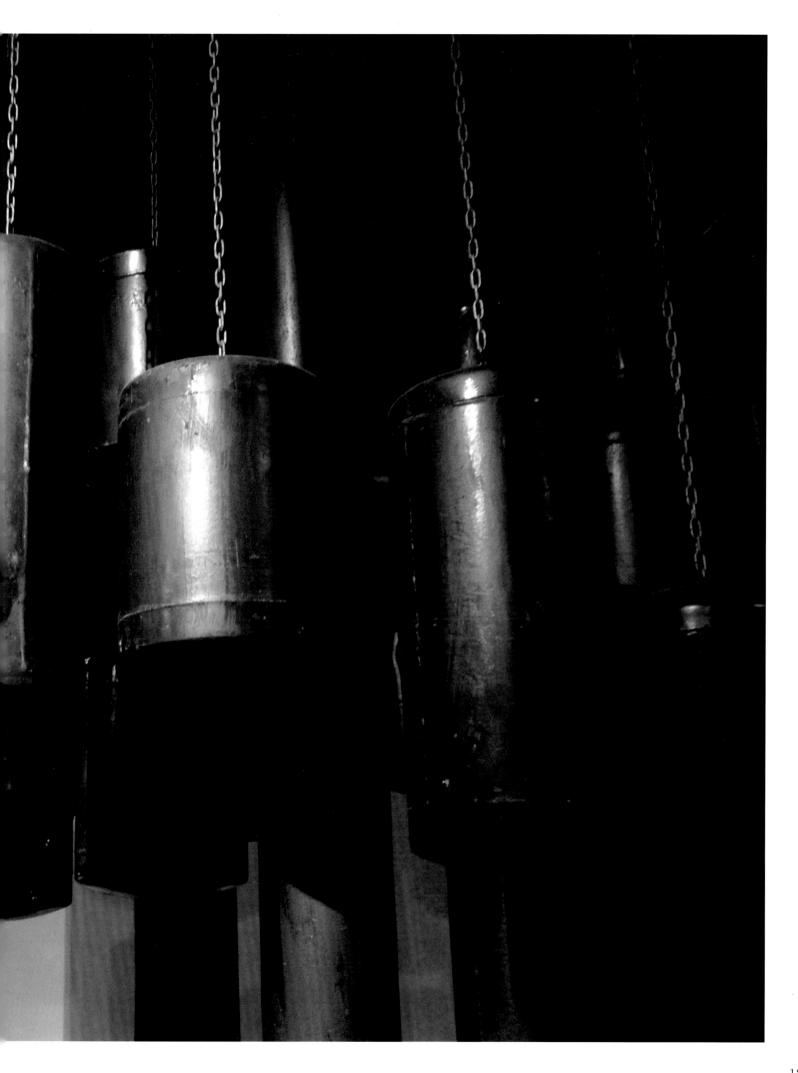

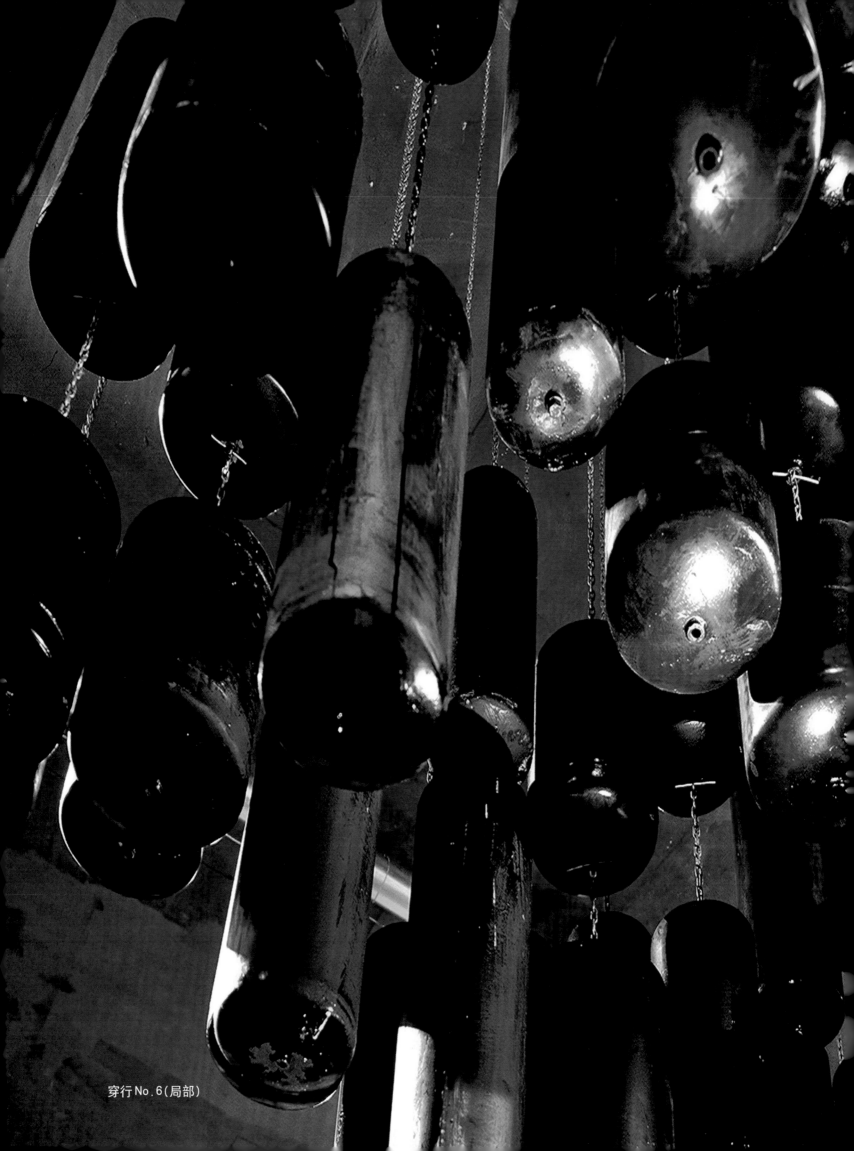

穿行 No.6（局部）

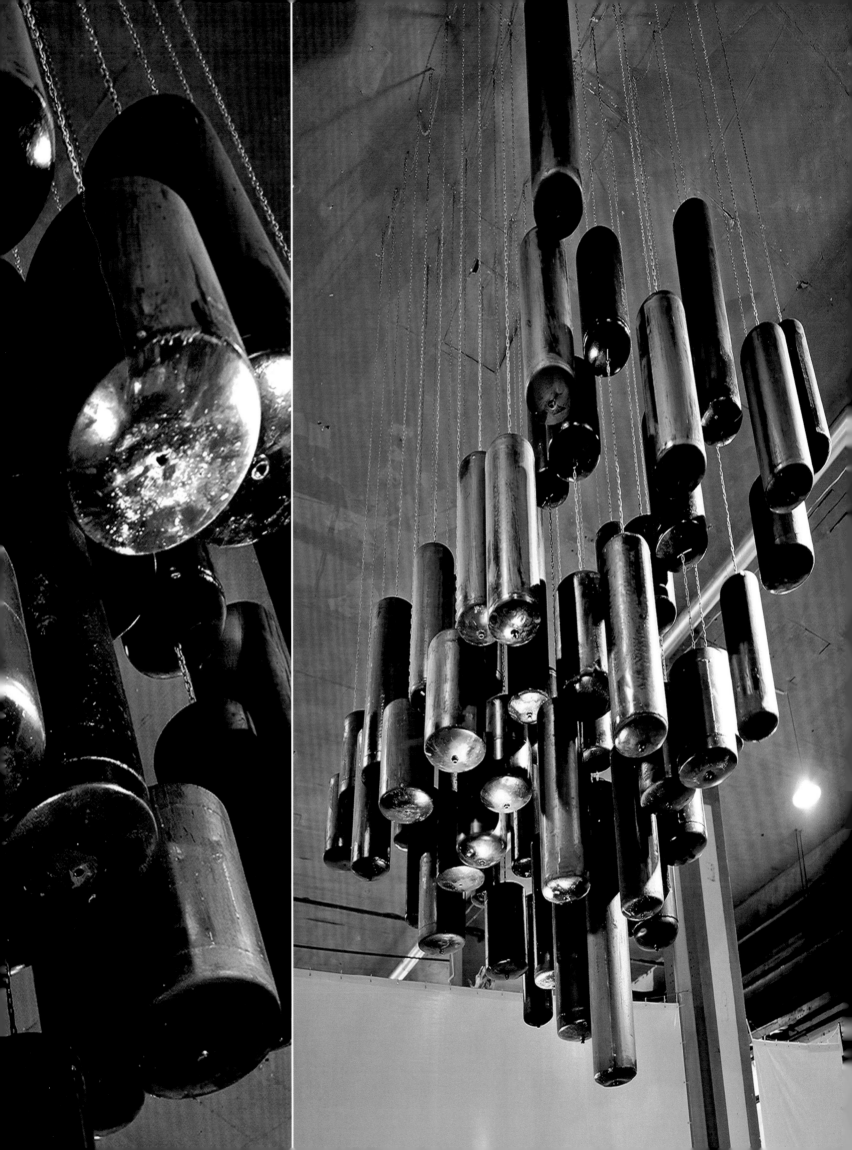

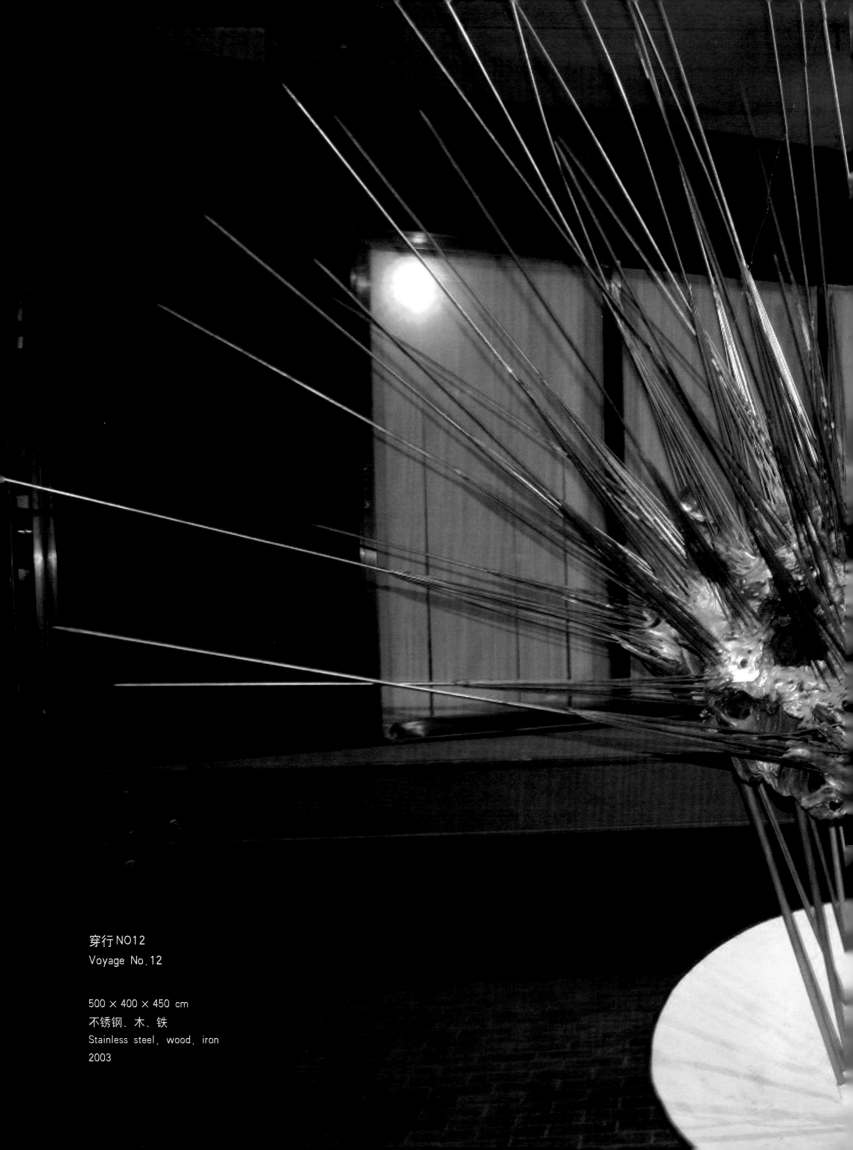

穿行 NO12
Voyage No.12

500 × 400 × 450 cm
不锈钢、木、铁
Stainless steel, wood, iron
2003

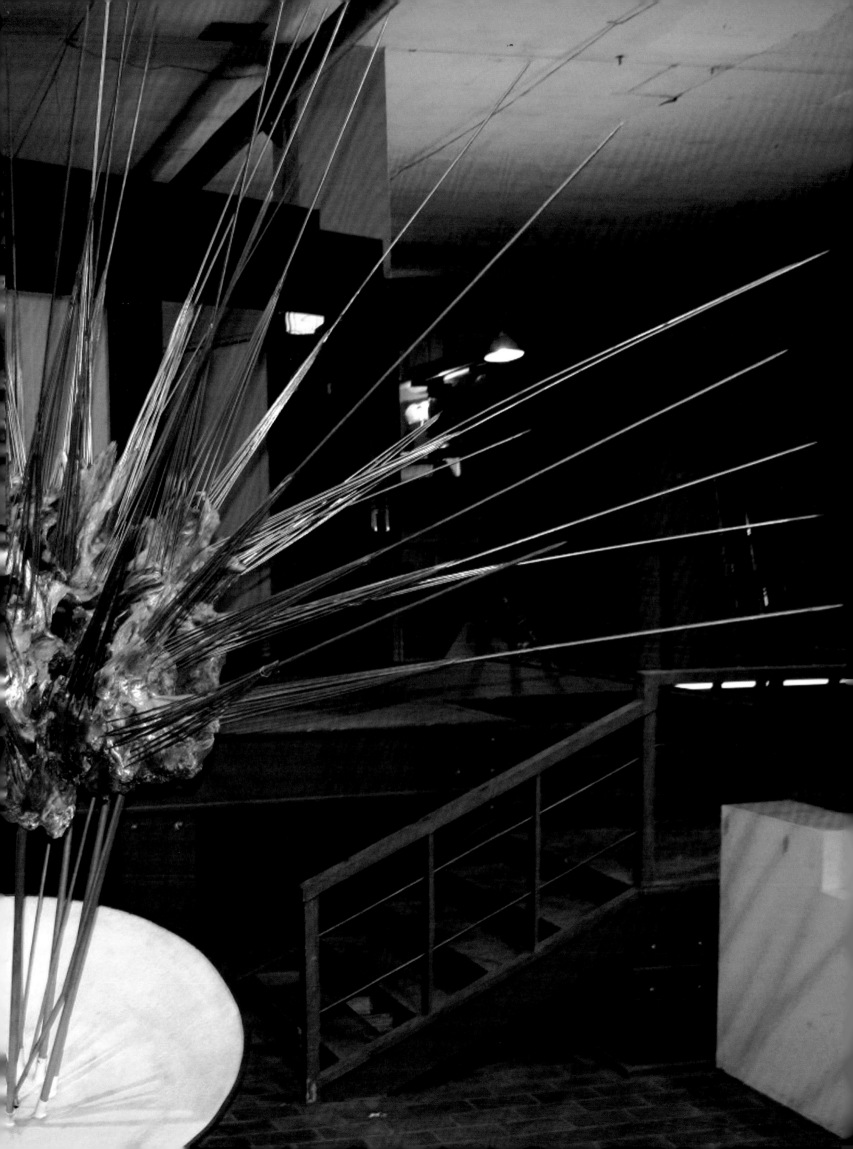

穿行NO12

　　借助穿越时空扩张与收缩的物质现象，表现"海纳百川，有容乃大"的气魄与胸襟。

Voyage No. 12

　　Referring to material expansion and contraction that transcends time and space, this piece is meant to express the great liberality and wonderful tolerance of the vast sea.

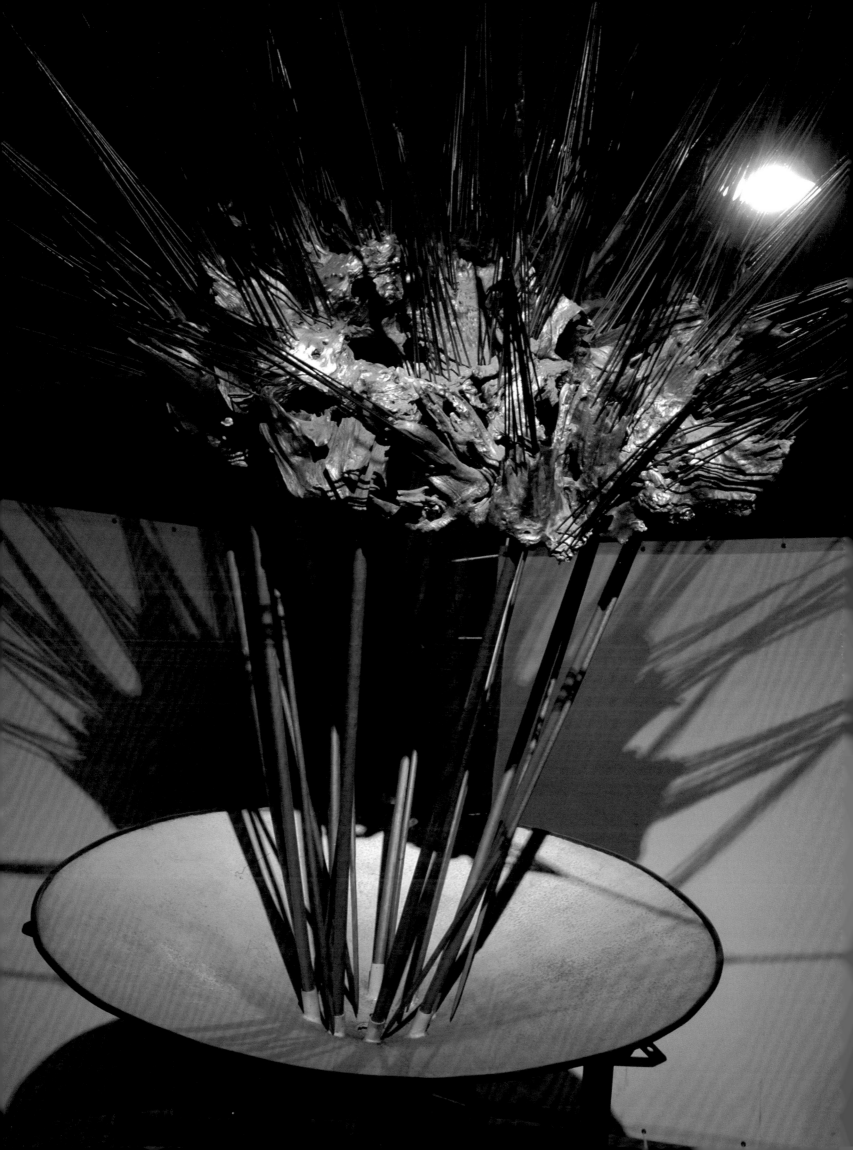

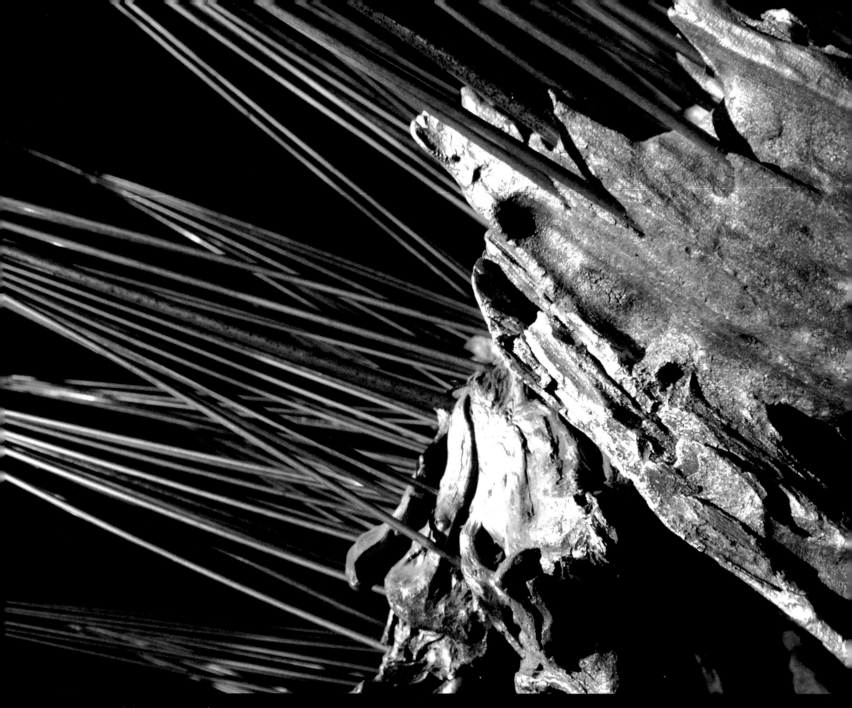

穿行No.12（局部）

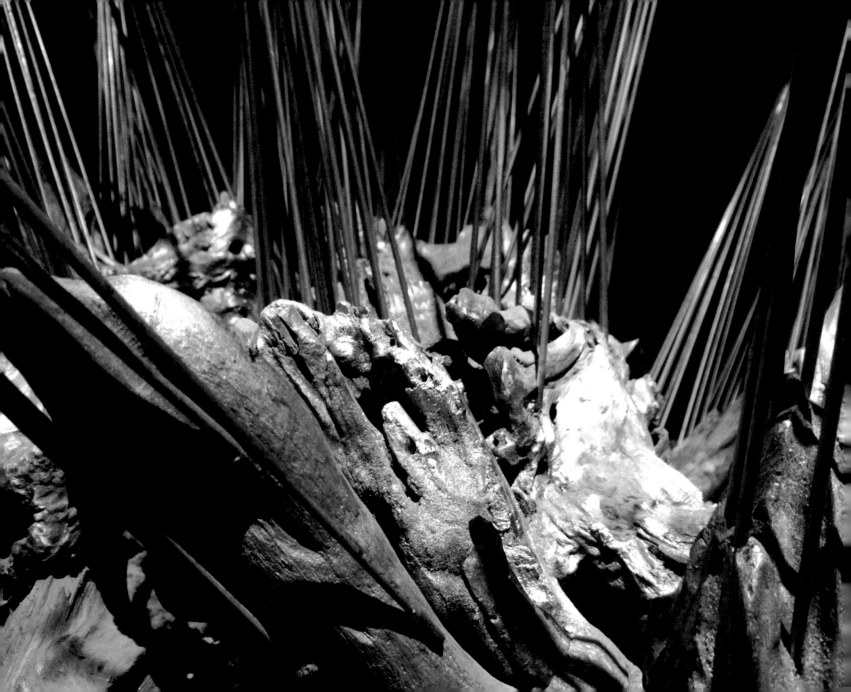

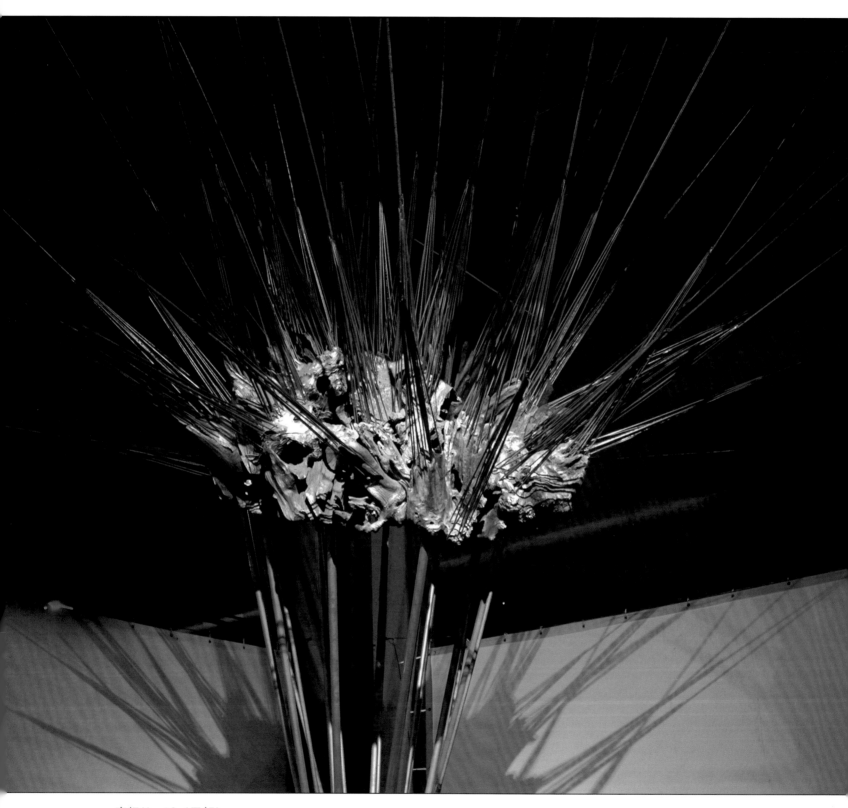

穿行No.12（局部）

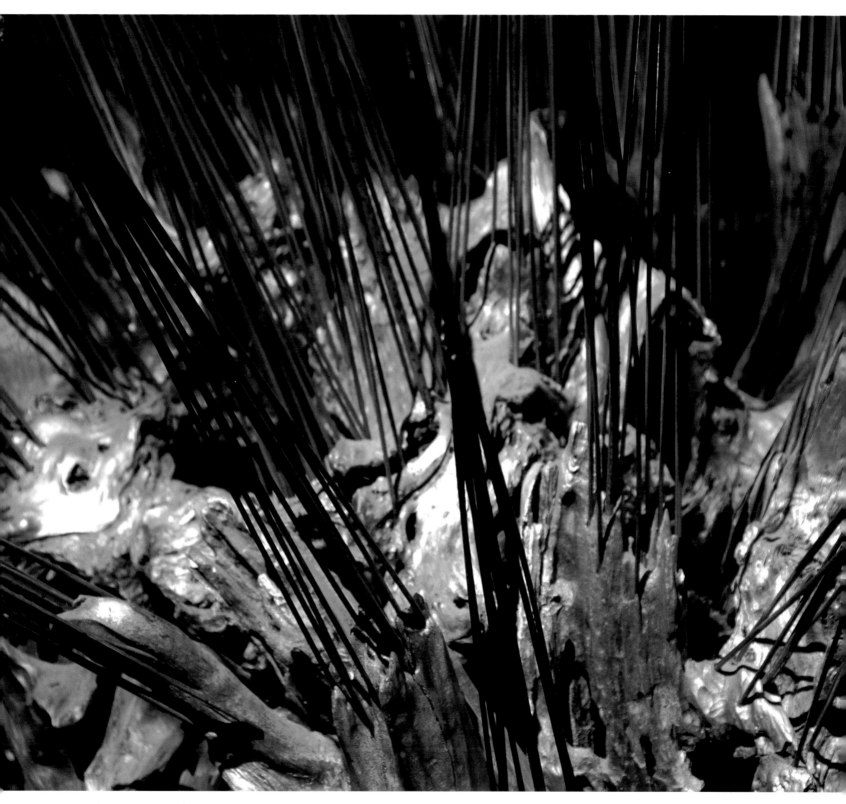

穿行No.12（局部）

穿行 NO19
Voyage No.19

450 × 300 × 150 cm
树杆、钢丝绳、钢管
Branches, wire ropes, steel pipes
2005

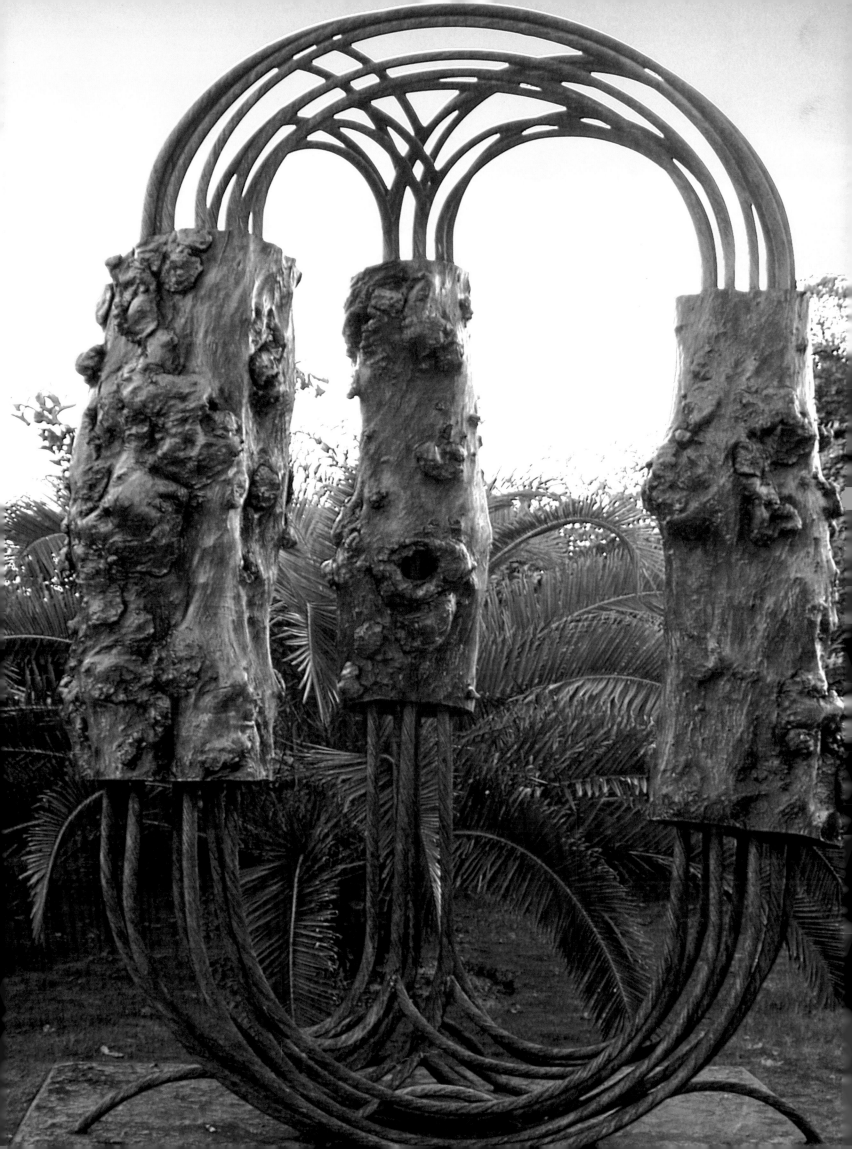

穿行NO19

　　岁月时光的流淌，留下了成熟的印记，生命的轮回运动，在风驰电骋中熠熠生辉。

Voyage No. 19

　　Flow of time imposes maturity upon human beings while the samsara of life shines in the instantaneous flash.

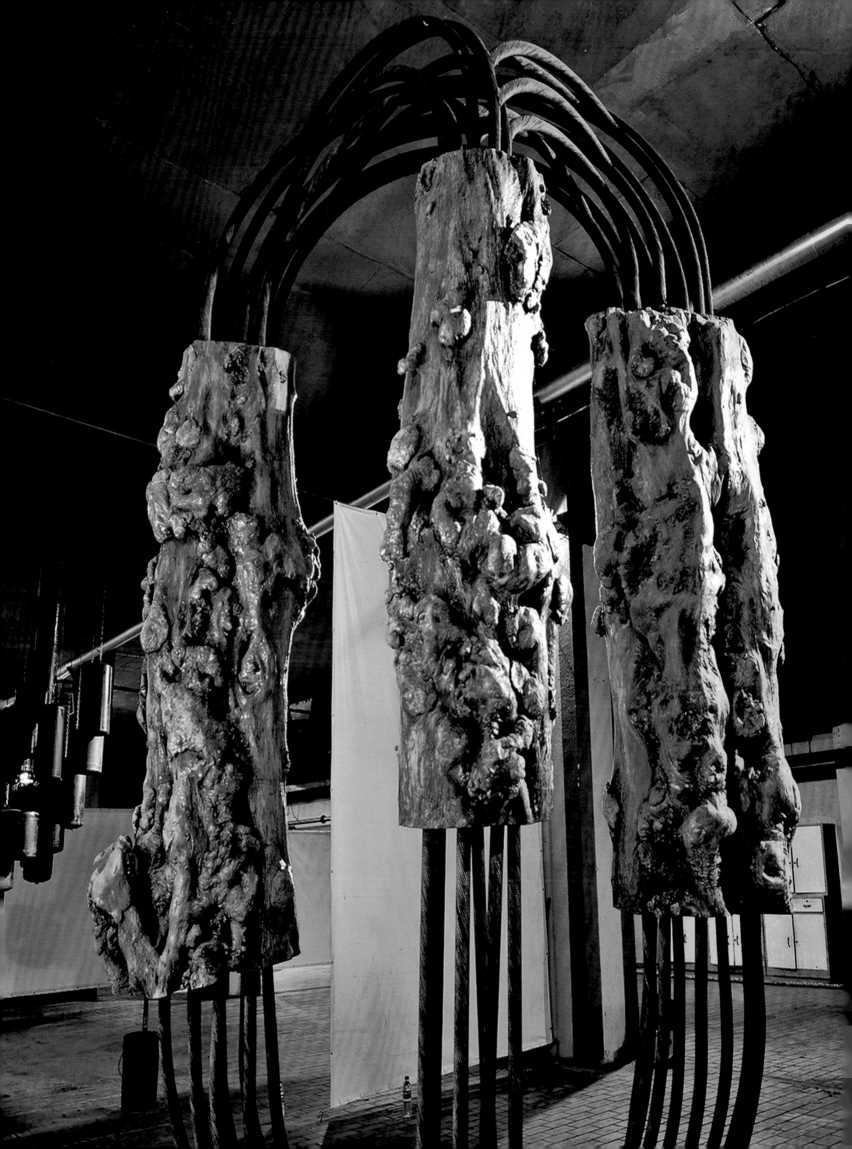

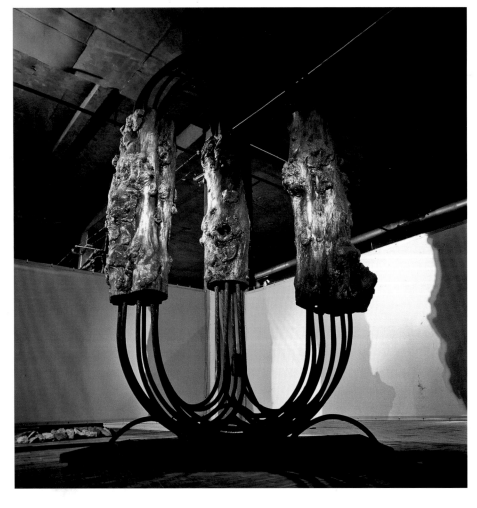

穿行No.19

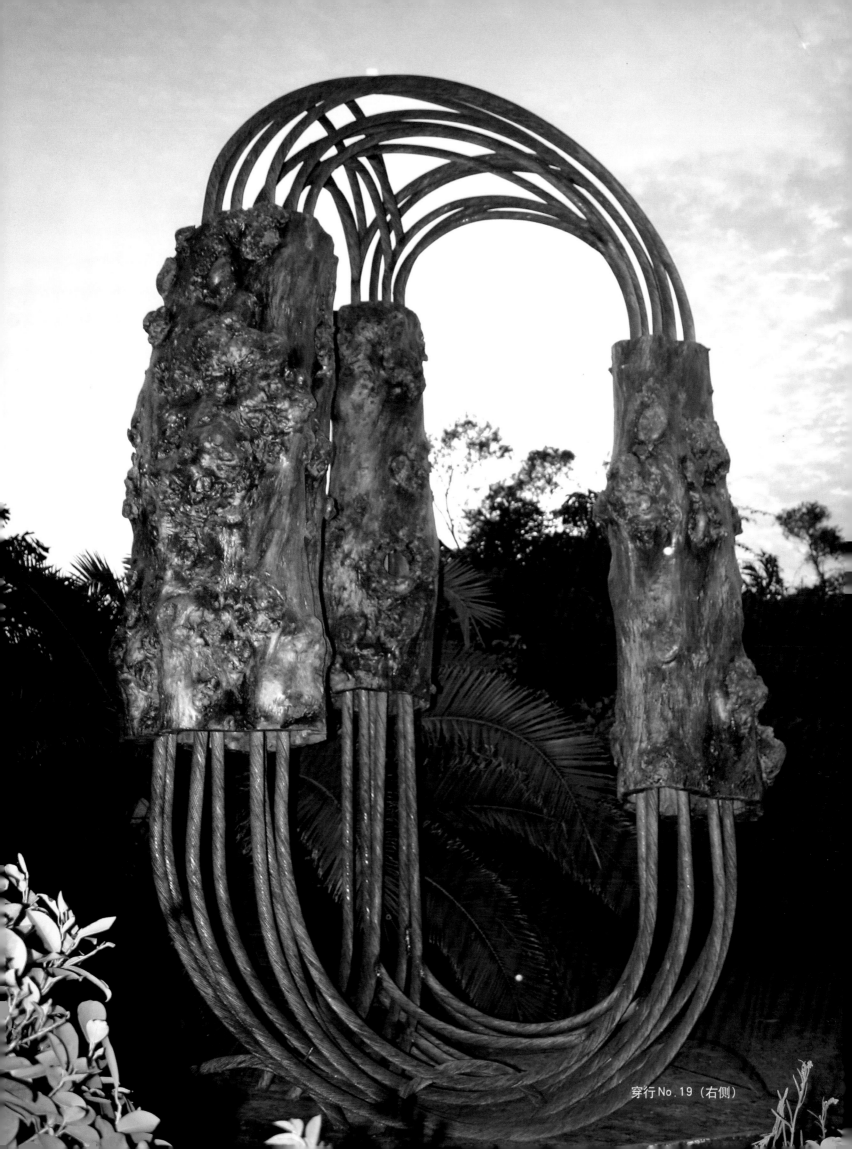

穿行No.19（右侧）

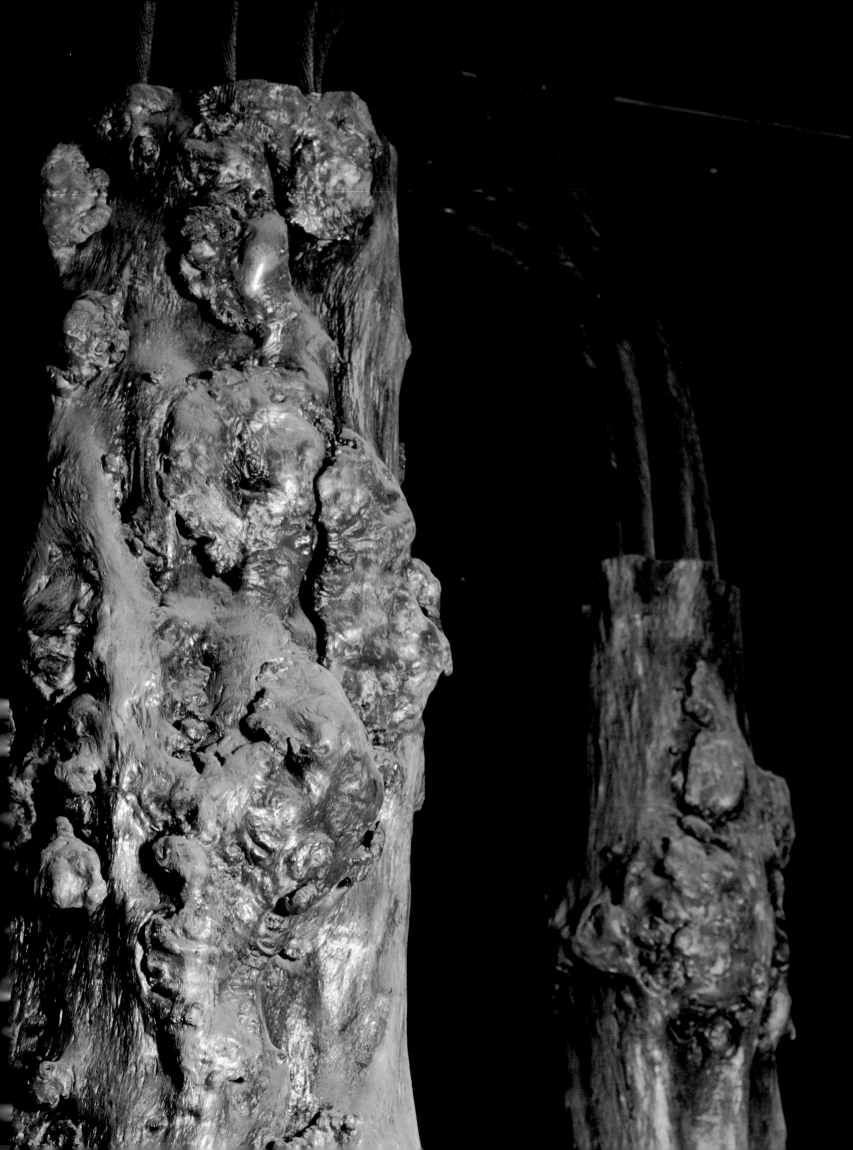

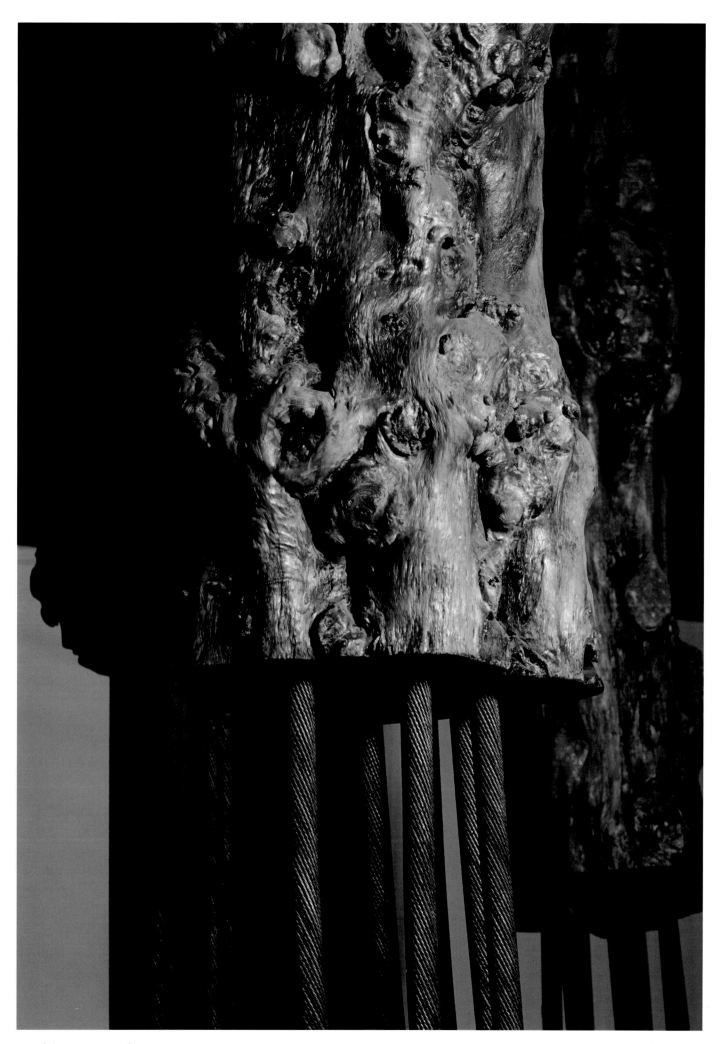

穿行 No.19（局部）

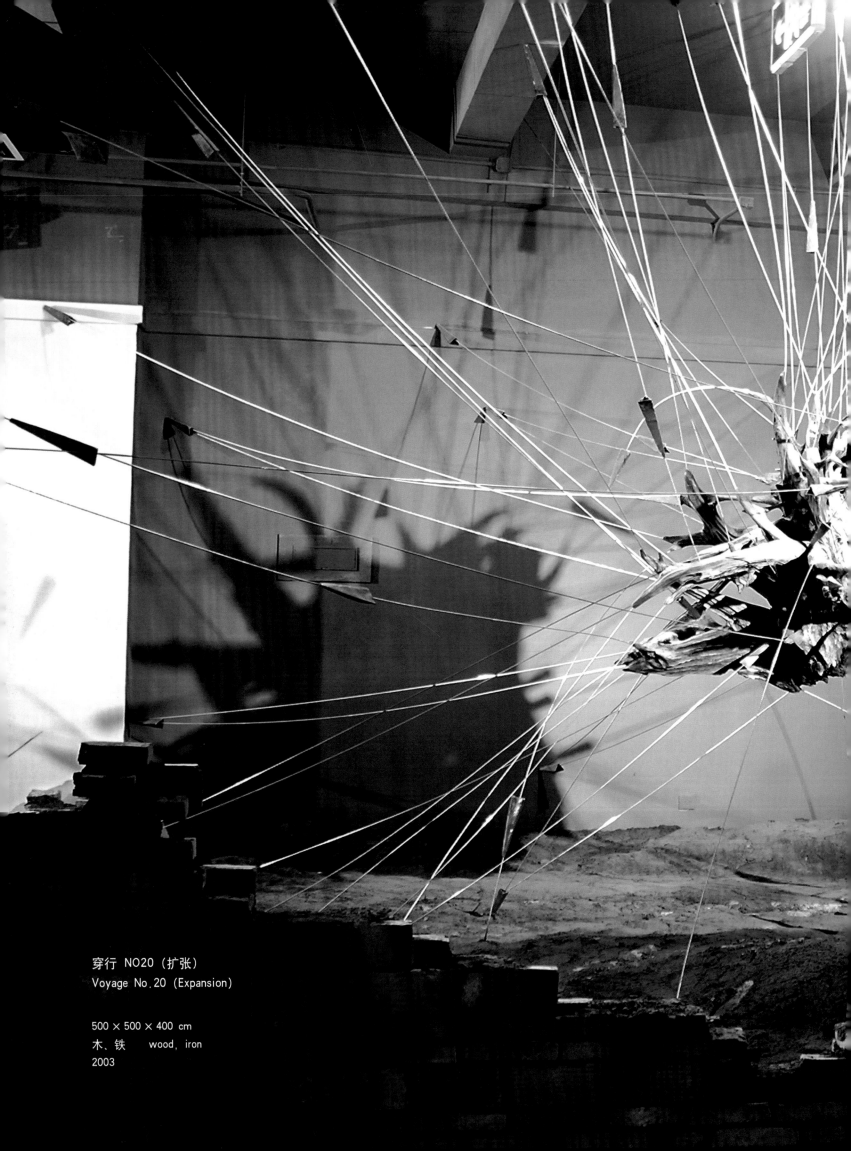

穿行　NO20（扩张）
Voyage No.20 （Expansion）

500 × 500 × 400 cm
木、铁　　wood, iron
2003

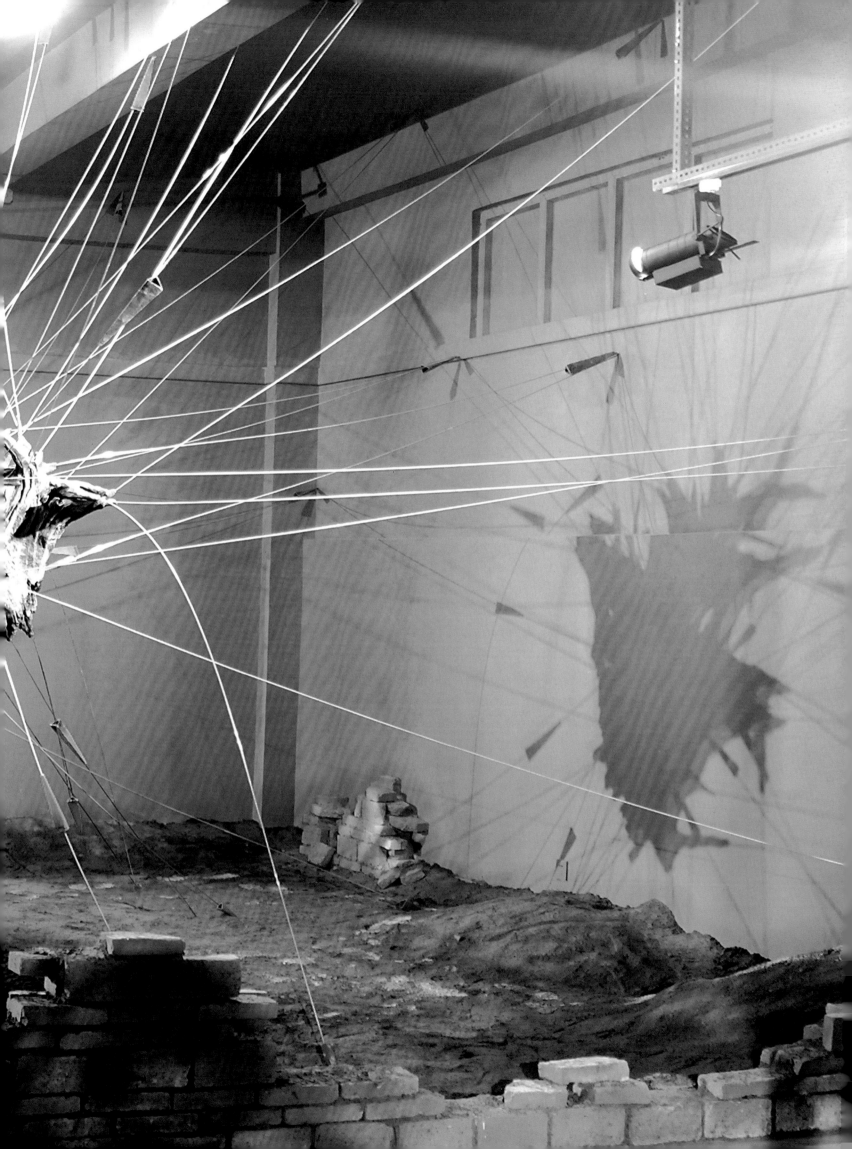

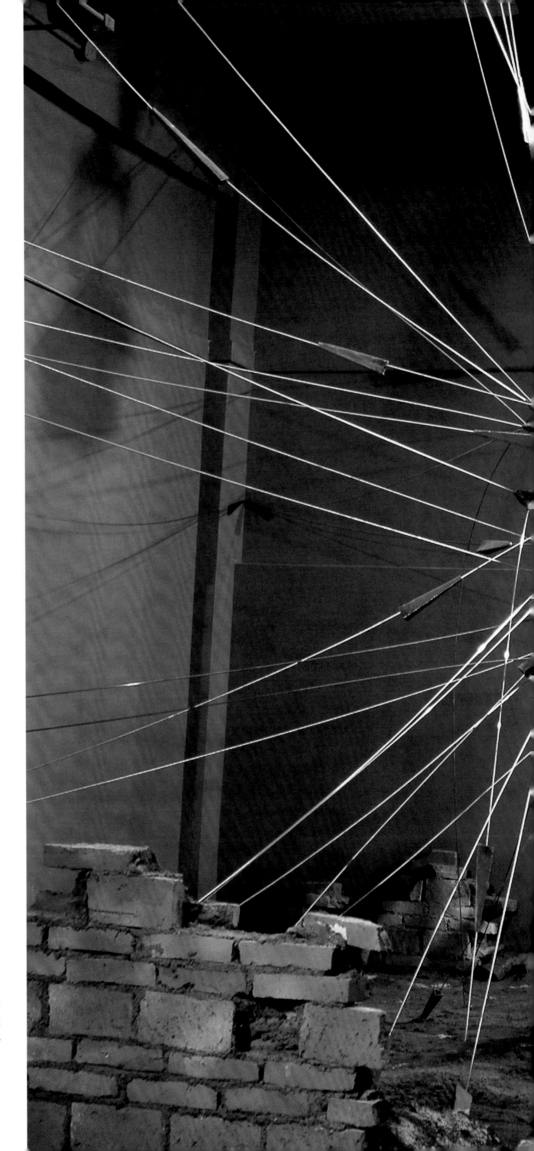

穿行 NO20 （扩张）

　　因为无限扩张，浑身是芒刺。它把自己之外的一切当做打击的目标。你伤害了世界，也必然要伤害到自己。

Voyage No. 20: Expansion

Excessive expansion results in thorns in one's flesh. When one targets its attack at everything other than itself, it is sure to suffer from the damage done onto the world.

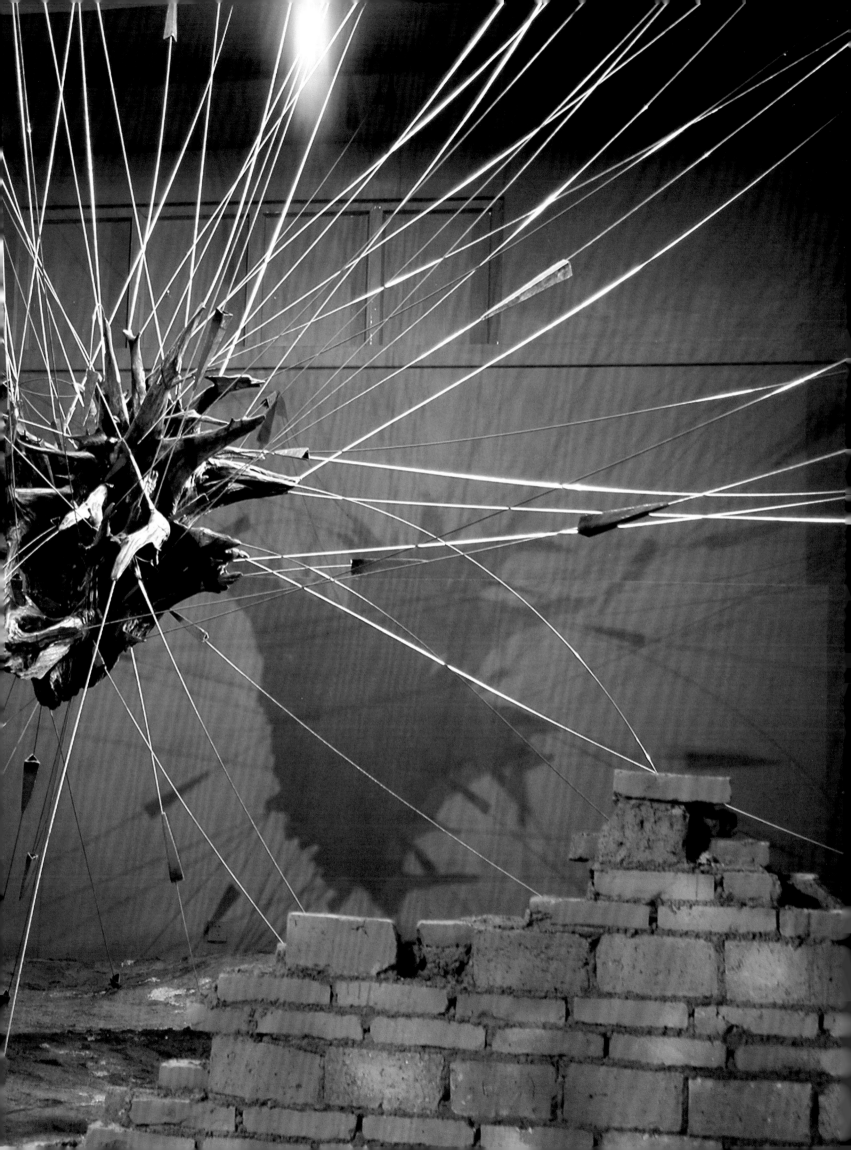

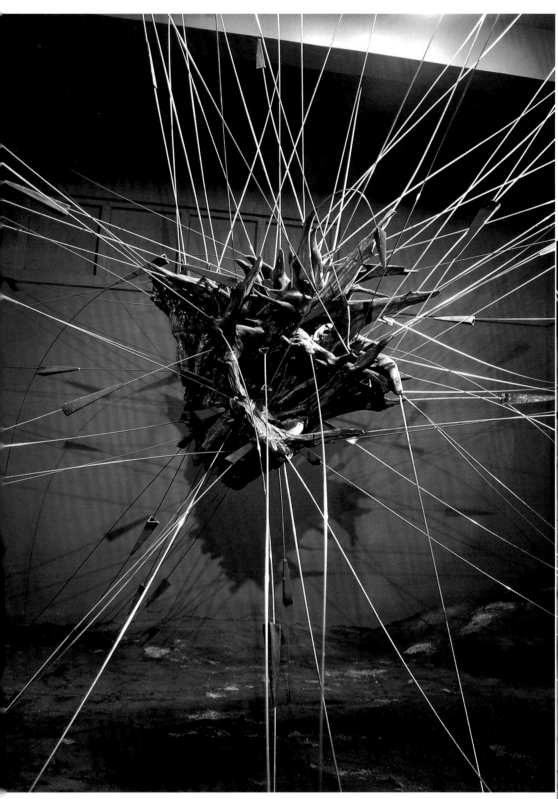
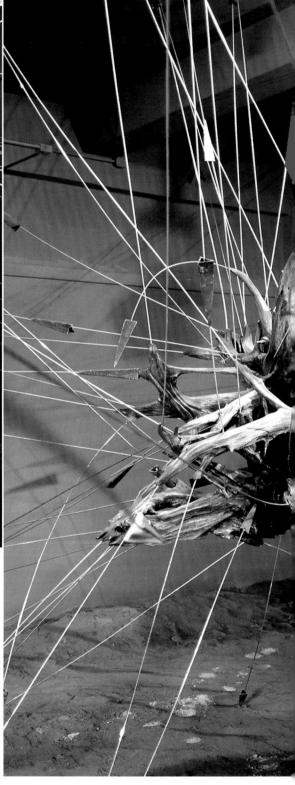

穿行No.19（局部：左 中 右）

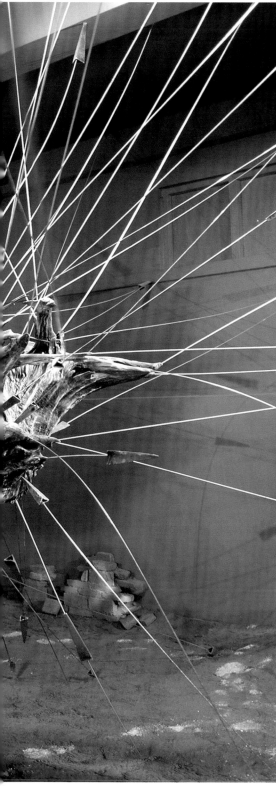

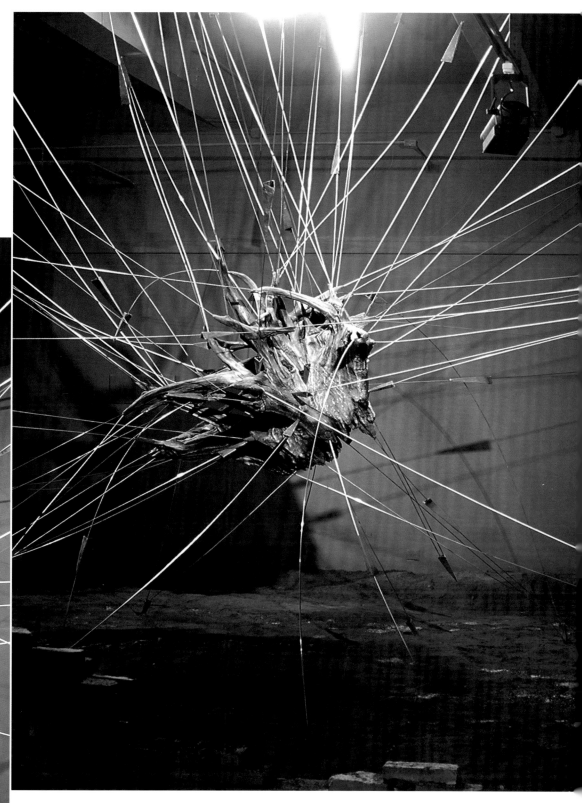

织 造 系 列

我用完全不同的材料,
让看似无关的建立起来各种密切的联系,
而联系的建立来自——力。

Weave Series

I use totally different material
to build various close relationships among the seemingly irrespective materials,
and it is based on FORCE that the relationship is forged.

织造 NO6
Weave No.6

直径／Diameter 300 cm
钢管、不锈钢丝、块根
Steel pipes, stainless steels, root tubes
2003

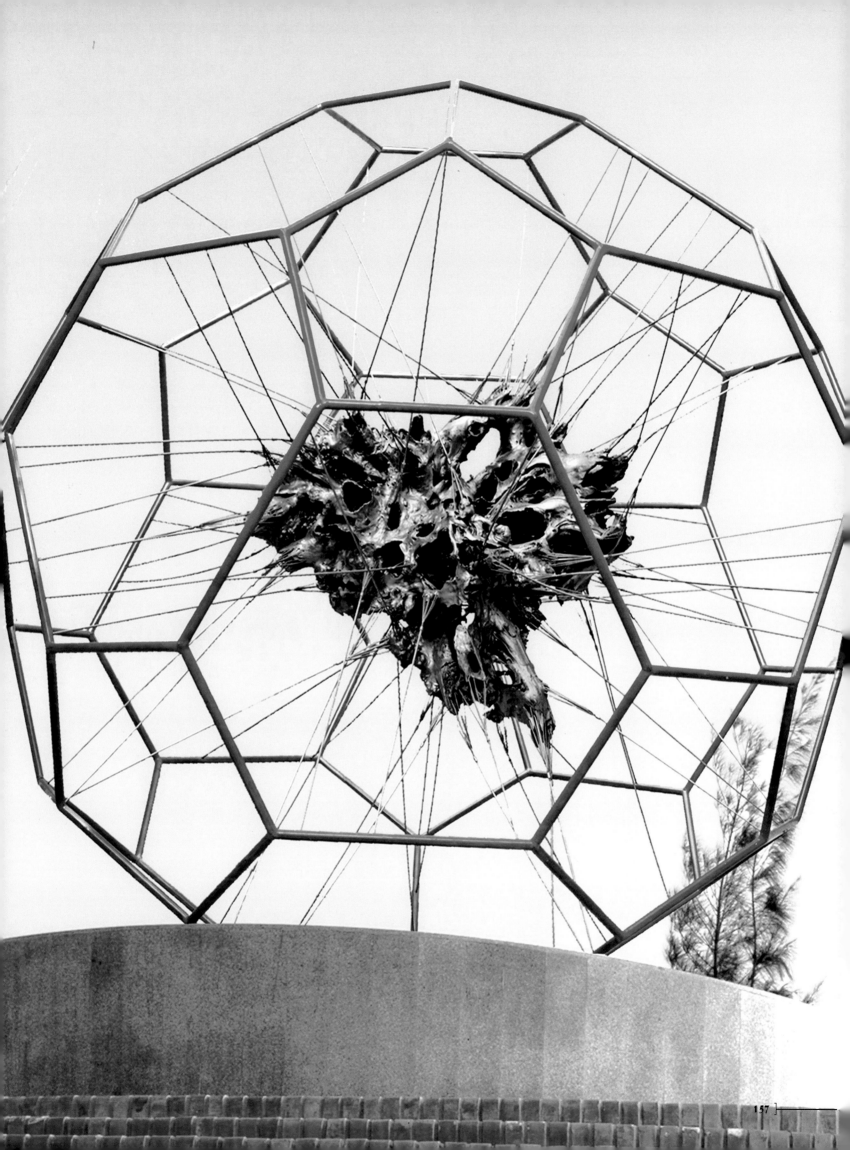

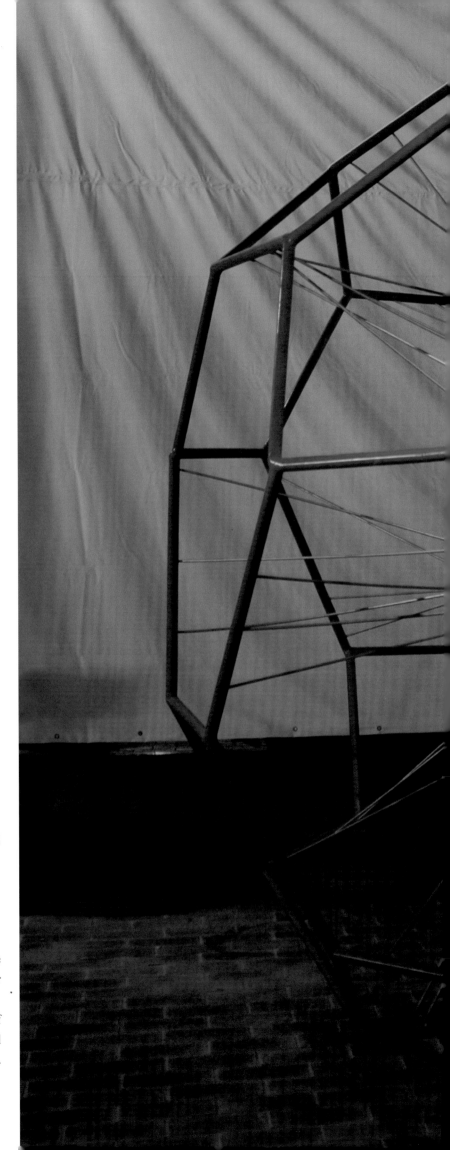

织造 NO6

　　用球形作"骨架"，是因为它连结着大地的脊梁；用残根作"内脏"是因为它散发着泥土的芬芳。
　　因为色调的不一致，我感受到一种残酷的撕咬。我统一了颜色，似乎是在表现宇宙的初始、炸裂的瞬间，一切都凝固于均衡。

Weave No.6

　　The "skeleton"is in the shape of a ball and is bound to the earth. Its broken roots have been used for the"bowel", for they have the fragrance of the soil.
　　The inconsistent colors impressed me with the feeling of cruel gnawing. I harmonize the colors to symbolize the initial explosive moment of the universe and froze them in equilibrium.

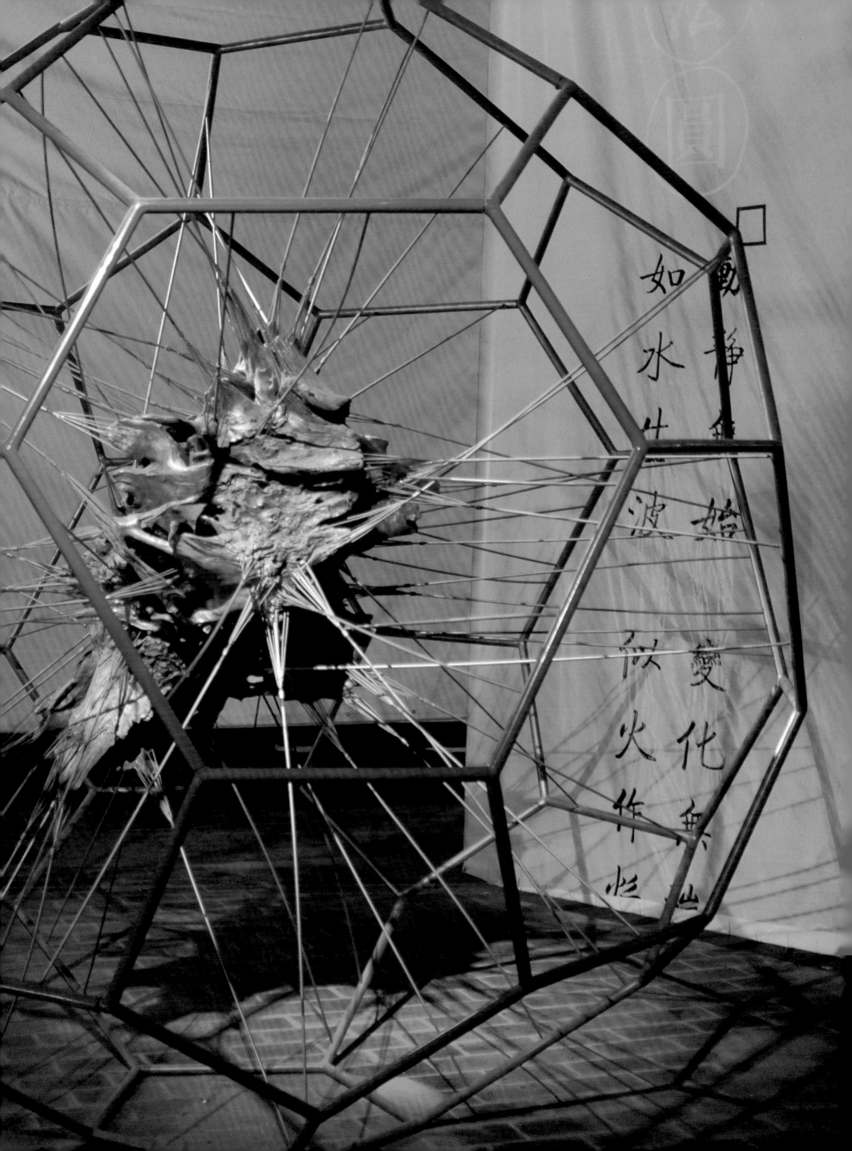

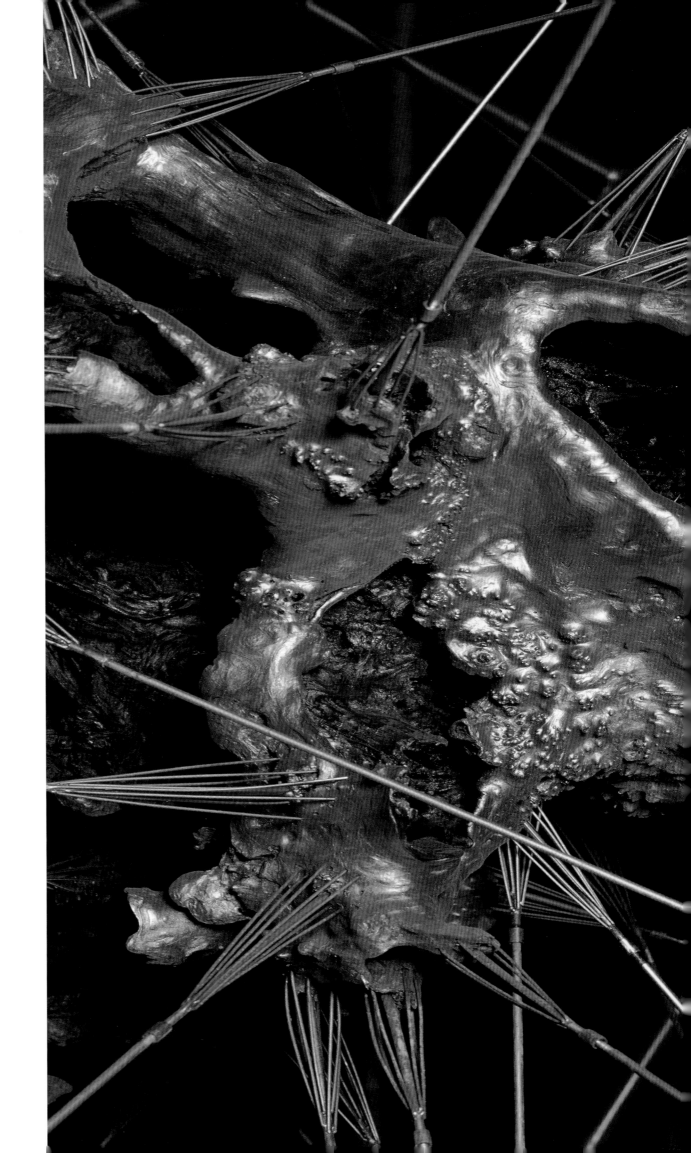

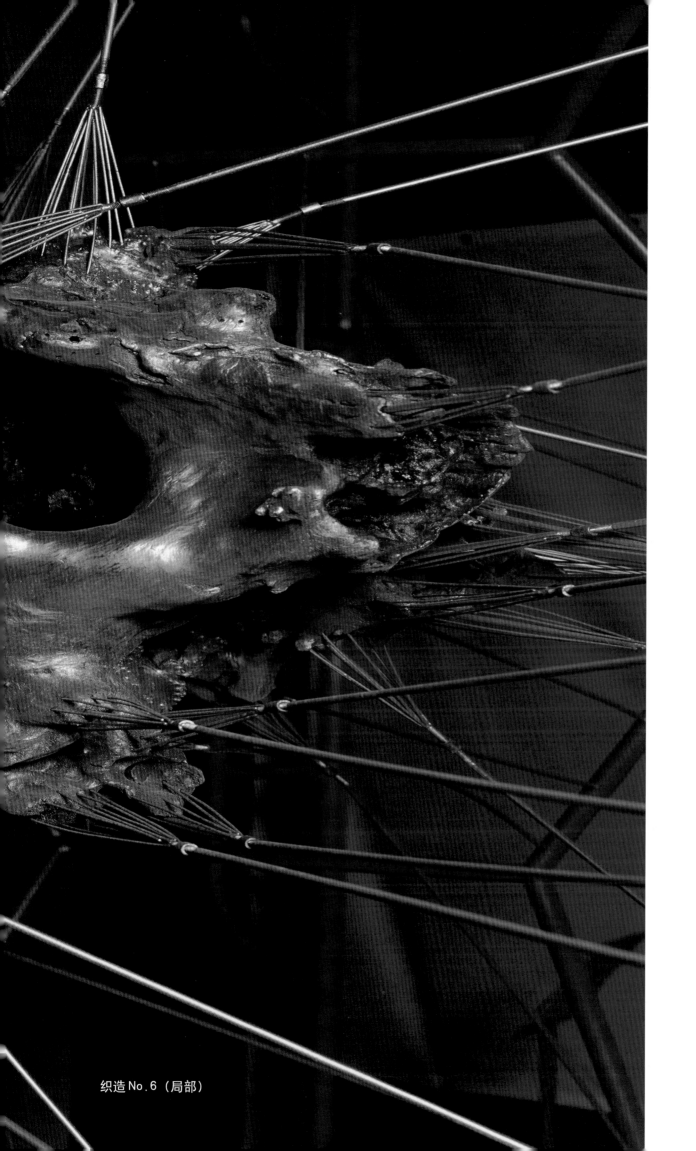

织造 No.6（局部）

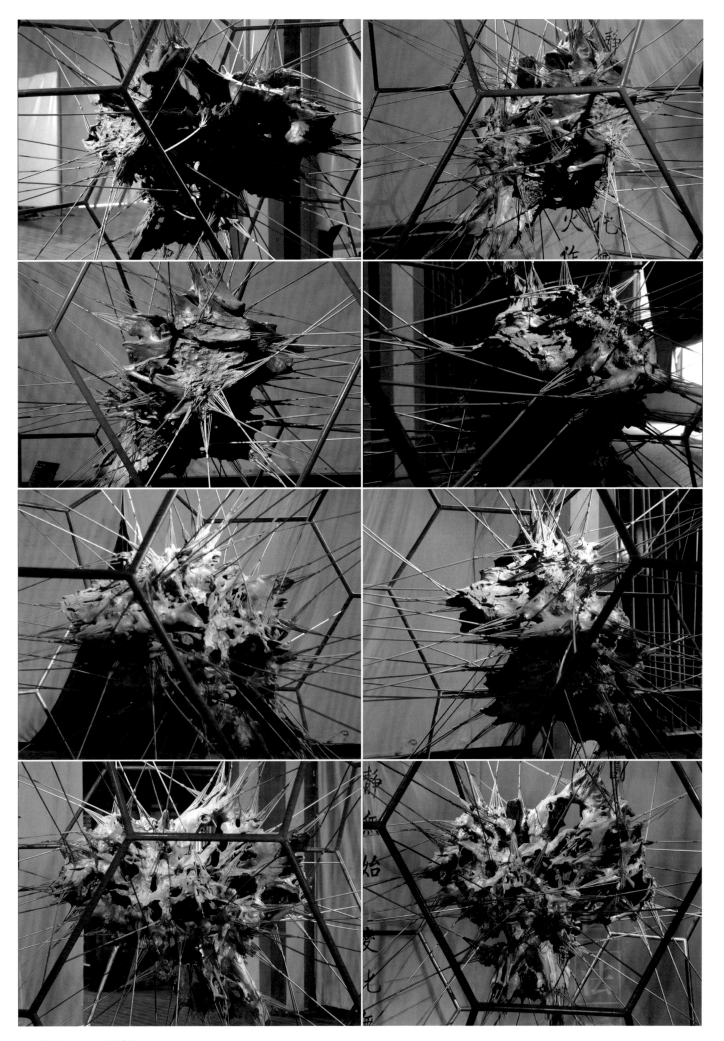

织造 No.6（局部）

凝 固 的 风 景 系 列

是一个见证人类生存与自然关系的纪念碑，
也是对当代人类生存经验的反思。

Frozen Landscape Series

It's a monument attesting to the existence of human relationship with the nature
and a retrospection of life's experiences of the contemporary human being.

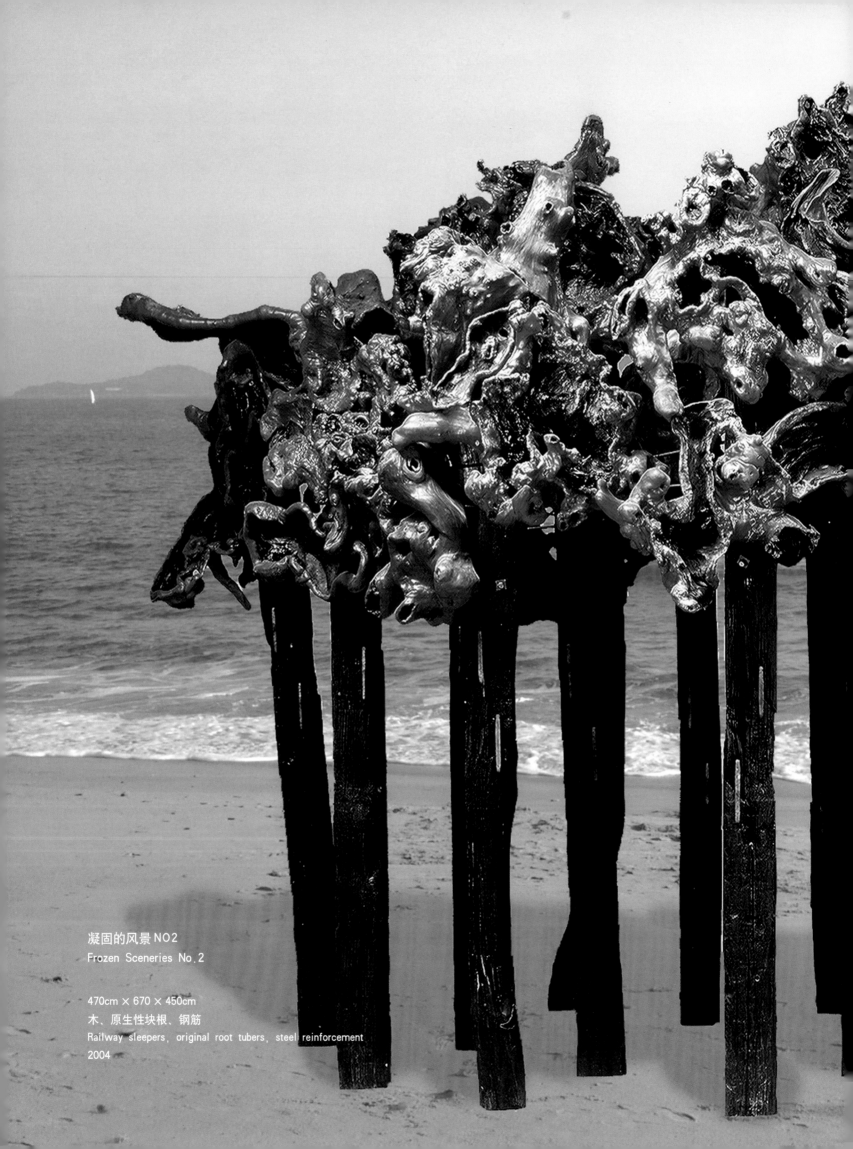

凝固的风景 NO2
Frozen Sceneries No.2

470cm × 670 × 450cm
木、原生性块根、钢筋
Railway sleepers, original root tubers, steel reinforcement
2004

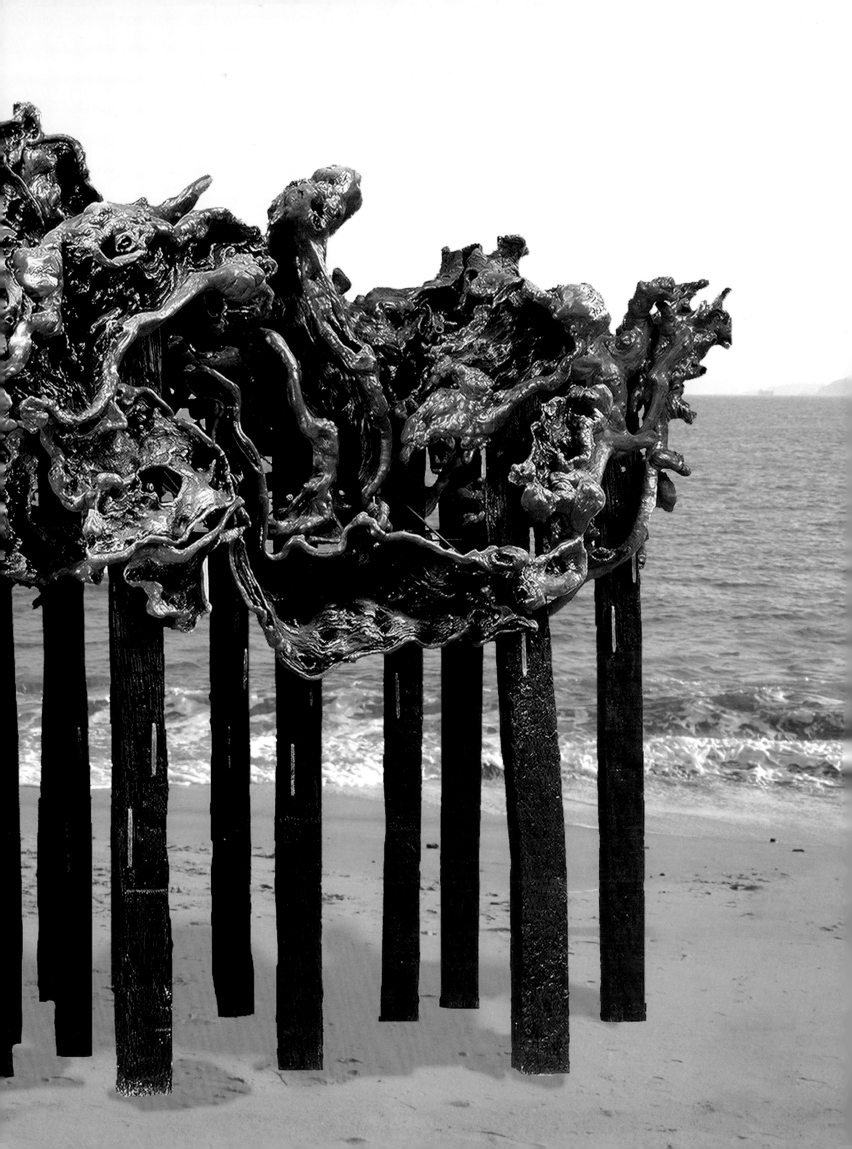

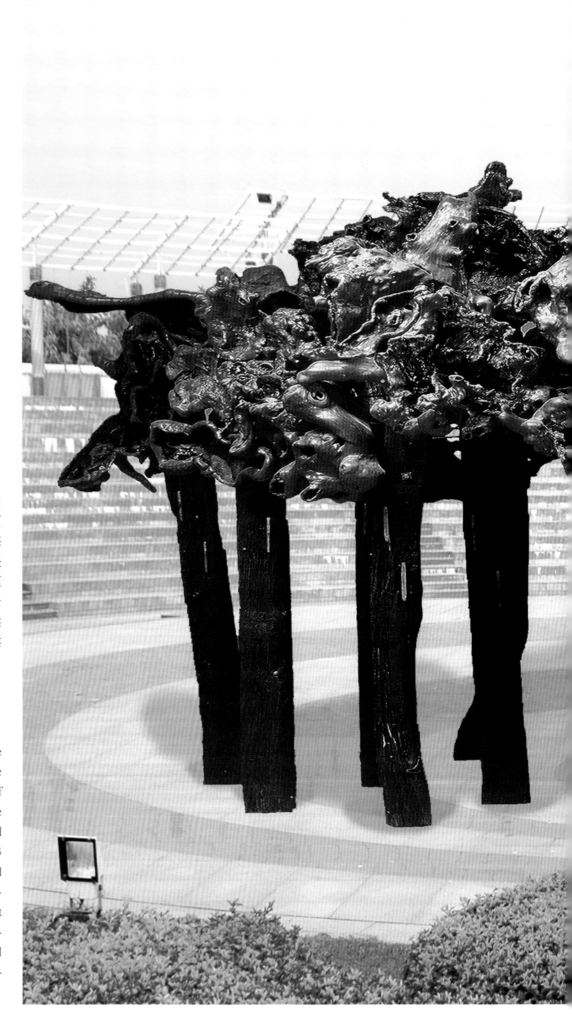

凝固的风景 NO2

　　在纯化世界的使命驱使下，用 42 根在铁道上退役下来又参加过厦门海上大桥和高速公路建设，在海水和泥浆中浸泡过的旧枕木和 83 块历经百年虫噬蚁造、风袭雨浊、疤痕沧桑的原生性块根，组合成一道景观雕塑，它是见证人类生存与自然关系的纪念碑，也是对现当代人类生存经验的反思。

Frozen Landscape No.2

　　Driven by a mission to purify the world, I took 42 railway sleepers that were formerly used in the construction of Xiamen Bridge and Expressway. These had been immersed in seawater and mud and reclaimed. I combined these with 83 dilapidated raw root tubers, which had survived age-old erosion and insect invasion to form a landscape sculpture. It is my monument to witnesses the tie between human survival and nature, as well as a reflection on the surviving experience of modern mankind.

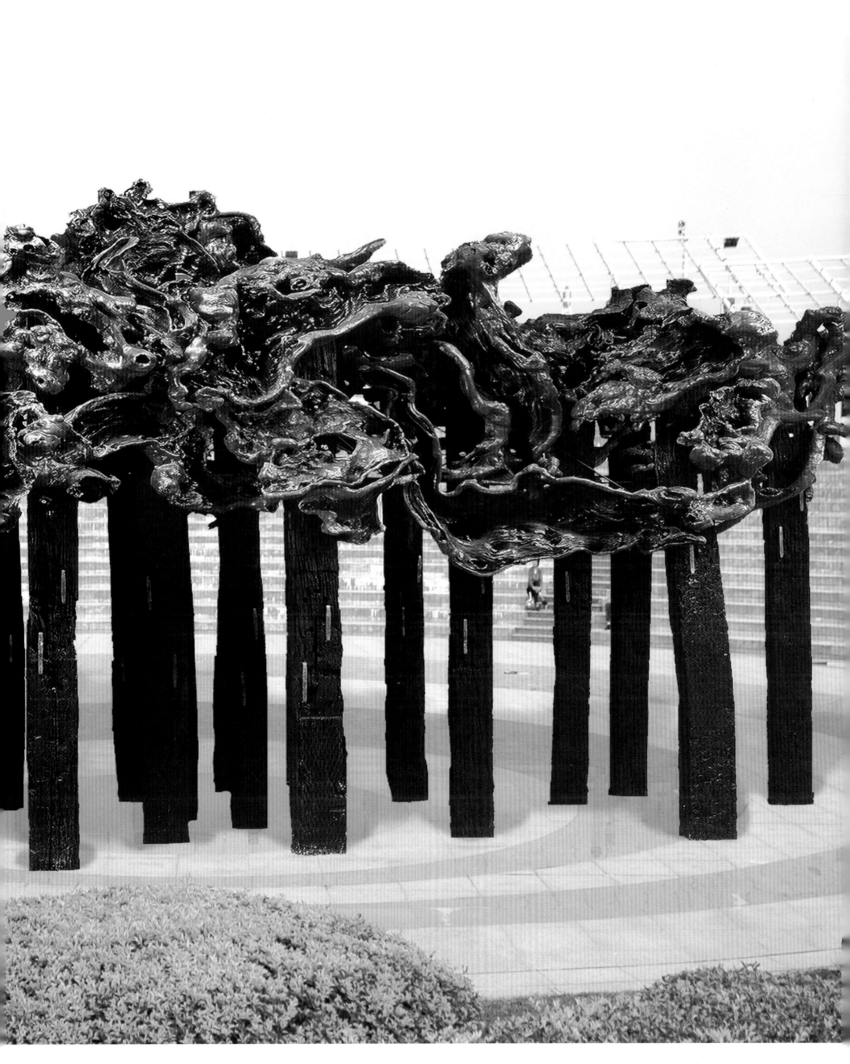

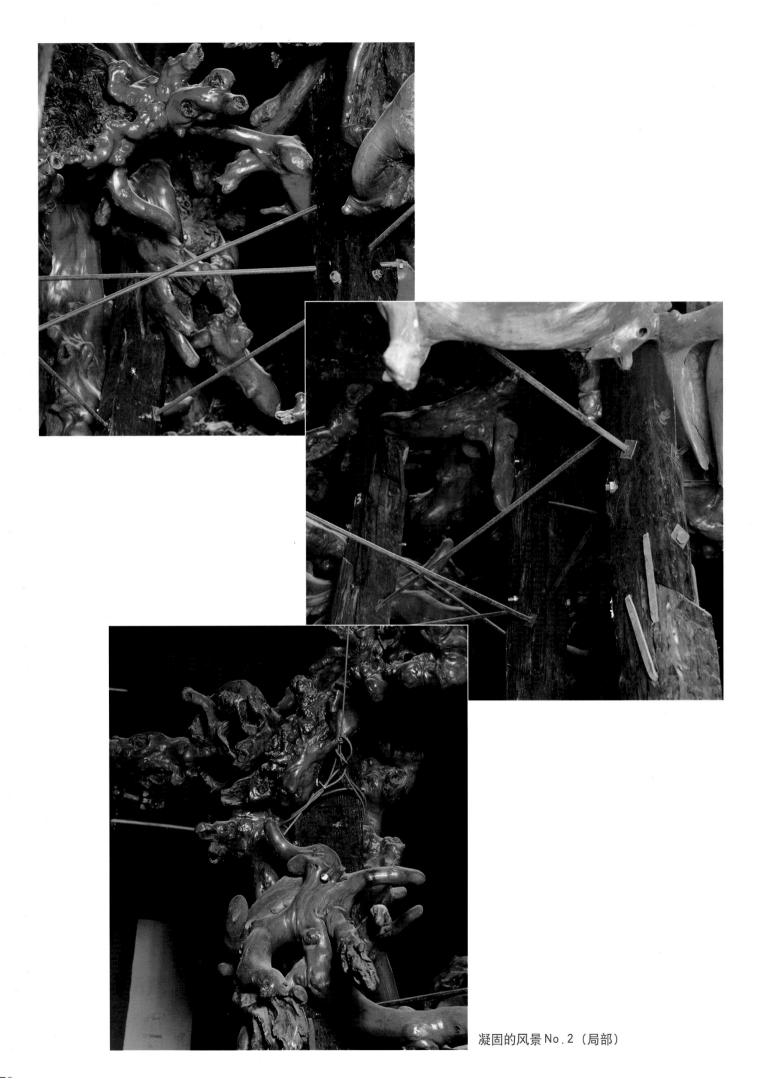

凝固的风景 No.2（局部）

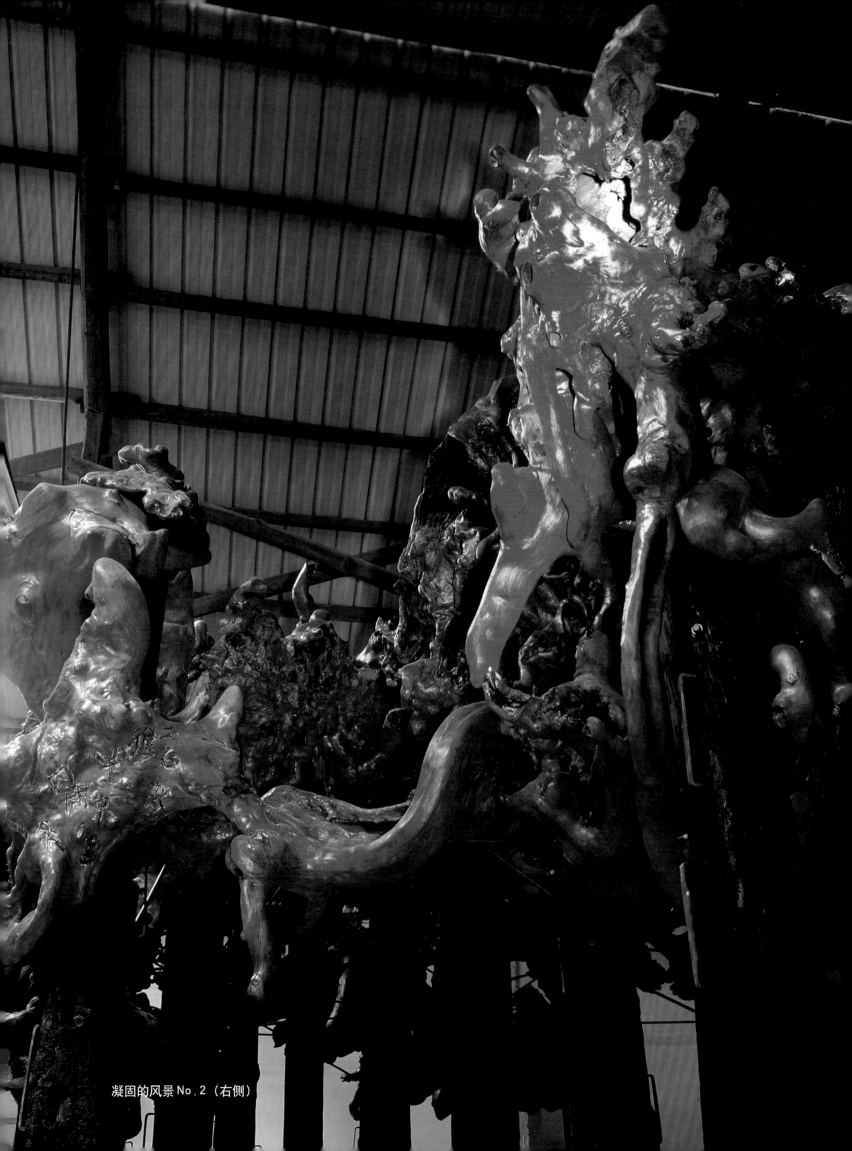

凝固的风景 No.2（右侧）

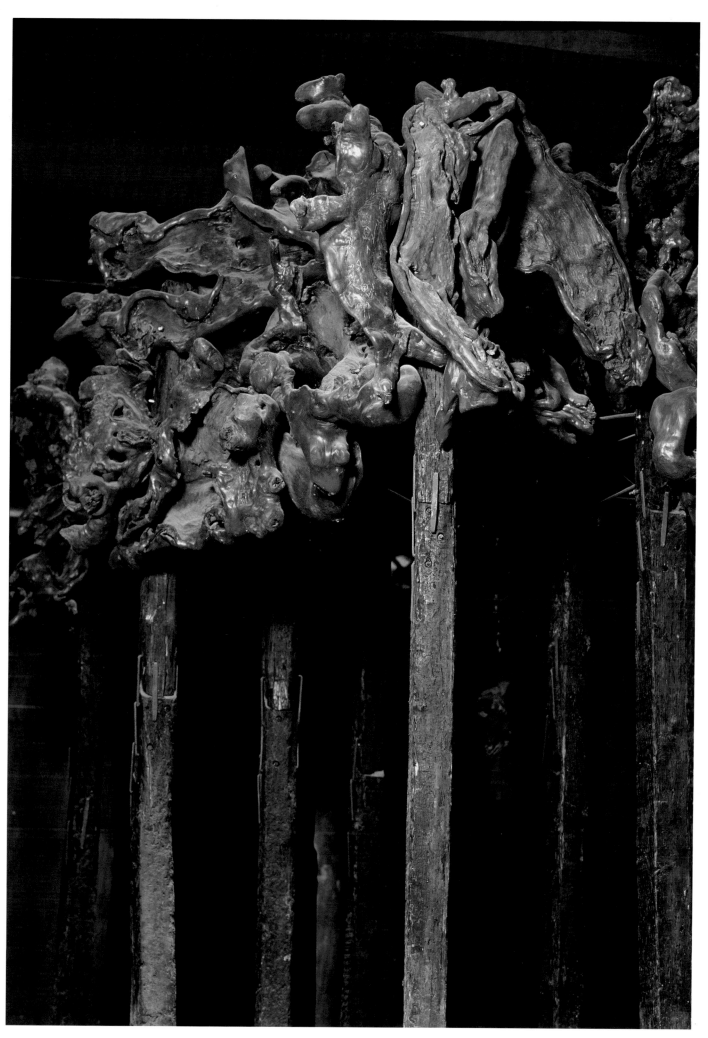

凝固的风景 No.2（左侧）

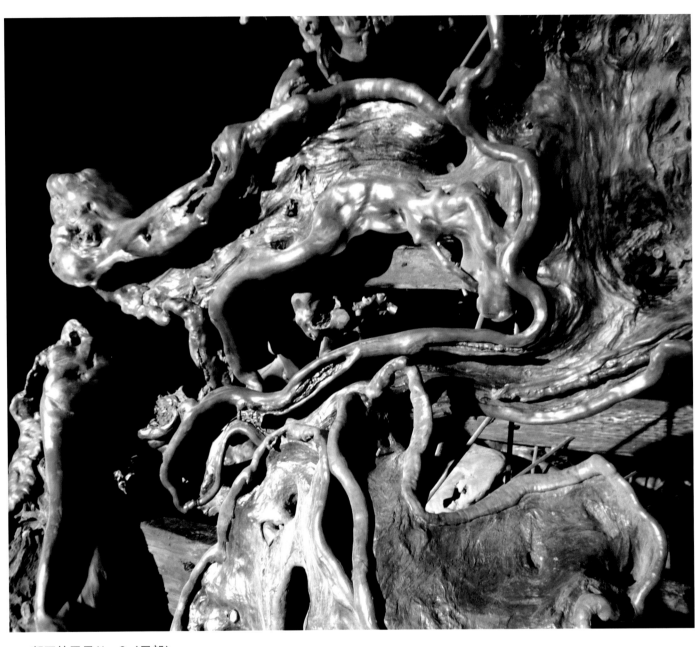

凝固的风景 No.2（局部）

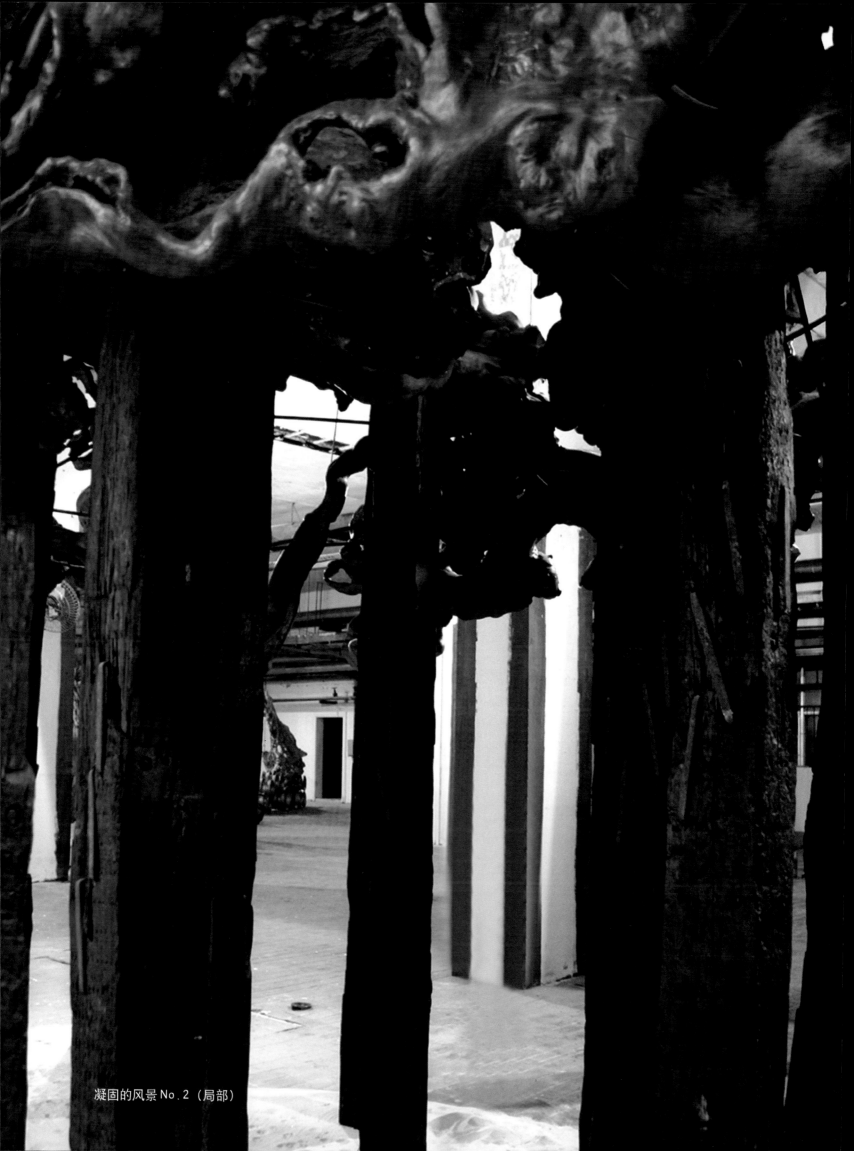

凝固的风景 No.2（局部）

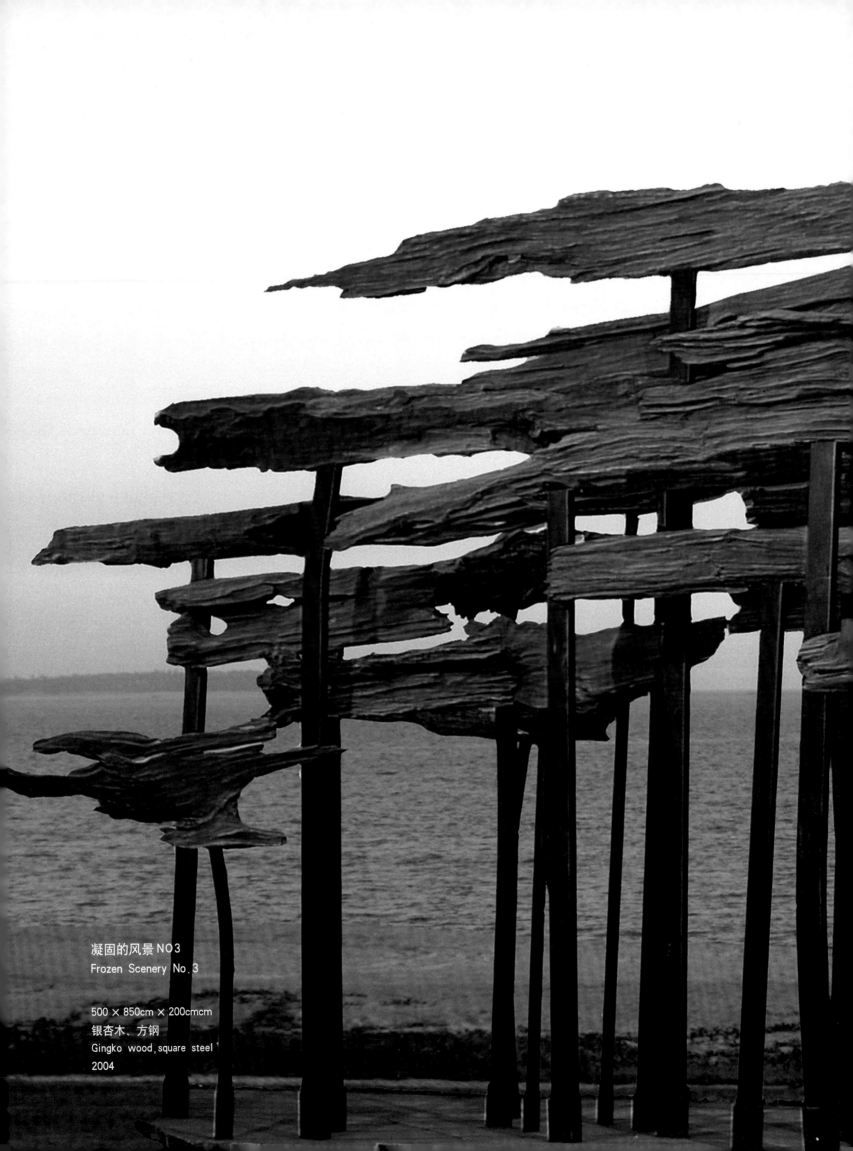

凝固的风景 NO3
Frozen Scenery No.3

500 × 850cm × 200cmcm
银杏木、方钢
Gingko wood,square steel
2004

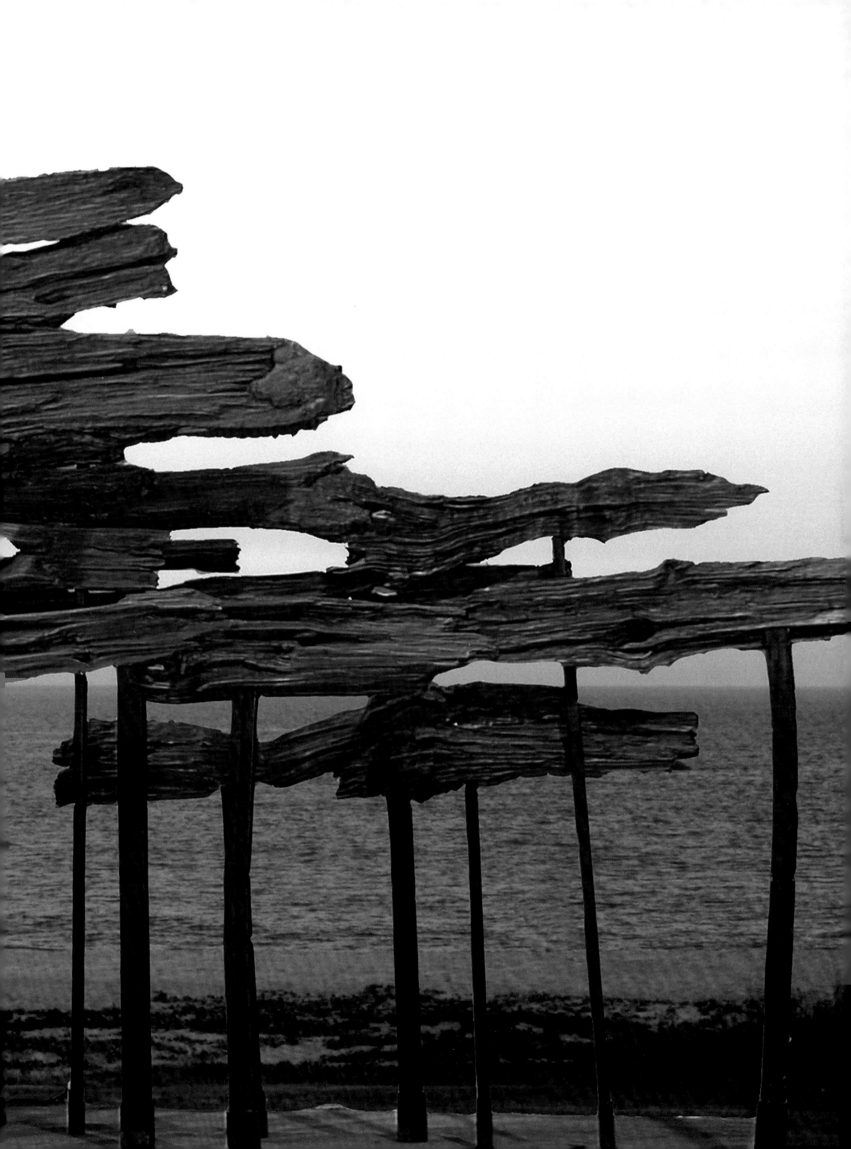

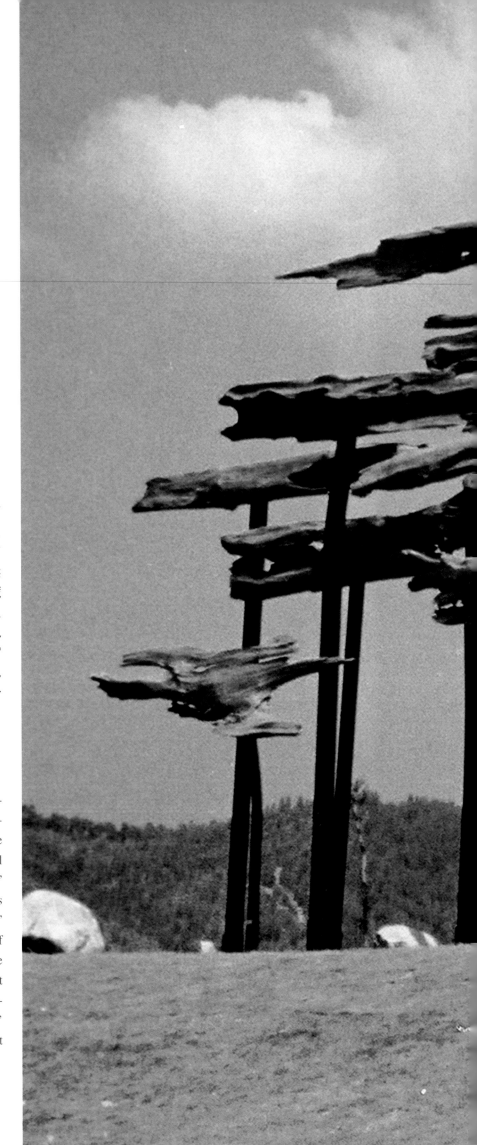

凝固的风景 NO3

在海边发现一片古松林，相传有200多年的历史，幸运的是"58年"大炼钢铁，"文革"无政府主义乱砍乱伐没有毁掉它们，据当地村民说，"谁砍了谁就会遭殃"，难得"神"的保佑，太特殊了，自然生态要都得到"神"的保护那该多好啊！我将收藏多年的具有"活化石"之称的银杏木重新让它"复活"。从这些木头上刻有岁月流淌着的"伤痕"的肌理，不难看出，它们已有百年以上的心路历程，它们历经艰险世故，毕生抗争，哪怕只剩下残骨，也要将这一腔热血释放，用火一般的热情去作最后一次生命的挣扎。

Frozen Landscape No. 3

An ancient 200 odd-year-old pinewood log was discovered along the coast. It survived the "Great Steel-Making time of 1958"and the wanton cutting of trees during the Great Cultural Revolution in China. According to the local villagers"Those who cut the trees will suffer from curses" What a particular blessing for the wood. What kind of bliss it would have been if "nature" had been under"Gods" protection? I "revived" the so-called "living-fossil"of gingko wood that I collected years ago. Evidently, the piece with"wounds" carved by time and nature, shows that it has undergone more than a century of change, surfing hardships and life-long struggles, even though only the 'ruin' remains, it still spews out enthusiasm, confronting its last struggle in life with the passion of a prairie fire.

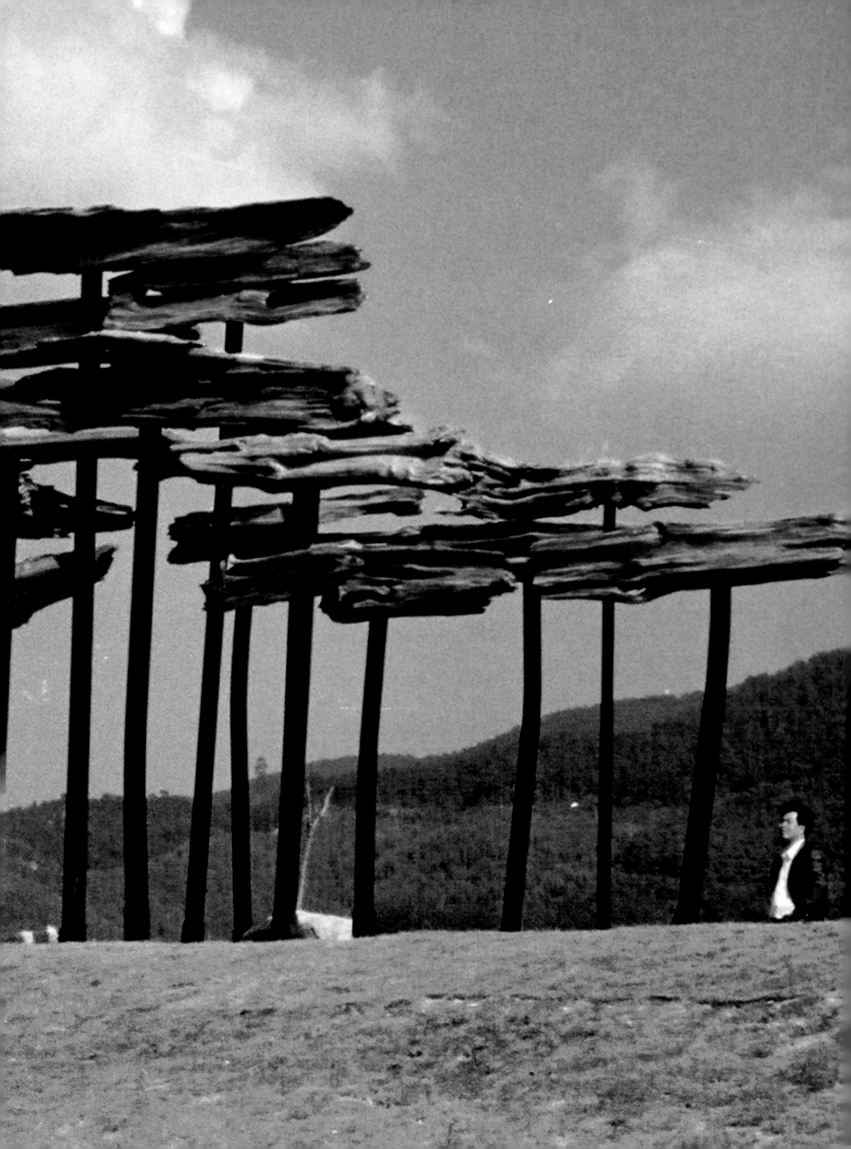

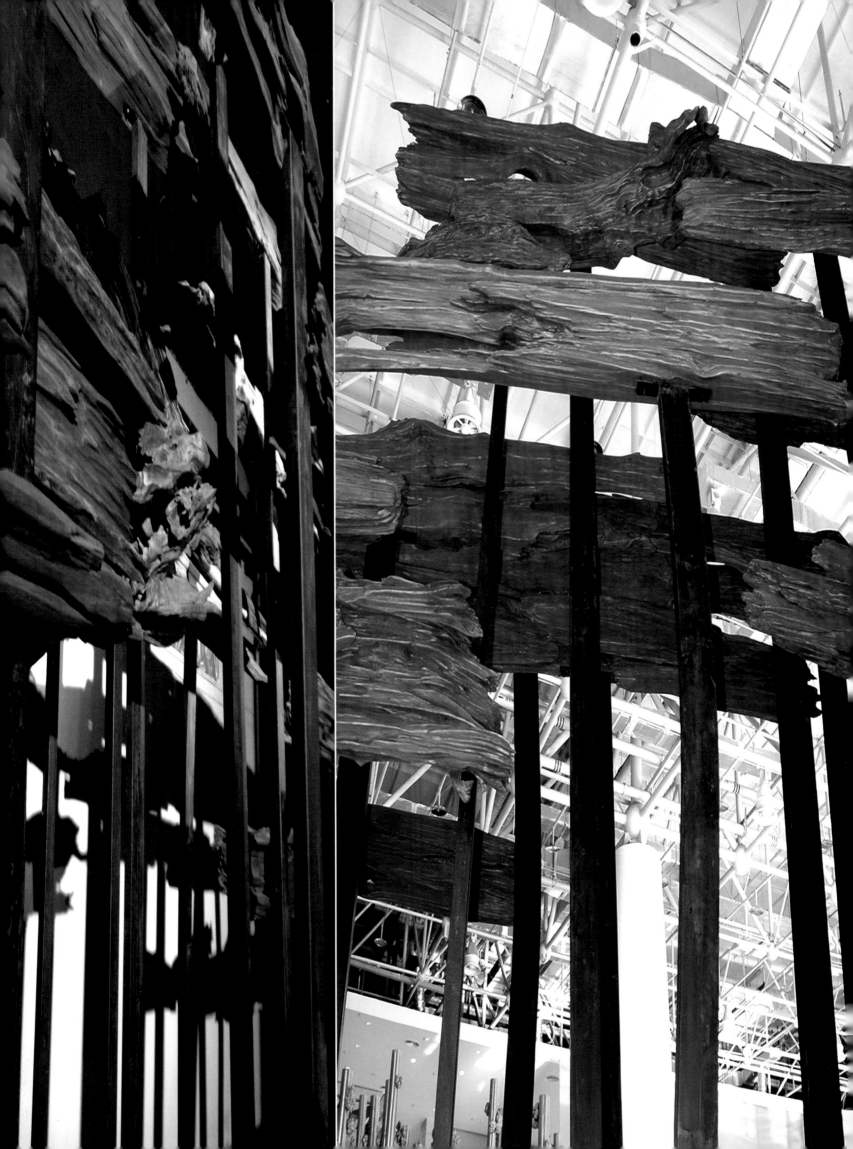

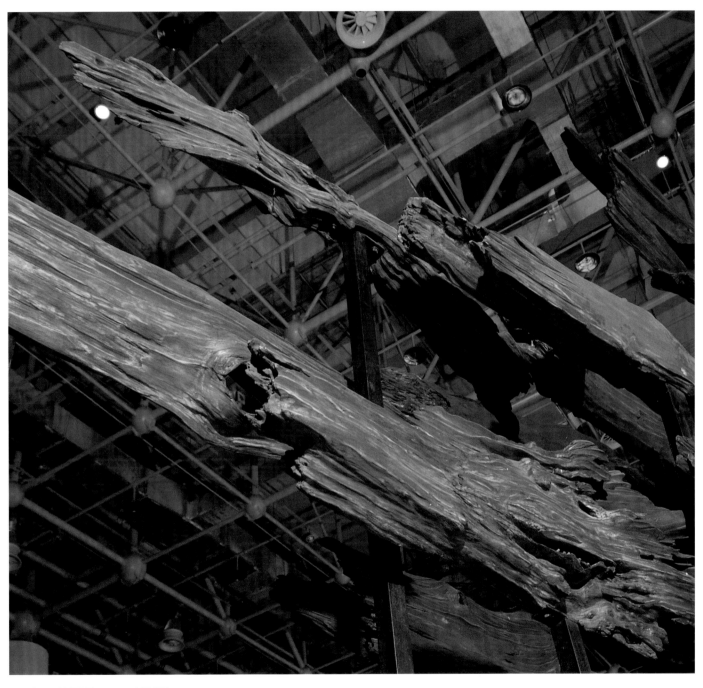

凝固的风景 No.3（局部）

凝固的风景 No.2（后侧）

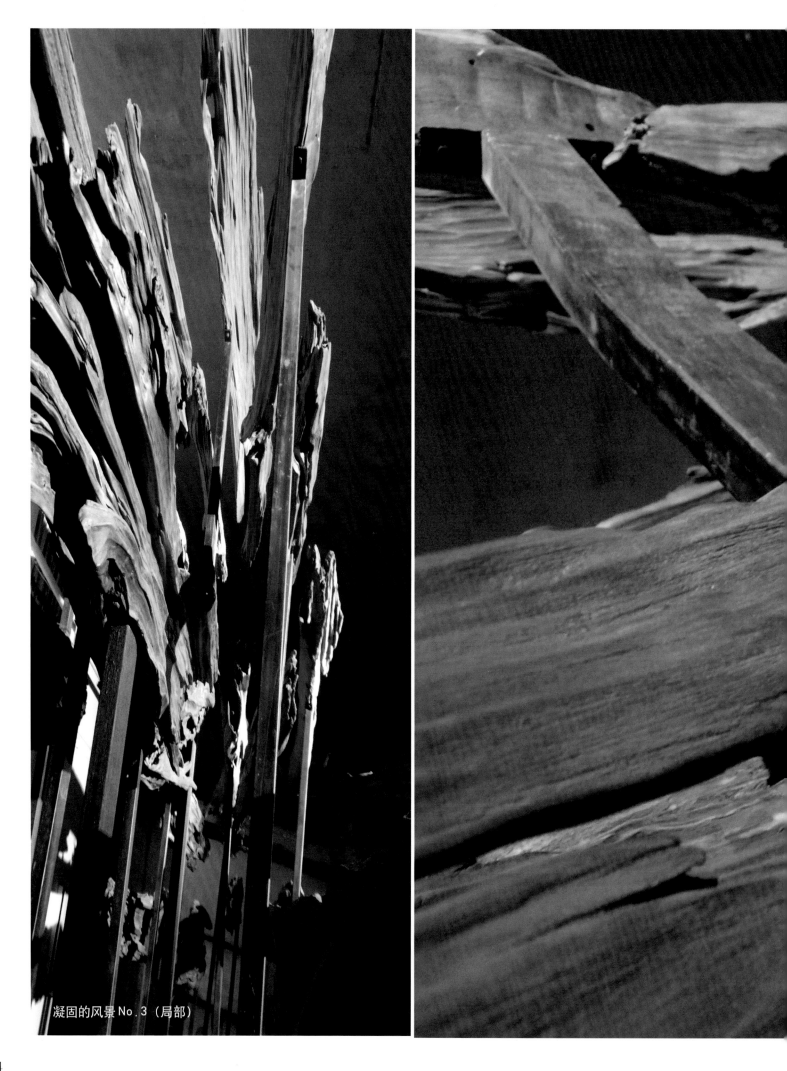

凝固的风景 No.3（局部）

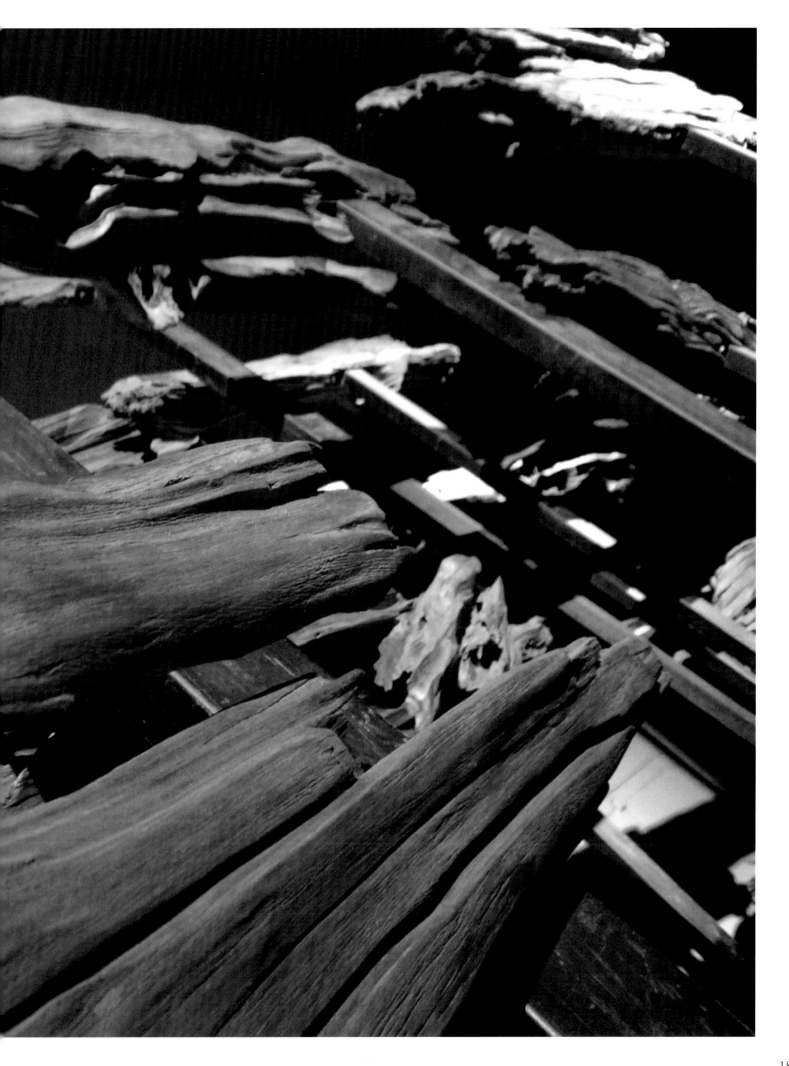

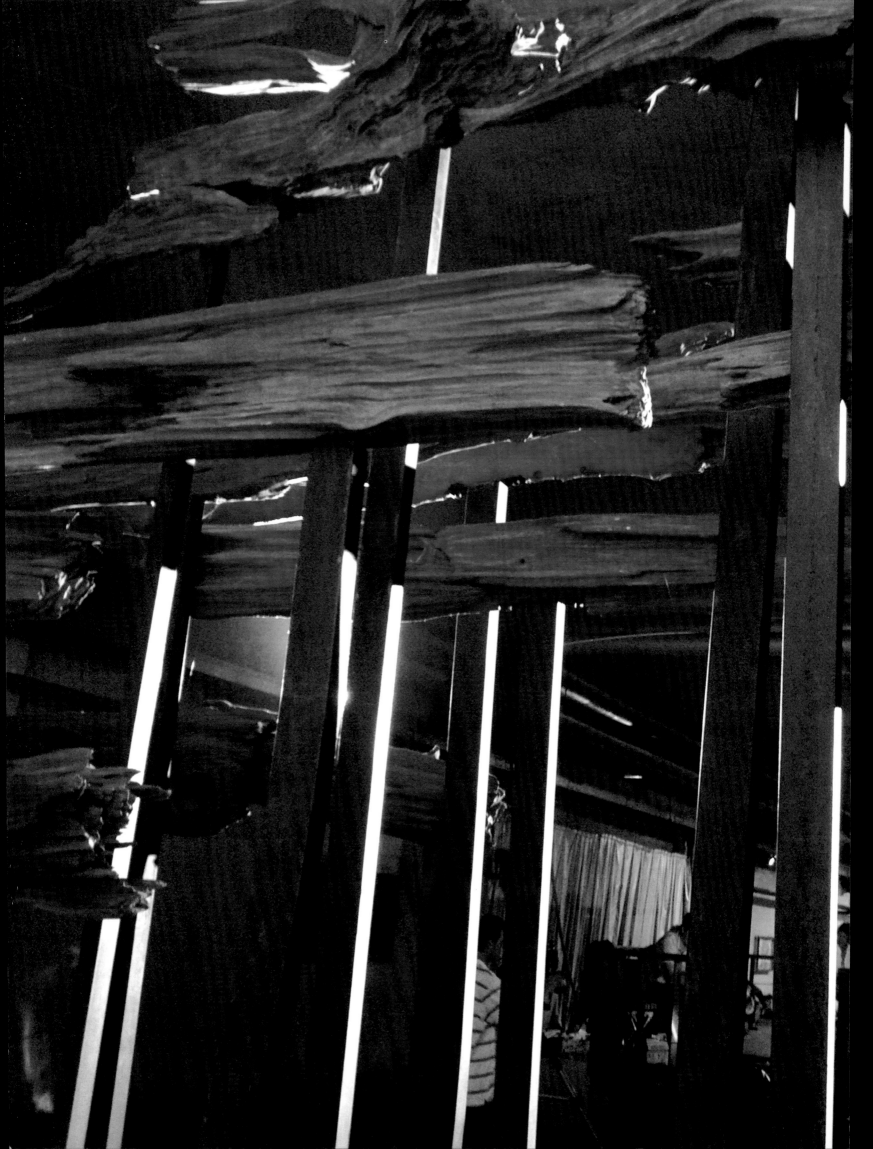

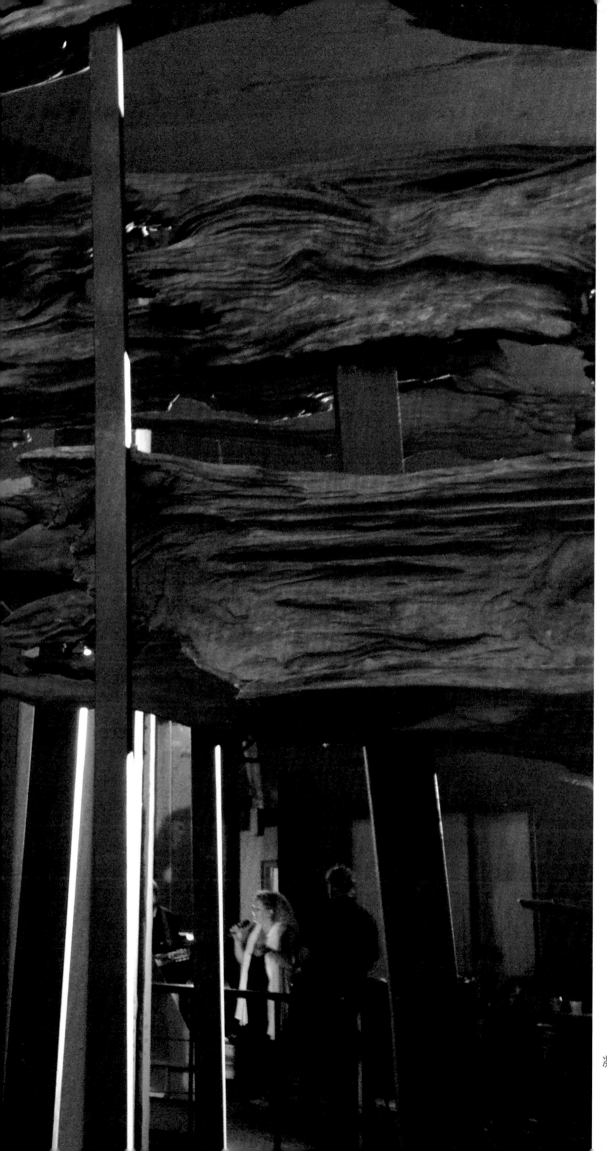

凝固的风景 No.3（局部）

187

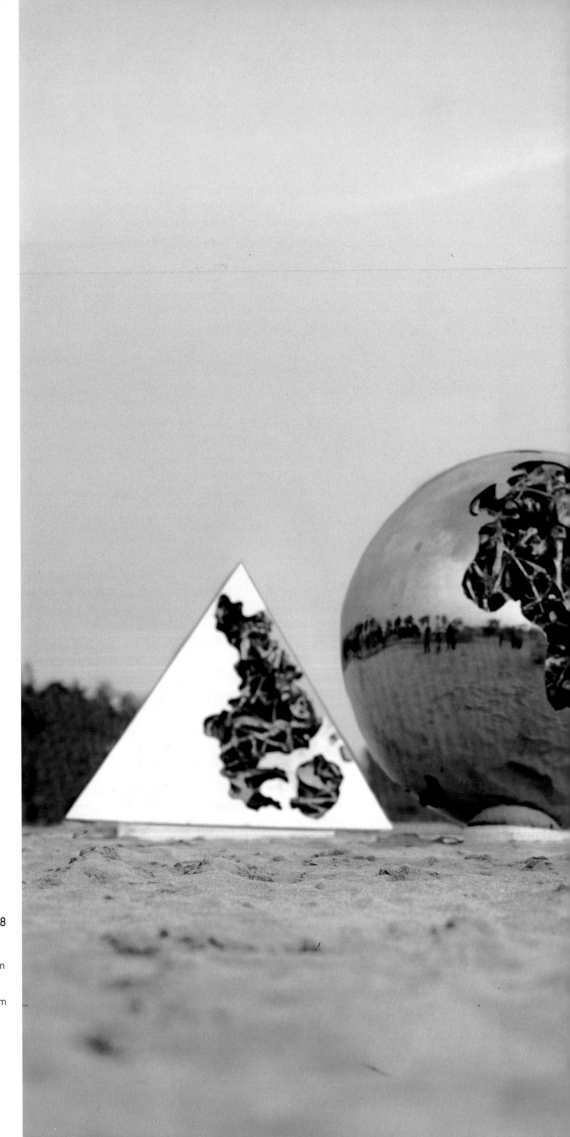

凝固的风景 NO6、NO7、NO8
Frozen Sceneries No.6, No.7, No.8

NO6 园　　直径 Circle Diameter　100cm
NO7 方　　Square　　80 × 80 × 80cm
NO8 三角 Triangle　120 × 120 × 120cm
不锈钢、原生性须根
Stainless steel，primary fibrous roots
2003

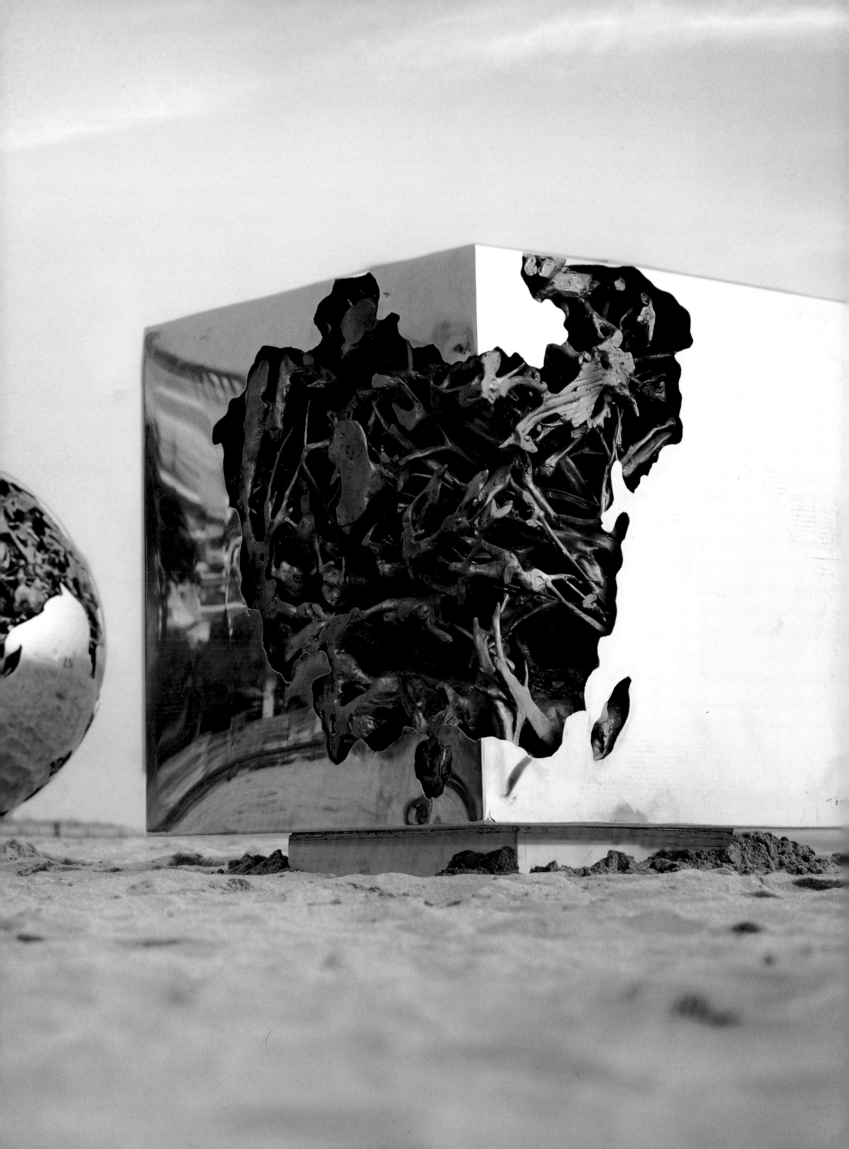

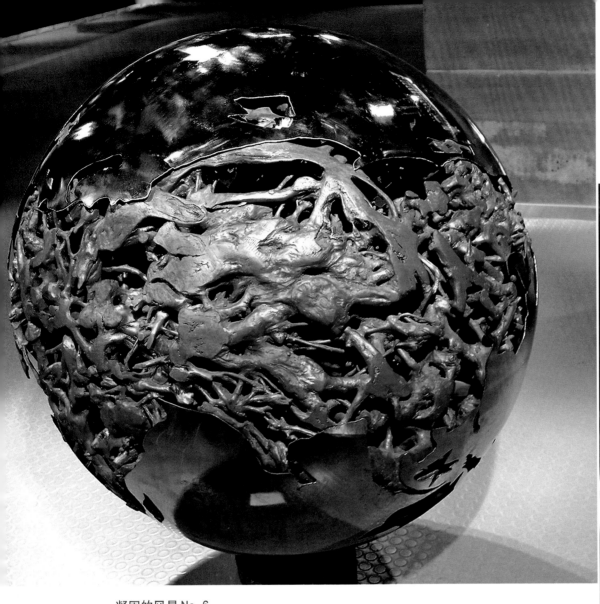

凝固的风景 No.6

凝固的风景 No.7

凝固的风景 NO6　NO7　NO8

　　用不锈钢制作的基本几何形体去包裹原生性的须根，感受一种自然的有生命的东西被人为的粗暴的行为去限制、禁锢，这是当今人类生存经验需要反思的问题。

Frozen Landscape No.6　No.7　No.8

Rough geometrical shapes of stainless steel have been used to circle the primary fibrous roots, constituting the feeling of some natural, living things being confined and restricted by artificial atrocity. It is an issue for people to reflect upon during their life's experiences.

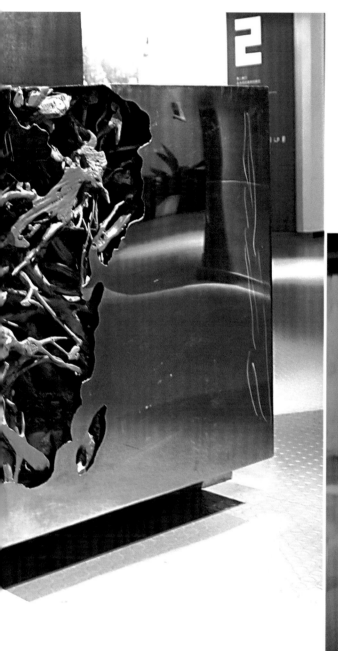

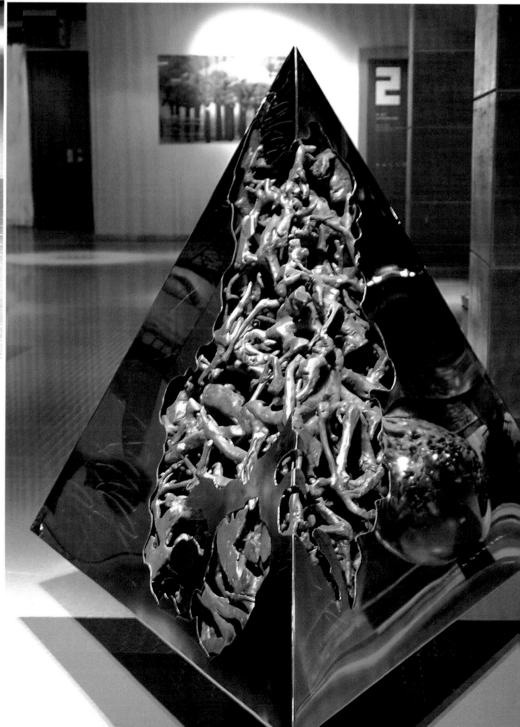

凝固的风景 No.8

凝固的风景 No.6（局部）

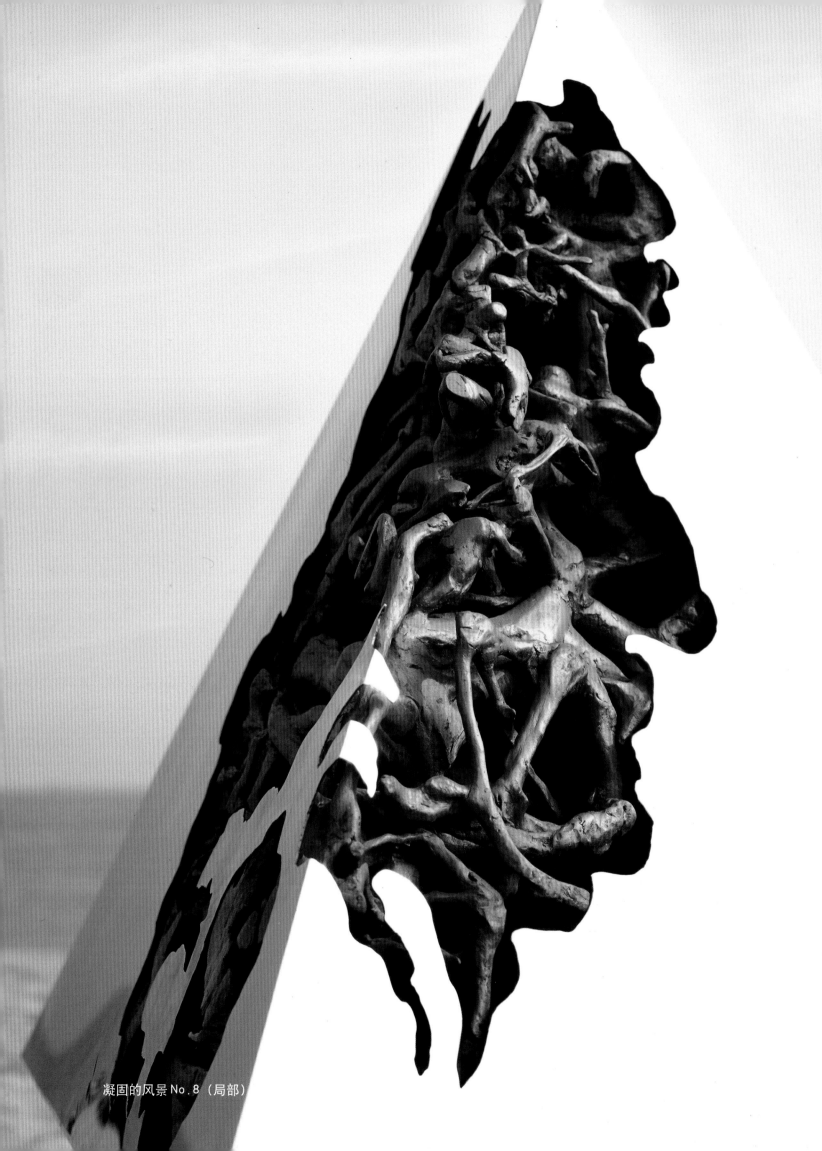

凝固的风景 No.8（局部）

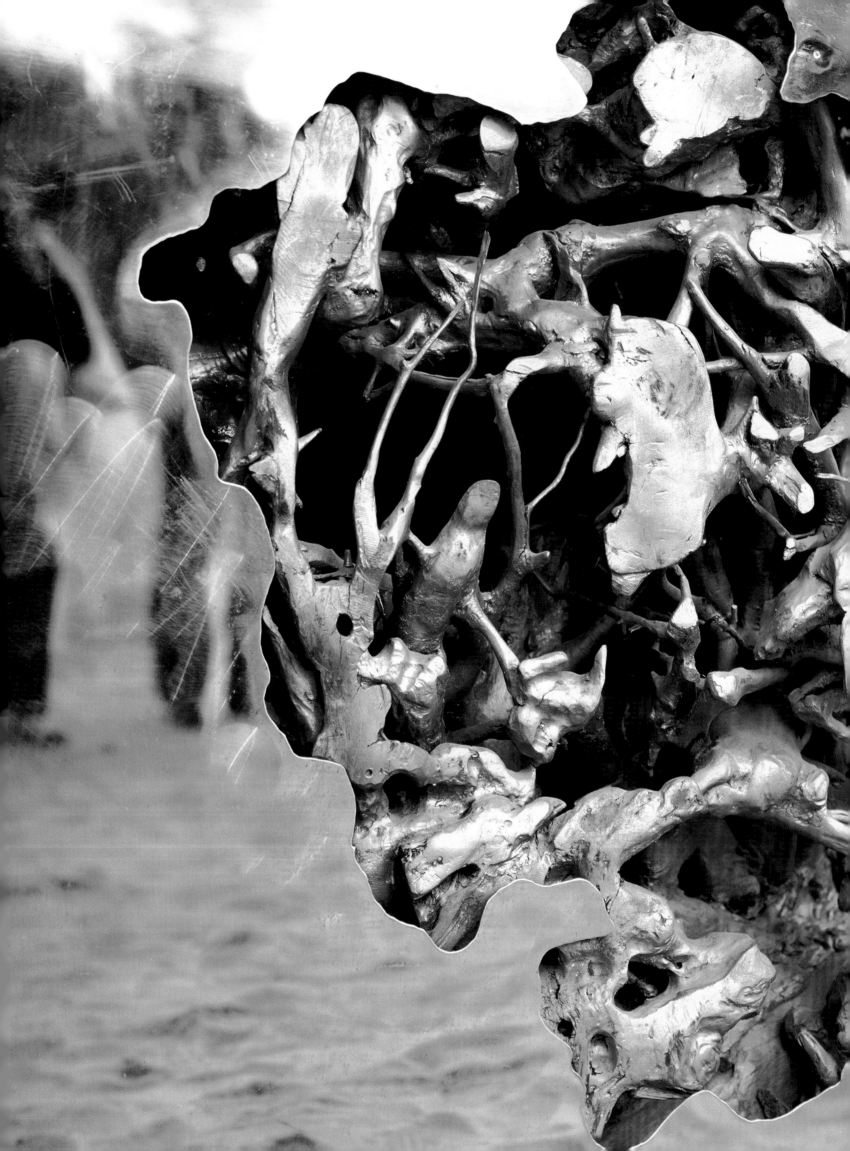

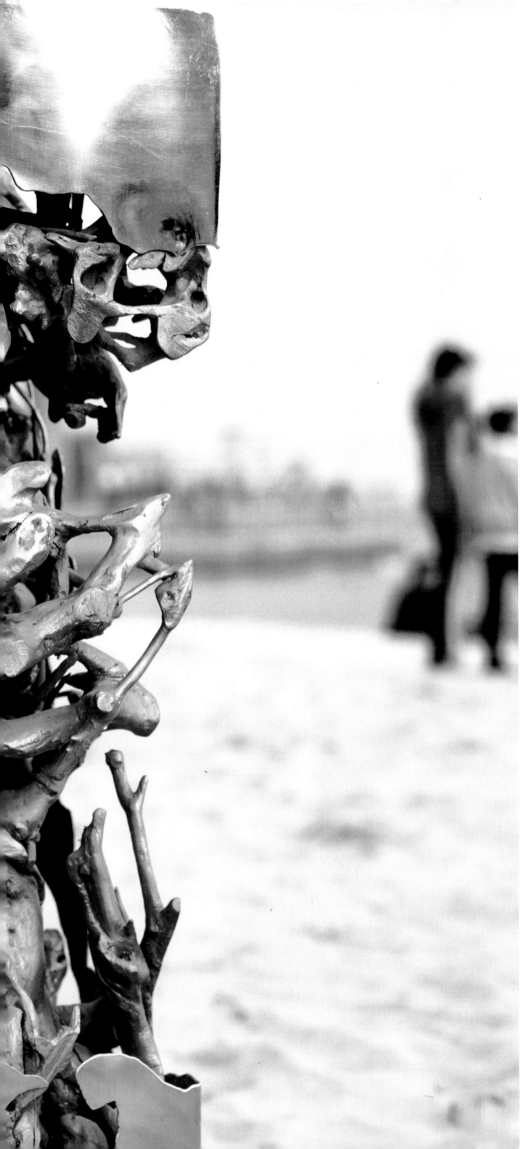

凝固的风景 No.7（局部）

195

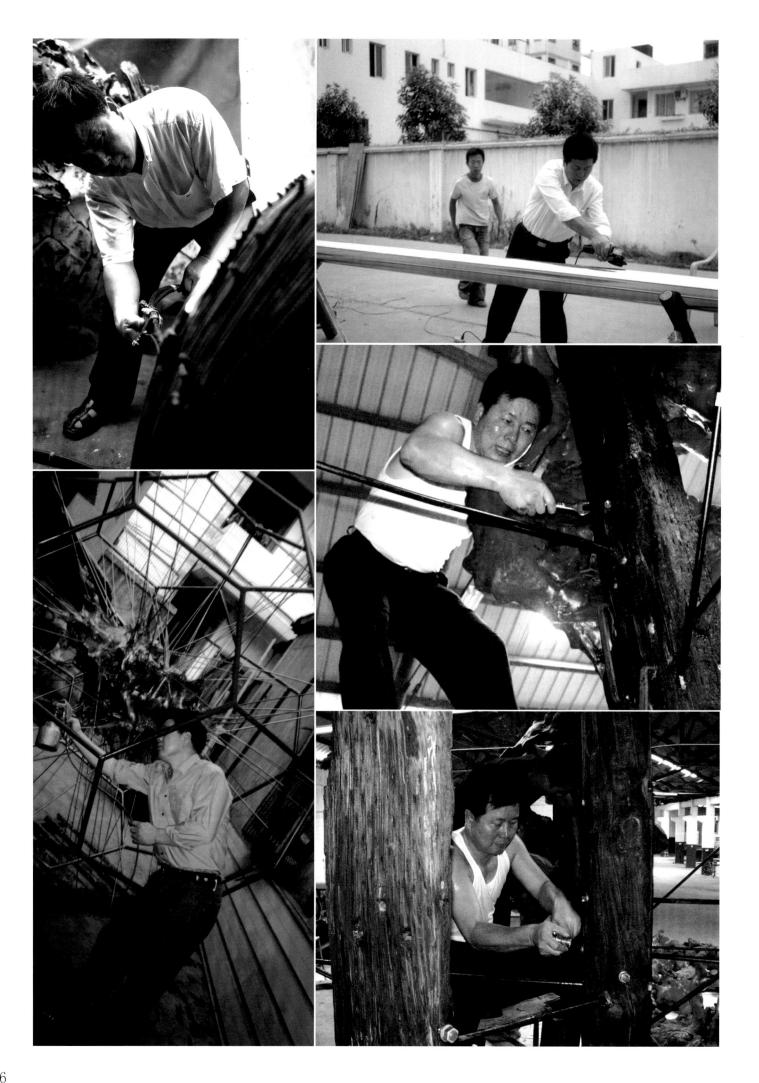

艺术家的工作状态

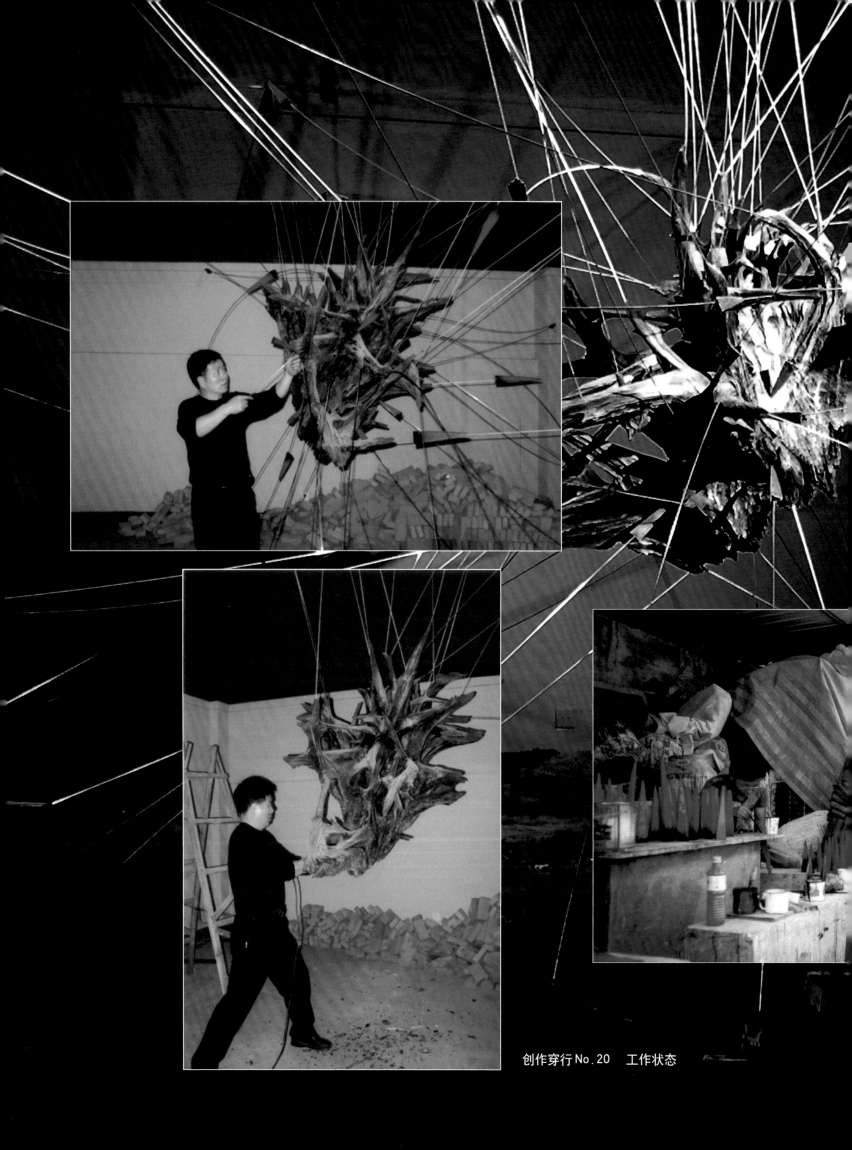

创作穿行No.20　工作状态

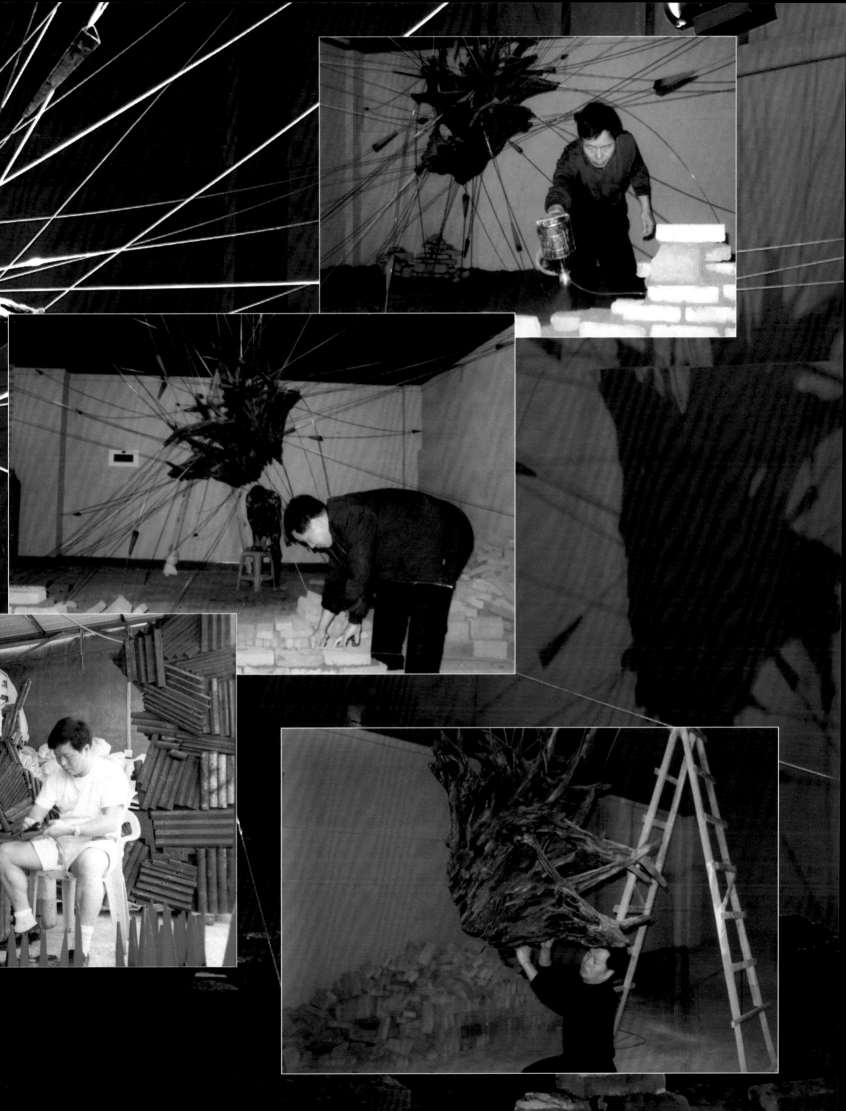

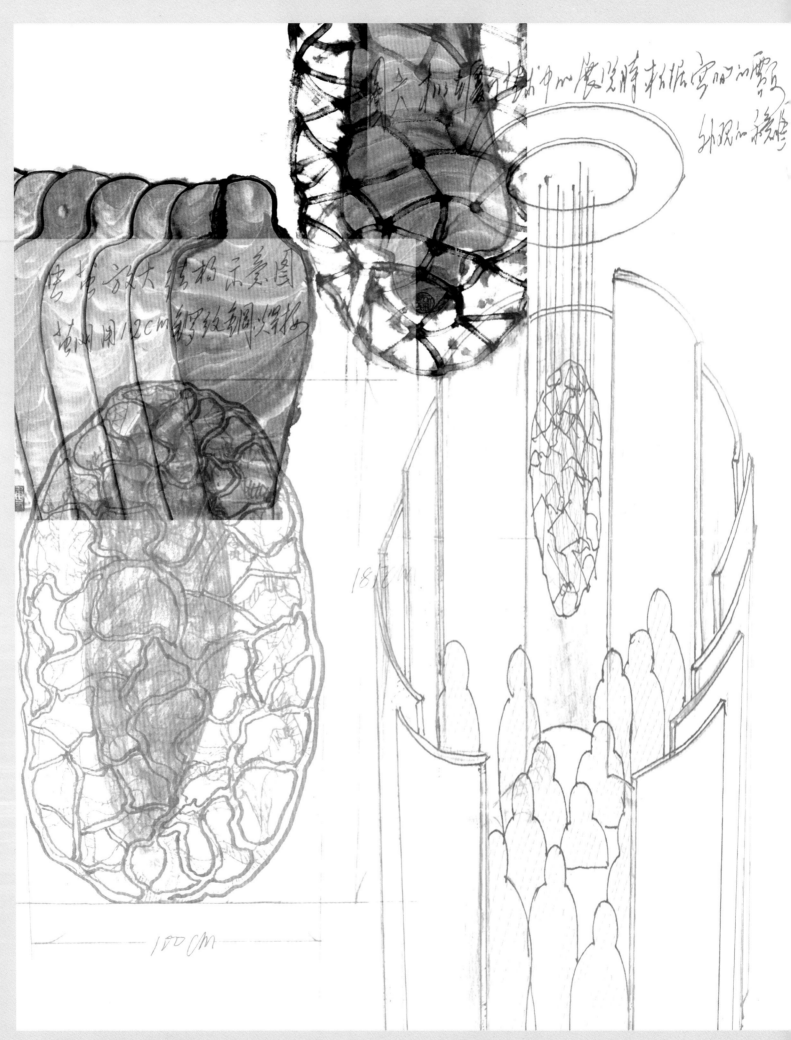

感悟No.3（蛹） 部分手稿

③

内柱钢管
高 1.2M

①

②

泥土

绿地

铝丝焊接在
基板上

混泥土

图2 钢柱直接固定在草地上.
示意图

④ ←—— 30cm ——→

铝杆(直径X高)
1.2 X 10cm

30cm

基板(厚X长宽)
(钢板)
0.8 X 30cm

角铁
3cm

钢筋
1cm

图2 钢柱直接固定在绿地上
示意图

⑥

柱底板
厚 0.8cm

30cm

←—— 30cm ——→

200cm

60cm

基坑(深X长宽)
80 X 50cm

基板离地面
200cm

混泥土

⑤

3 钢柱痼件结合示意说明图

②

安装要领
1.用两根 0.5cm 不锈钢筋首先穿透钢柱固定，再穿
透根痼,利用钢筋制成的枝角紧紧夹住痼件后上铝顶紧固
2.选好痼件钻好洞,用替代钢筋初步固定,才能确定不
锈钢筋加工的准确位置。

剖面图

穿透两层钢

根痼内四方枝角中固

用瓦根痼
块面封堵

③

图一
支柱（枕木）结构连接示意图

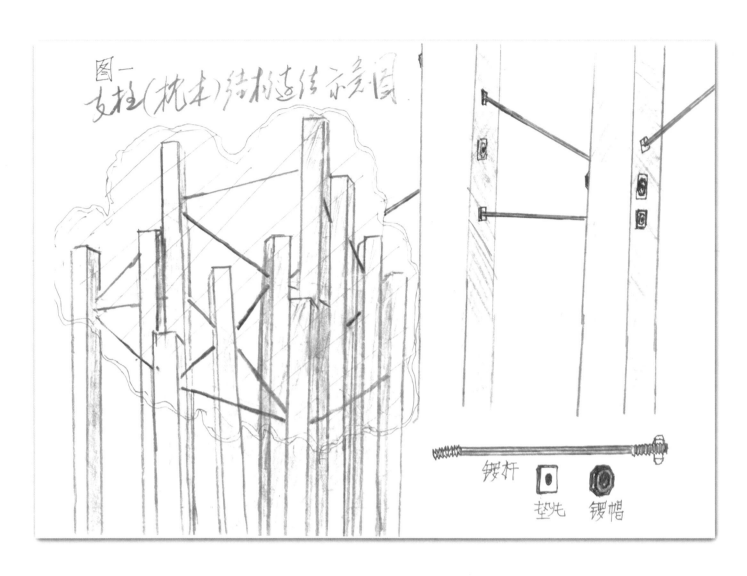

铆杆
垫片　铆帽

图二　《假日》No.2 基底规格示意图

高　中　　　　　　　　　低

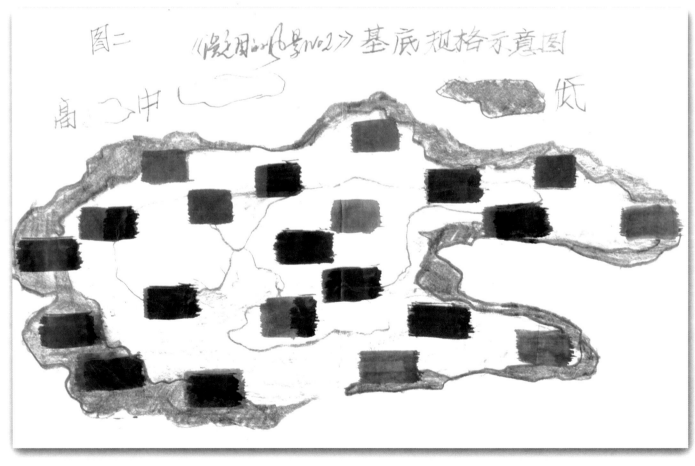

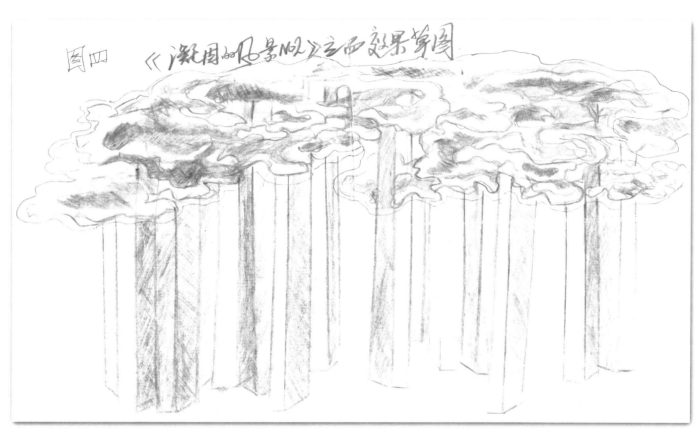

凝固的风景No.2　部分手稿

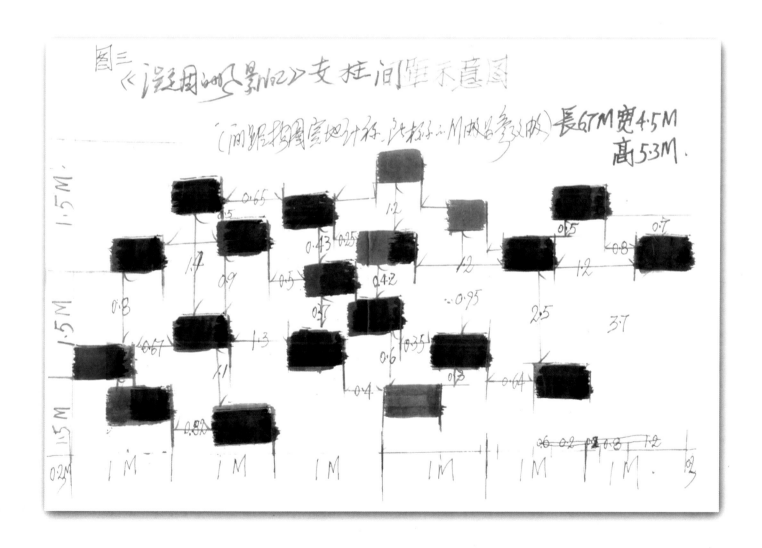

傅新民

号新萌，1949 年 6 月生于中国江西南昌，现就职于中国厦门。

从事绘画、雕塑艺术创作四十多年，先后被中国厦门大学艺术学院、集美大学艺术学院、福州大学工艺美术学院聘为客座教授，中国根艺美术大师，中国美术家协会会员。

自 2001 年以来，雕塑作品参加过中国第十届美术展览、首届中国国际建筑艺术双年展、第二届中国北京国际美术双年展、奥运景观国际雕塑大赛、巡展等多次国际、国内大展。现代水墨画作品应邀先后在美国波士顿、西班牙巴塞罗纳、荷兰祖特梅尔、日本崎玉越谷、瑞典马尔默等地展览。

作品先后被中国美术馆、成都现代艺术馆、上海城市雕塑中心、厦门艺术中心等地收藏。出版过多本现代雕塑、水墨画专著。

展　览

● 2002 年 07 月 "长征——艺术活动"（雕塑）　叶坪文物馆　瑞金

● 2003 年 12 月 "大海·音乐——厦门国际雕塑展"　厦门

● 2004 年 5 月 "新萌现代水墨画展"　厦门文化宫　集美大学美术馆　厦门

● 2004 年 8 月 "第十届全国美术展览"（雕塑）　长春　厦门

● 2004 年 9 月 "首届中国国际建筑艺术双年展——国际城市公共空间环境艺术展"（雕塑）

　　　　　　　　　　　　　　　首都城市规划展览馆　北京

● 2005 年 4 月　"汇合——中外艺术家第二届作品展"（水墨画）　巴塞罗那　西班牙

● 2005 年 7 月　"成都双年展"　成都现代艺术馆　成都

● 2005 年 9 月　"第二届中国北京国际美术双年展"（雕塑）　中国美术馆　北京

● 2005 年 11 月 "新萌现代重彩水墨画展"　厦门美术馆　厦门

● 2006 年 4 月　"奥运景观国际大赛、巡展"　北京……

● 2006 年 7 月　"来真的——当代艺术展"（雕塑）　朱屺瞻美术馆　上海

● 2006 年 9 月　"汇合——中外艺术家第三届作品展"（雕塑）　厦门

● 2006 年 10 月 "2006 中韩雕塑交流展"　厦门艺术中心　厦门

● 2006 年 10 月 "中国画三人展"　祖特梅尔市美术馆　荷兰

● 2006 年 11 月～2007 年 7 月 "海峡书画交流展"　郑州　厦门　台北

● 2007 年 3 月 "雕塑与城市的对话—— 2007 迎世博.上海国际雕塑年度展》上海城市雕塑中心　上海

● 2007 年 5 月 "生命的颜色——人与环境主题雕塑展"　厦门

● 2008 年 1 月 "生命的涌动——雕塑水墨画个展"　你好网际现代艺术馆　厦门

● 2008 年 2 月 "傅新民现代水墨画个展"　波士顿　美国

● 2008 年 5 月 "第四届亚洲新意美术交流展"（水墨画）　河南郑州

● 2008 年 6 月 "中国兰瑞典文化节"　（水墨画雕塑）　瑞典马尔默

● 2008 年 7 月 "中国姿态首届雕塑大展"　厦门　长春　西安　北京

Fu Xinmin,
also called Xinmeng, meaning "New Bud", was born in June, 1949 in Nanchang, Jiangxi, China. Fu presently holds the position of P.R.C. in Xiamen, Fujian, China.

A devotee to the field of painting and sculpture, Fu has been honored as a visiting professor at the Art College of Xiamen University, Art College of Jimei University, The Arts & Design College of Fuzhou University and Modern Art College of Tianjin Academy of Fine Arts.

Fu's first started exhibiting in 2001. Since then, his sculptures have been included in the 10th Fine Arts Exhibition of China, 1st International Architecture Biennial of China, 2nd International Art Biennial of Beijing and the Olympic Landscape Sculpture International Exhibition. His Sculptures have also been exhibited in many other international and domestic exhibitions. He was also invited to exhibit his modern ink and wash paintings in Barcelona, Spain, Zoetermeer, Netherlands and Koshigaya, Japan.

Many of his books on modern sculpture and ink and wash painting can be found in numerous book stores throughout China. His works are in the collection of the National Art Museum of China (NAMOC), Modern Art Gallery of Chengdu, Shanghai Municipal Sculpture Center of China and the Art Center of Xiamen.

Exhibitions

● July 2002 "Long March¡ªArtistic Activity" (Sculpture) Yeping Heritage Museum Ruijin,China

● December 2003 "Ocean & Music¡ªXiamen International Sculpture Exhibition" Xiamen,China

● May 2004 "Exhibition of Modern Ink Paintings Created by Xin Meng" Xiamen Cultural Palace Gallery of Jimei University Xiamen,China

● August 2004 "The 10th National Art Exhibition" (Sculpture) Changchun, Xiamen,China

● September 2004 "The 1st China International Architecture Biennale ¡ªArt Exhibition of International Urban Public Space" (Sculpture) Beijing Urban Planning Exhibition Hall Beijing,China

● April 2005 "Confluence¡ªThe 2nd Chinese and Foreign Artistic Works Exhibition" (Ink Panting) Barcelona Spain

● July 2005 "Chengdu Art Biennale" Chengdu Modern Art Museum Chengdu,China

● September 2005 "The 2nd International Art Biennale of Beijing, China" (Sculpture) National Art Museum of China Beijing

● November 2005 "Modern Colored Ink Painting Exhibition of Xin Meng" Xiamen Gallery Xiamen,China

● April 2006 "International Contest of Olympic Landscape and Exhibition Tour" Beijing,China

● July 2006 "This Is For Real: An Exhibition of Contemporary Art" Zhu Qizhan Art Museum Shanghai,China

● September 2006 "Confluence¡ªThe 3rd Chinese and Foreign Artistic Works Exhibition" (Sculpture) Xiamen,China

● October 2006 "2006 Sino-Korea Sculpture Exchange Exhibition" Xiamen Art Center Xiamen,China

● October 2006 "Chinese Painting Exhibition of Three Artists" Zoetermeer Gallery Holland

● November 2006¡«July 2007 "Cross-Strait Paintings and Calligraphy Exchange Exhibition" Zhengzhou, Xiamen, Taipei

● March 2007 "Dialogue Between Sculpture and Cities¡ªShanghai International Sculpture Annual Exhibition,in preparation for 2007 Shanghai World Exposition" Shanghai Sculpture Space Shanghai,China

● May 2007 "The Color of Life¡ªSculpture Exhibition on Human and the Environment" Xiamen,China

● January,2008 "Sculpture Works&Ink-and-wash paintings of Mr. Fu Xinmin for a great exhibition" at Xiamen Art Biennale

● February,2008 "Ink & Wash Paintings of Mr. Fu Xinmin for a great exhibition" Boston, Mass. U.S.A.

● May ,2008 "Fourth Asian new Art Exhibition" (Ink Panting) Zhengzhou, Henan , China

● June ,2008 "China-Sweden Cultural Festival" (Ink Panting .Sculpture) Malmo, Sweden

● July ,2008 "China's first sculpture exhibition gesture" Xiamen Changchun Xi'an Beijin

图书在版编目（CIP）数据

傅新民现代雕塑艺术作品集．2／傅新民编．－北京：
人民美术出版社，2008.8
ISBN 978-7-102-04290-9
Ⅰ．傅… Ⅱ.傅… Ⅲ.雕塑－作品集－中国－现代
Ⅳ.J321
中国版本图书馆CIP数据核字（2008）第171612号

傅新民现代雕塑艺术作品集（二）

出版发行：人民美术出版社
　　　　　（北京北总布胡同32号　100735）
网　　　址：www.renmei.com.cn
编　　辑：戚　彧　郑文福　阙　飞
责任编辑：陈　林
装帧设计：郑文福
摄　　影：西　蒙　杨　星　张格展　李　军　陈　杰
英文翻译：詹姆斯·庞格拉斯　李琼花　王文菁　范晓莉
印刷制版：厦门华彩印务有限公司
经　　销：新华书店总店北京发行所

2008年11月第1版　第1次印刷
开本:635毫米×965毫米　1/8　印张：26.5
印数：1—2000册
ISBN 978-7-102-04290-9
定价：198.00元